50 WOMEN ARTISTS
YOU SHOULD KNOW

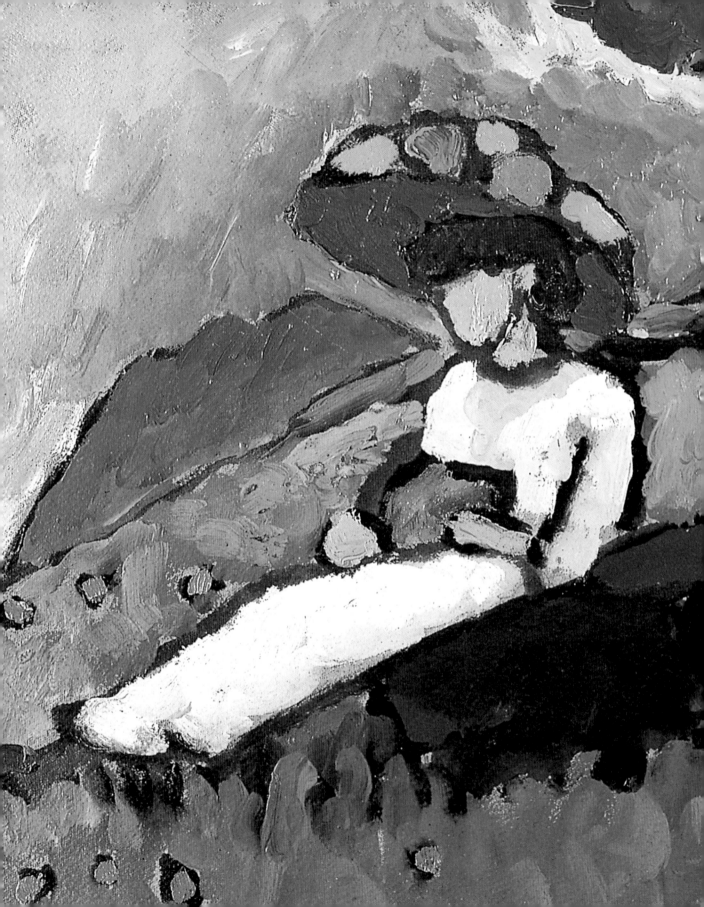

50 WOMEN ARTISTS
YOU SHOULD KNOW

Christiane Weidemann
Petra Larass
Melanie Klier

Prestel

Munich · London · New York

© Prestel Verlag, Munich · London · New York, 2008
Reprinted in 2013
© for the works reproduced is held by the architects and artists, their heirs or assigns, with the exception of: Marina Abramović, Louise Bourgeois,
Sophie Calle, Camille Claudel, Hannah Höch, Jenny Holzer, Rebecca Horn, Käthe Kollwitz, Lee Krasner, Tamara de Lempicka, Gabriele Münter,
Georgia O'Keeffe, Meret Oppenheim, Niki de Saint Phalle, Alfred Stieglitz and Ulay with VG Bild-Kunst, Bonn 2013; Frida Kahlo with Banco de México
Diego Rivera & Frida Kahlo Museums Trust / VG Bild-Kunst, Bonn 2013; Tacita Dean courtesy the artist, Frith Street Gallery, London and Marian Goodman
Gallery, New York and Paris; Tracey Emin with Tracey Emin, courtesy Jay Jopling / White Cube London; Pipilotti Rist courtesy the artist and Hauser & Wirth
Zürich London; Kiki Smith with Kiki Smith, courtesy PaceWildenstein, New York; Eva Hesse with The Estate of Eva Hesse. Hauser & Wirth Zürich London

Prestel Verlag, a member of Verlagsgruppe Random House GmbH
Neumarkter Straße 28
81673 Munich
Tel. +49 (0)89 4136-0
Fax +49 (0)89 4136-2335

Prestel Publishing Ltd.
4 Bloomsbury Place
London WC1A 2QA
Tel. +44 (0) 20 7323-5004
Fax +44 (0) 20 7636-8004

Prestel Publishing
900 Broadway. Suite 603
New York, N.Y. 10003
Tel. +1 (212) 995-2720
Fax +1 (212) 995-2733

www.prestel.com

The Library of Congress Control Number: 2008921120

British Library Cataloguing-in-Publication Data: a catalogue record for this book is available from the British Library. The Deutsche Bibliothek
holds a record of this publication in the Deutsche Nationalbibliografie; detailed bibliographical data can be found under: http://dnb.d-nb.de

Project management by Claudia Stäuble
Translated from the German by Paul Aston, Rome and Jane Michael, Munich
Copy-edited by Chris Murray, Crewe
Cover and design by LIQUID, Agentur für Gestaltung, Augsburg
Layout and production by zwischenschritt, Rainald Schwarz, Munich
Picture research by Claudia Stäuble, Andrea Weißenbach
Origination by ReproLine Mediateam
Printing and Binding by Druckerei Uhl GmbH & Co. KG, Radolfzell

Verlagsgruppe Random House FSC®-DEU-0100
The FSC®-certified paper *Hello Fat Matt* has been
supplied by Deutsche Papier.

Printed in Germany

ISBN 978-3-7913-3956-6

CONTENTS

RAPHAEL

HANS HOLBEIN THE YOUNGER

1519 Charles V becomes
Holy Roman Emperor

1520–1521 Circumnavigation of the
world by Ferdinand Magellan

1541 Spain conquers the Maya kingdom
in Central America

1550–1650 Witch-hunts
reach their peak

HIGH RENAISSANCE 1475–1600

| 1470 | 1475 | 1480 | 1485 | 1490 | 1495 | 1500 | 1505 | 1510 | 1515 | 1520 | 1525 | 1530 | 1535 | 1540 | 1545 | 1550 | 1555 |

CATHARINA DE
HEMESSEN
PINGEBAT
1·5·4·8

1558 Elizabeth I becomes Queen of England

1588 Spanish Armada defeated

1571 Battle of Lepanto ends maritime supremacy of the Turks

1590 Dome of St. Peter's Basilica completed

1601 *Hamlet* (William Shakespeare)

1562 Huguenot Wars of Religion in France

1602 Cape Colony in South Africa founded by the Dutch

1475–1600 HIGH RENAISSANCE BAROQUE 1600–1700

1560 1565 1570 1575 1580 1585 1590 1595 1600 1605 1610 1615 1620 1625 1630 1635 1640 1645

CATHARINA VAN HEMESSEN

Catharina van Hemessen was the first Flemish women painter whose work is known today. Her known oevre is not large, but occupies a significant position in 16th-century art.

Catharina van Hemessen was mentioned as a famous woman painter in a book about the Netherlands published in 1567. She was of the same generation of artists as Pieter Brueghel the Elder and Frans Floris, who worked in Antwerp in the 16th century. Antwerp was at that time one of the leading art centers of Europe. Around 300 painters had master status there, and their pictures were exported to Scandinavia, Germany, Italy, and Spain. Catharina's father Jan van Hemessen, considered the inventor of the Flemish genre picture, ran a successful master workshop in the city. Young Catharina thus trained as a painter while still a girl, helping her father with his paintings and finally taking over commissions on her own behalf. It was at the time quite normal for workshops to be run as family businesses, but daughters and sons rarely worked under their own names. The result is that many artists of both sexes have disappeared into oblivion and their works can no longer be clearly identified.

Early Masterworks of Portrait Painting

However, Catharina van Hemessen signed her paintings with her full name. A remarkable work is a self-portrait of her at 20, thought to be the earliest surviving painting of an artist at work on a self-portrait. It is signed top left: EGO CATERINA DE / HEMESSEN ME / PINXI 1548 // ETATIS / SVÆ /20 ("I, Catharina van Hemessen, painted myself in 1548 at the age of 20"). Among her earliest masterpieces is also the *Girl at the Spinet* (1548), showing her sister Christina as a young girl at the keyboard, though the girl looks remarkably like Catharina. Portraits remained Catharina's specialism. Most of her pictures date from 1548 to 1554, and are small-format. Her clientele paid very well for them. The *Portrait of a Lady* from 1551 is now in the London National Gallery collection. It shows a dignified lady dressed appropriately for her social class wearing red sleeves and a transparent *haube* (small head-dress), the details of which are shown with great skill. She carries a small dog under one arm, which was a popular accessory in elegant society.

In 1554, Catharina married musician Chrétien de Morien. Two years later, she went with him to Spain: Mary of Hungary had noticed the young painter, and after her abdication as regent of the Netherlands invited her to her court in Madrid. When the art-loving patroness, whose appearance we know from a portrait by Titian, died in 1558, she left the artistic couple a generous pension. No works are known from the period after her return to the Netherlands. She died in Antwerp around 1587.

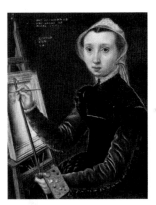

1528 Born in Antwerp. Trained by her father Jan van Hemessen, working with him in his workshop.
1548 Paints a self-portrait and the *Girl at the Spinet*.
1554 Marries Chrétien de Morien. Works for the Spanish court.
C. 1587 Dies in Antwerp.

FURTHER READING:
Anne Sutherland Harris and Linda Nochlin, *Women Artists: 1550–1950*, Los Angeles County Museum of Art / Knopf, New York, 1976
Delia Gaze (ed.), *Dictionary of Women Artists*, Fitzroy Dearborn, London and Chicago, 1997

left page:
Portrait of a Lady, 1551, oil on panel, 23 x 18 cm, National Gallery, London

above:
Self-Portrait, 1548, tempera on panel, 31 x 24.5 cm, Kunstmuseum Basel

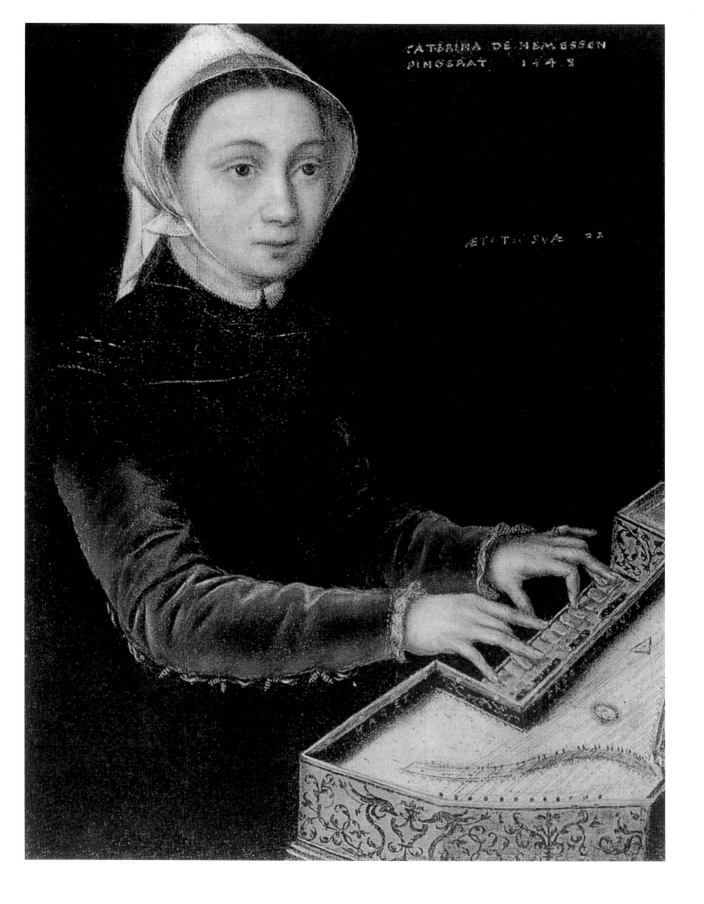

CATERINA DE HEMESSEN
PINGEBAT 1548

ÆTATIS SVÆ 22

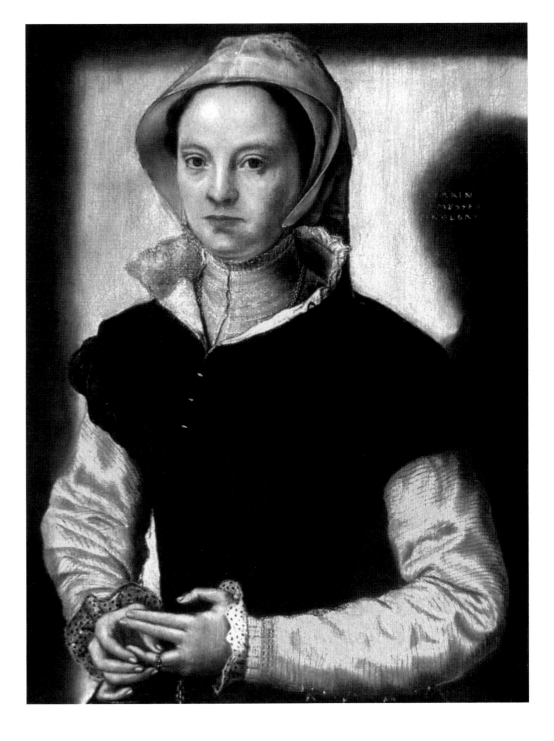

left page:
Girl at the Spinet, 1548, oil on panel,
30.5 x 24.3 cm, Wallraf-Richartz
Museum, Cologne

above:
Portrait of a Lady, after 1550,
oil on panel, 40.9 x 39.1 cm,
The Bowes Museum, Barnard Castle

CATHARINA VAN HEMESSEN

1492 b. Marguérite de Navarre, poet of
the early French Renaissance

1515 b. Teresa of Avila, Spanish
religious teacher and mystic

1541 Spain conquers the Maya kingdom in Central America

1501–1504 *David* (Michelangelo)

1543 Copernicus' theory of **1555** Peace of
heliocentric universe Augsburg

HIGH RENAISSANCE 1475–1600

| 1480 | 1485 | 1490 | 1495 | 1500 | 1505 | 1510 | 1515 | 1520 | 1525 | 1530 | 1535 | 1540 | 1545 | 1550 | 1555 | 1560 | 1565 |

1571 Battle of Lepanto ends maritime supremacy of the Turks

1590 Dome of St. Peter's Basilica completed

1633 Galileo brought before the Inquisition

1643 Louis XIV becomes King of France

1648 End of Thirty Years' War

1475–1600 HIGH RENAISSANCE BAROQUE 1600–1700

1570 1575 1580 1585 1590 1595 1600 1605 1610 1615 1620 1625 1630 1635 1640 1645 1650 1655

SOFONISBA ANGUISSOLA

With her expressive portraits and humoristic family pictures, Sofonisba Anguissola was regarded as the most successful female artist of the Italian Renaissance. She was recognized by major contemporaries such as Michelangelo and Giorgio Vasari, and Peter Paul Rubens even copied her on several occasions.

Amilcare Anguissola, a nobleman from Cremona, was greatly disappointed that the longed-for male heir put in an appearance only after six daughters. All six daughters received a broadly based education in music, painting, languages, literature, and philosophy—not only as a substitute dowry, but also in response to contemporary fashion. Primarily as a result of her remarkable talent, the eldest of the six, Sofonisba, received artistic training together with her sister, Elena; they studied between 1546 and 1551 under Bernardino Cami and Bernardino Gatti (Il Sojaro). Sofonisba's ambitious father skillfully arranged contacts with rulers and artists in order to make her paintings better known.

Humorist Portraits

Anguissola was 20 years old when she painted her best-known picture, *Three Sisters Playing Chess*. The detailed representation of an everyday domestic scene, the first in Italian painting, was very unusual at the time. So, too, was the highly expressive portrayal of physiognomy: the youngest sister Europa is laughing spontaneously at Minerva's surprised reaction as their elder sister, Lucia, is in the process of carrying out a clever move and looks at the viewer, confident of victory. Even the art chronicler Giorgio Vasari was enchanted by the picture's charm and realism.

At the Spanish Court

Thus Sofonisba Anguissola became famous as a portraitist beyond the boundaries of Italy, and in 1559 King Philip II of Spain invited her to become lady-in-waiting and art teacher to Queen Isabella of Valois, who was only 14 years old at the time. They became close friends, and when the Regent died ten years later, Sofonisba left the court grief-stricken. She had painted all the members of the royal family; even the Pope commissioned a portrait of the Queen painted by Anguissola.

Return to Italy

Among the clauses of her agreement with the court was one stating that upon completion of her duties, she would be entitled to an arranged marriage with a man of appropriate standing. So, accompanied by her new husband, Don Fabricio di Moncada, Anguissola set off to return to Italy and settle in Palermo. It seems to have been more than just a whim of nature that di Moncada should drown in a shipwreck and Anguissola, on her way home, should fall in love with the captain of the ship, the Genoese nobleman Orazio Lomellino, during the journey to Genoa. They married without the permission of the King that same month and for the next 30 years the artist maintained contact with artists and men of letters from her house in Genoa: Peter Paul Rubens, who had copied several of her paintings in Spain on the

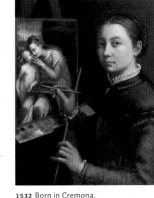

1532 Born in Cremona.
1546 Starts her training under Bernardino Cami and Bernardino Gatti.
1559 Becomes a lady-in-waiting and art teacher under King Philip II of Spain.
1625 Dies in Palermo.

FURTHER READING:
Ilya Sandra Perlingieri, *Sofonisba Anguissola*, Rizzoli International, New York, 1992
Sylvia Ferino-Pagden and Maria Kusche, *Sofonisba Anguissola: A Renaissance Woman*, National Museum of Women in the Arts, Washington, DC, 1995

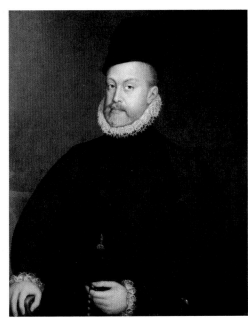

left page:
The Artist's Sister Wearing a Nun's Habit, 1551, oil on canvas, 75 x 60 cm, Southampton City Art Gallery

left:
Portrait of King Philip II, c. 1565, oil on canvas, 88.3 x 72.4 cm, Museo del Prado, Madrid

above: *Portrait of the Artist at the Easel*, 1556, oil on canvas, 66 x 57 cm, Muzeum Lancut, Zamek

Renaissance

The word "Renaissance" means rebirth; in the context of art history it is applied to the rediscovery of classical antiquity from the 14th century onwards. Man and his life on Earth became once more the focus of art and literature. The Early Renaissance originated largely in Florence, but the center of the High Renaissance at the beginning of the 16th century became Rome when, on the instructions of the pope, St. Peter's was built and numerous important artists settled in the city.

instructions of the Duke of Mantua, visited her, as did Anthony van Dyck. The latter sketched her, by now almost 90 years old and virtually blind, in 1624, one year before her death in Palermo.
In addition to her own creative work, Sofonisba Anguissola was always an enthusiastic teacher, either of her sisters, of the Queen of Spain, or, later, of her pupils of both sexes. She was also a keen miniaturist. She was famous not only as a talented artist *virtuosa*, but also as a cultivated *Grandezza*.

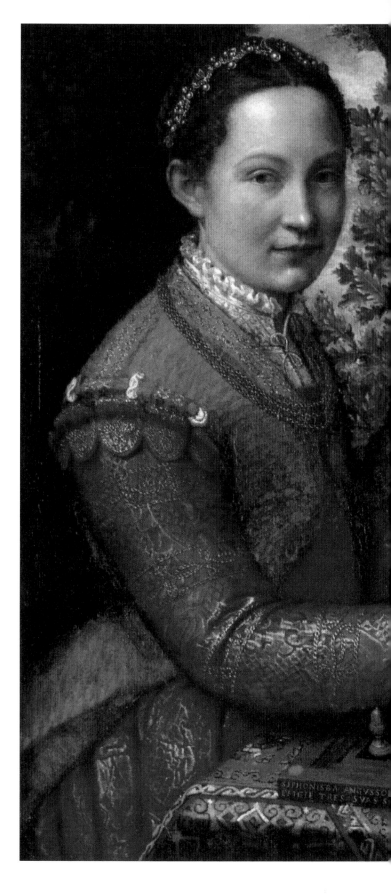

Three Sisters Playing Chess, 1555,
oil on canvas, 72 x 97 cm,
Muzeum Norodowe, Poznan

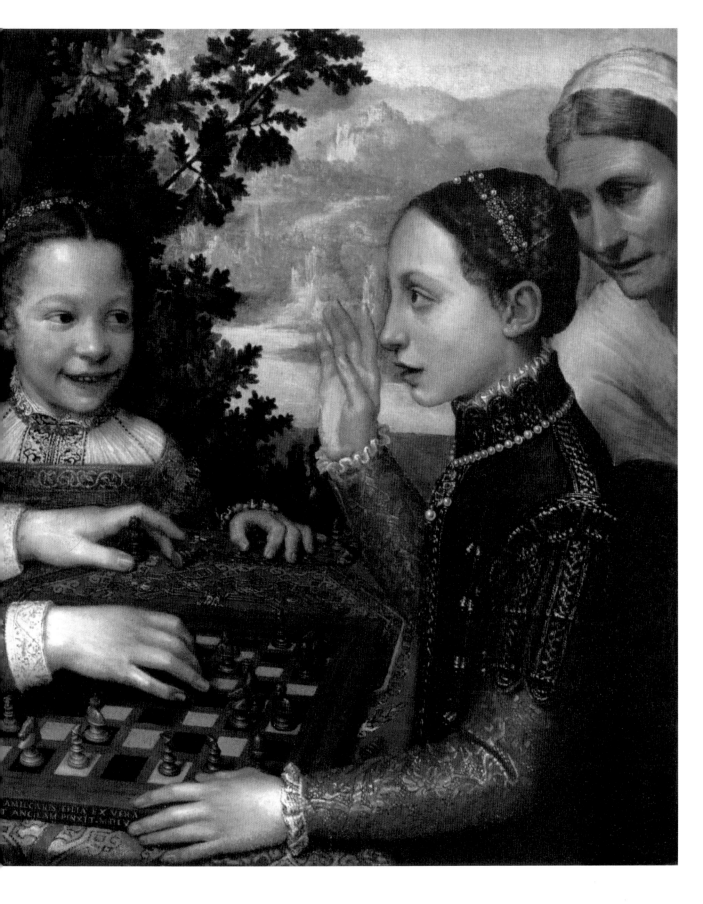

1519 b. Catherine de' Medici, consort
of Henri II of France

1541 Completion of frescoes in the
Sistine Chapel (Michelangelo)

1567 b. Claudio Monteverdi, Italian composer

1571 Battle of Lepanto ends maritime
supremacy of the Turks

1500 1505 1510 1515 1520 1525 1530 1535 1540 1545 1550 1555 1560 1565 1570 1575 1580 1585

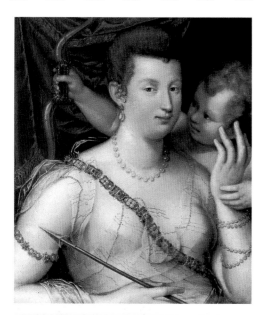

left:
Venus and Cupid, 1592, oil on canvas,
72.5 x 60 cm, Musée des Beaux Arts,
Rouen

below:
Family Portrait, end of 16th century,
oil on canvas, 85 x 105 cm, Pinacoteca
Nazionale di Brera, Milan

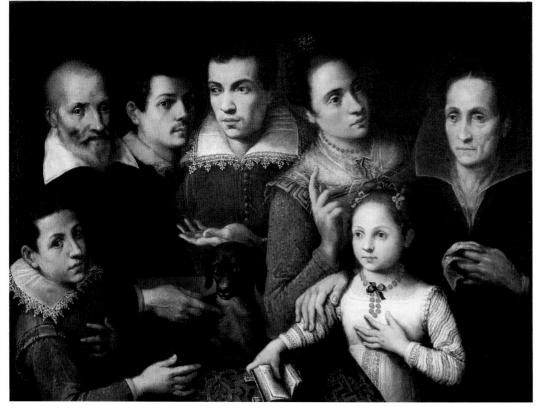

DIEGO VELÁZQUEZ

1609 Expulsion of Moors from Spain **1630** Building of Taj Mahal commences

1590 Dome of St. Peter's Basilica **1618** Start of Thirty Years' War
completed

1601 *Hamlet* (William Shakespeare) **1620** The Mayflower lands in America

1475–1600 HIGH RENAISSANCE BAROQUE 1600–1700

1590 1595 1600 1605 1610 1615 1620 1625 1630 1635 1640 1645 1650 1655 1660 1665 1670 1675

LAVINIA FONTANA

As an artist of the Italian Renaissance, Lavinia Fontana emancipated herself in two ways: firstly, as a successful painter of portraits and history paintings, she was the main breadwinner for a family of 13; and secondly, she was the first woman artist to paint female nudes.

Her career started classically enough: her father, Prospero Fontana, a reputable painter of history paintings in Bologna, recognized his daughter's talent; as she was his only child, it was planned that she should inherit his studio. Prospero Fontana steered his daughter's fate in a well-directed and far-sighted manner. Initially, he took over her artistic education himself and even saw to it that she studied the sculptures in his admired collection of antique works and casts. This privileged start enabled her later to produce highly sensuous paintings with female nude figures—an unheard-of and risky venture which to date no female artist had permitted herself to attempt. Her last painting, *Minerva Dressing*, was a true masterpiece. She finally completed her training under the Netherlandish artist Denis Calvaert, who had once been a pupil of Prospero and who ran an influential painting school.

Portrait Painter to the Aristocracy

Fontana soon acquired a reputation as the most sought-after portrait painter of Bologna's upper society. Her meticulous style appealed above all because it was influenced by fashion and reflected in every detail the costly attributes of the elaborately decorated costumes. The people themselves look, by contrast, unapproachable and stiff as they gaze self-assuredly out of the dark paintings. Even Pope Gregory XIII commissioned her to paint his portrait in 1580, thus making it possible for her to find clients among the clergy. Lavinia Fontana received for her individual or group portraits fees more generous than those of virtually any other artist of her time.

Exchange of Roles in the Family

In 1577, she produced her first *Self-Portrait*, which she designed along the lines of the works by her role model, her somewhat older fellow-artist Sofonisba Anguissola. She shows herself playing the spinet, a sign that she was highly educated; her air, as she looks at the viewer, is self-confident and assured. In the background, we can clearly make out her studio, and an inscription explicitly refers to the fact that she "painted the picture of her face herself from the mirror." Not without reason, for the recipient of the picture was no less a person than her father-in-law, a prosperous merchant from Imola. Giovanni Paolo Zappi, the selected bridegroom, was also formerly a pupil of Prospero Fontana. His own talent was rather mediocre, but he recognized the talent of his future wife and allowed her to retain responsibility for the studio. He himself functioned as his wife's manager and helped her with the execution of many of her commissions. Lavinia also had the strength to give birth to 11 children in rapid succession.

Recognized Painter of History Paintings

Some years were to pass before Pope Clement VII finally summoned her to Rome, where many of her colleagues worked. She had painted the *Triumph of St. Hyacinth*, the altarpiece for the chapel in Santa Sabina, which was greeted with great enthusiasm. Lavinia's style became more lively and less focused on detail. She received further commissions for altar paintings and also for history paintings, becoming the first Renaissance artist to achieve recognition in this genre. Lavinia painted a total of more than 100 paintings, a remarkable and comprehensive oeuvre.

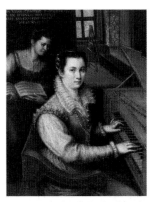

1552 Born in Bologna, the daughter of the well-known painter and teacher Prospero Fontana. Receives a thorough artistic training under her father and then the Netherlandish artist Denis Calvaert.
1577 Marries Giovanni Paolo Zappi from Imola.
1589 Commissioned for the Escorial in Madrid.
1603 Moves to Rome with her family.
1614 Dies in Rome

FURTHER READING:
Caroline P. Murphy, *Lavinia Fontana: A Painter and Her Patrons in Sixteenth-century Bologna*, Yale University Press, New Haven, CT, 2003

Self-Portrait at the Spinet, 1577, oil on canvas, 27 x 24 cm, Accademia Nazionale di San Luca, Rome

1529 First siege of Vienna by the Turks

1541 Completion of frescoes in the
Sistine Chapel (Michelangelo)

1532 b. Orlando di Lasso,
Flemish composer

1562 Huguenot Wars of Religion in France

1500 1505 1510 1515 1520 1525 1530 1535 1540 1545 1550 1555 1560 1565 1570 1575 1580 1585

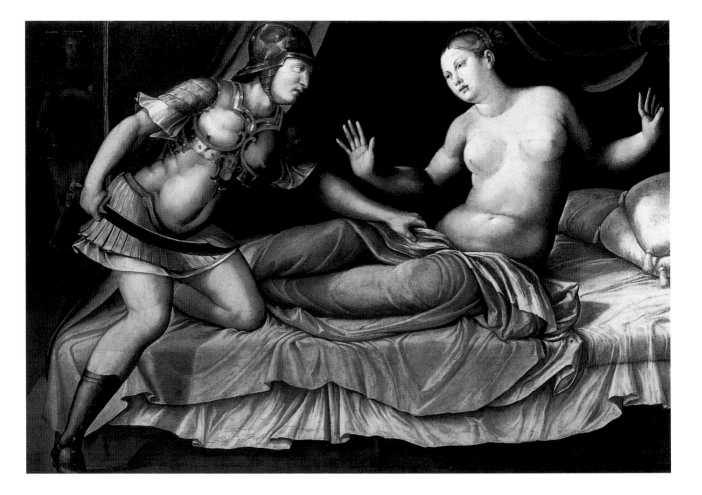

Sextus Tarquinius and Lucretia,
undated, oil on canvas, 98 x 146 cm,
Private collection

DIEGO VELÁZQUEZ

JUDITH LEYSTER

1587 Execution of Mary Stuart, Queen of Scots

1611 Gustavus (II) Adolphus becomes King of Sweden

1628 Memoirs of Marguérite de Valois, Queen of France

1664 Newton's Binomial Theorem

1668 *The Return of the Prodigal Son* (Rembrandt van Rijn)

1475–1600 HIGH RENAISSANCE BAROQUE 1600–1700

1590 1595 1600 1605 1610 1615 1620 1625 1630 1635 1640 1645 1650 1655 1660 1665 1670 1675

BARBARA LONGHI

The delicate, introverted figures in Barbara Longhi's devotional pictures correspond more closely to the tradition of the High Renaissance than to the lively Mannerism that represented the spirit of the age in which she lived.

Like her brother Francesco, Barbara Longhi grew up in Ravenna in the studio of her father, Luca Longhi, where she learned the craft of painting from her earliest years. The sparse information about her life seems to indicate that Barbara Longhi never left her native town; in general she seems to have lived a rather retiring life.

In line with the tradition of family studios, Barbara assisted her father with his studio's larger commissions. She was also required to copy her father's famous works in order to increase their distribution. It is therefore extremely difficult to distinguish between the styles of the two artists, and to determine who produced which paintings. To date, only 15 paintings have been attributed to Barbara Longhi; some of them are signed with the monogram BLF (Barbara Longhi fecit: "Barbara Longhi painted it").

Surprisingly enough, these works include only one portrait. This seems remarkable, as Barbara Longhi's expressive portraits in particular were specifically praised, for example by Munizio Manfredi, the head of the academy in Bologna.

Painter of Icons

Among Barbara Longhi's works are a number of paintings of the Madonna, whom she preferred to depict in small-format devotional compositions. Here, too, it is easy to understand the recognition afforded her artistic skills: her representations of the Virgin Mary and the Christ Child radiate a tender beatitude. The figures are often grouped in a triangular composition before a curtain, with a section of landscape seen in the background. This corresponds to a popular composition found among Renaissance artists in Florence, including Raphael and Leonardo da Vinci. The viewer's gaze is thus concentrated on tranquil figures. The representation of the divine individuals is not so much intended to reflect their personal characteristics, but rather to depict an idealized image of spiritual virtue.

These devotional pictures, which were very popular as private altarpieces, were designed to reflect the views of the Counter-Reformation and the new cult of the Virgin Mary. Barbara Longhi painted numerous variations showing the Madonna: with the sleeping Infant; with Christ and John the Baptist as children; reading; or as a witness to the mystical marriage of St. Catherine.

Even the art chronicler and painter Giorgio Vasari wrote admiringly of the works of Barbara Longhi, although she was only 16 at the time: "Her clear lines and the soft brilliance of her colors are unique." The fact that she was even mentioned in his famous *Lives of the Artists* was due to her technical skills rather than her stylistic characteristics. Barbara Longhi devoted her attention primarily to the conservative ideals of the Renaissance and refused to study the new ideas of Mannerism. Unfortunately, only very few of her works are dated; her most productive period seems to have been between 1590 and 1605.

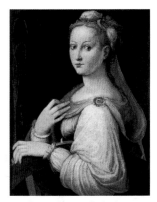

1552 Born in Ravenna, Italy, the daughter of the Mannerist painter Luca Longhi. First painting lessons from her father.
1590–1605 Most productive period. Frequent motifs are portraits and representations of the Madonna.
1638 Dies in Ravenna.

FURTHER READING:
Anne Sutherland Harris and Linda Nochlin, *Women Artists: 1550–1950*, Los Angeles County Museum of Art / Knopf, New York, 1976
Delia Gaze (ed.), *Dictionary of Women Artists*, Fitzroy Dearborn, London and Chicago, 1997

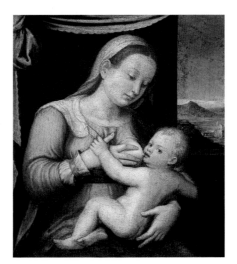

left:
Virgin Mary with the Infant Jesus, undated, oil on canvas, 57 x 48.5 cm, Museo Civico, Vicenza

above:
St. Catherine of Alexandria, undated, oil on canvas, 69 x 54 cm, Pinacoteca Nazionale, Bologna

1588 Spanish Armada defeated

1590 Dome of St. Peter's Basilica completed

1585 Anglo-Spanish War

1620 The Mayflower
lands in America

1609 Expulsion of Moors from Spain

1475–1600 HIGH RENAISSANCE BAROQUE 1600–1700

| 1540 | 1545 | 1550 | 1555 | 1560 | 1565 | 1570 | 1575 | 1580 | 1585 | 1590 | 1595 | 1600 | 1605 | 1610 | 1615 | 1620 | 1625 |

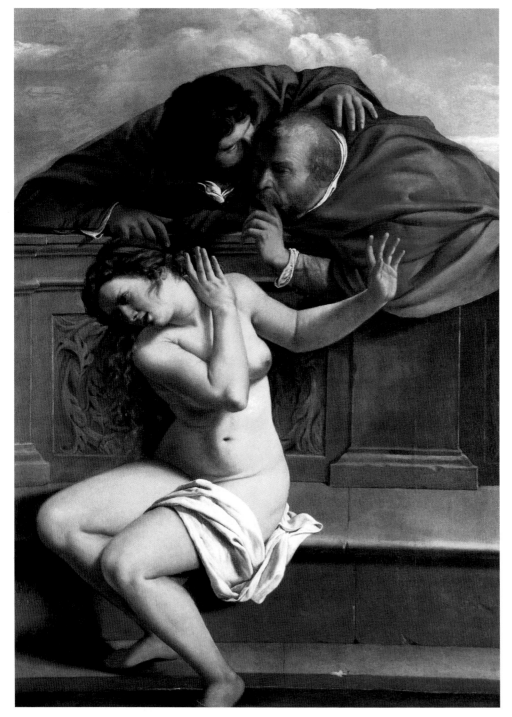

Susanna and the Elders, 1610, oil on canvas,
178 x 125 cm, Schloss Weissenstein,
Schönbornsche Kunstsammlungen,
Pommersfelde

1642 *The Night Watch* (Rembrandt van Rijn)

1643 Louis XIV becomes King of France ("The Sun King")

1633 Galileo brought before the Inquisition

1680 b. Antonio Vivaldi, Italian composer

1668 Building of Versailles commences

1600–1700 BAROQUE ROCOCO 1700–1780

1630 1635 1640 1645 1650 1655 1660 1665 1670 1675 1680 1685 1690 1695 1700 1705 1710 1715

ARTEMISIA GENTILESCHI

To this day, the naturalistic style, the luminous colors, and the dramatic use of light in the paintings of Artemesia Gentileschi leave a deep and sometimes disturbing impression on the viewer.

The life and work of this important representative of the Italian Baroque would provide a fascinating subject for a novel—Artemisa Gentileschi was an outstanding woman who possessed not only the courage, but also the rare talent to produce uncompromising art.

Artemisia was a pupil of her father Orazio Gentileschi, a successful Baroque painter in Rome. In order to perfect her technical skills, he apprenticed her to his artist friend Agostino Tassi. The latter, however, made sexual advances to his talented pupil; when he failed to keep his promise of marriage, the affair was taken to court. As the main protagonist in the first public rape case, Artemisia was humiliated, and acquired a dubious reputation, especially as the trial ended without a clear verdict. In 1611, she was obliged to leave Rome. She went to Florence, married, and, thanks to her outstanding artistic skills, soon received a number of public commissions. Moreover, she was the only woman to be admitted to the Accademia del Disegno.

Murder in Dramatic Chiaroscuro

The painting *Judith Beheading Holofernes*, which is accorded a central importance in Artemesia's oeuvre, was produced shortly after her move to Florence. The Bible story, in which Judith and her maid saved the beleaguered Jews by decapitating the enemy king Holofernes, was treated by Artemisia in various paintings. It also inspired numerous other artists in her circle, including Orazio Gentileschi, Caravaggio, and Tintoretto. Subjects like this were very popular at the time, possibly as a result of the social unrest resulting from the Reformation and the Counter-Reformation.

What is new and almost arrogant in Artemisia Gentileschi's painting is the realistic, merciless interpretation of the story, which is not played down by the introduction of a moralizing or religious tone. With a determined, unemotional expression, the two women go to work with the strength and skill

of butchers as they behead Holofernes, who is writhing in mortal fear.

The dramatic elements of the scene are supported by a dynamic composition, clear colors, and a striking contrast of light and dark. The gestures and appearance of the figures are strongly expressive. Seldom can one establish autobiographical elements in a picture as clearly as here, if one interprets the painting as a cold-blooded and calculated act of revenge against Artemisia's aggressor, Tassi. Gentileschi wrote to one of her clients at the time: "I shall show what a woman is capable of. You will find Caesar's courage in the soul of a woman."

Caravaggio's Worthy Successor

In the contrasts of light and dark, and in the realistic portrayal in her dramatic representations, Artemisia clearly followed the much-imitated Caravaggio, and can thus be included in the broad circle of Caravaggisti.

Artemisia Gentileschi finally returned to Rome, where she worked primarily as an important portrait artist. In 1630 she went to Naples, until she was persuaded seven years later, by King Charles of England, to move to his court in London. Her elderly father was working there on the decoration of the Queen's House in Greenwich. After her father's death, Artemisia returned to Naples, where she clearly suffered from poor health and financial difficulties. She died in 1652/53.

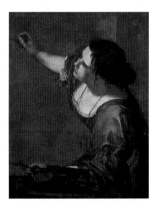

1593 Born 8 July in Rome, the daughter of the painter Orazio Gentileschi. Serves her apprenticeship in her father's studio and under Agostino Tassi.

1611 After a rape trial against Tassi, she moves to Florence, where she married and is admitted to the Accademia del Disegno.

1622 Returns to Rome.

C. 1630 Moves to Naples.

1635 She is called to the English court, an invitation she accepts two years later.

1652/53 Dies, probably in Naples.

FURTHER READING:
Mary D. Garrard, *Artemisia Gentileschi*, Princeton University Press, Princeton, NJ, 1989
Mieke Bal (ed.), *The Artemisia Files: Artemisia Gentileschi for Feminists and Other Thinking People*, University of Chicago Press, Chicago, 2005
Judith W. Mann (ed.), *Artemisia Gentileschi: Taking Stock*, Brepols, Turnhout (Belgium), 2005

La Pittura (*Self-Portrait as the Allegory of Painting*), 1630, oil on canvas, 97 x 74 cm, St. James's Palace, Collection of Her Majesty the Queen, London

Caravaggisti

The painter Michelangelo Merisi (1571–1610), named Caravaggio after his birthplace, attracted great attention with the dramatic chiaroscuro (contrasts of light and dark) in his works, a style that influenced artists throughout Europe. During the Baroque, this style was known as Caravaggism and was imitated especially in Italy, the Netherlands, France, Spain, and Germany. Orazio and Artemisia Gentileschi, Francisco Ribalta, Jusepe de Ribera, Hendrick Terbrugghen, Gerrit van Honthort, and Georges de La Tour were all important Caravaggisti (followers of Caravaggio).

below:
Lucretia, c. 1621, oil on canvas, Palazzo Cattaneo-Adorno, Genoa

right page:
Judith Beheading Holofernes, 1595/96, oil on canvas, 145 x 195 cm, Galleria Nazionale d'Arte Antica, Palazzo Barberini, Rome

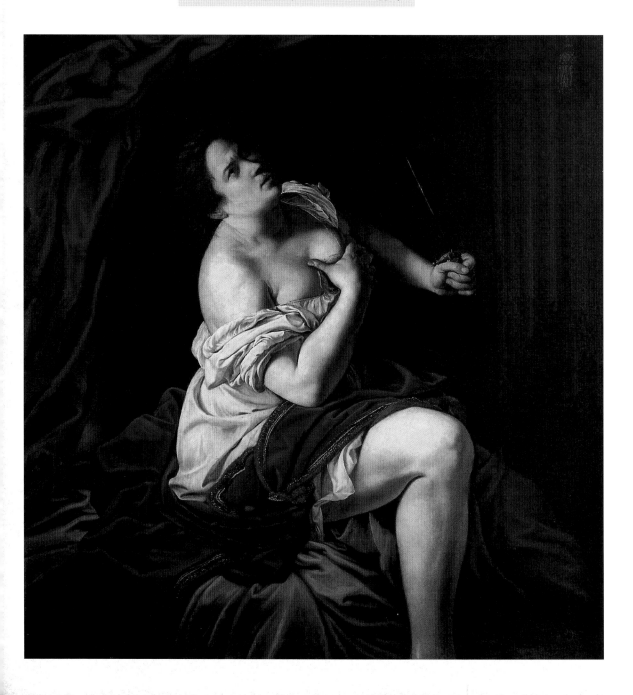

JAN VERMEER

1643 Louis XIV becomes King of France
("The Sun King")

1668 Building of Versailles commences

1699 Austria dominant power
in Europe

1630 Building of Taj Mahal commences **1655** Britain starts trading with the West Indies

1685 b. Johann Sebastian Bach, German composer

1600–1700 BAROQUE ROCOCO 1700–1780

1630 1635 1640 1645 1650 1655 1660 1665 1670 1675 1680 1685 1690 1695 1700 1705 1710 1715

CLARA PEETERS

Virtually nothing is known about the life of the Flemish artist Clara Peeters, who lived and worked at the beginning of the 17th century. Nonetheless, her impressive pictures bear witness to the fact that she was one of the founders of still-life painting.

There are, indeed, remarkably few clues about Clara Peeters, and even they seem to be uncertain. Is it really possible that the Clara Peeters who was listed in the Register of Baptisms in 1594 in Antwerp is one and the same as the artist who, just 13 years later, in 1607, put her signature to her first small-format, lovingly detailed, still-lifes? Some experts think it questionable that such a young girl should already be so famous that her works were not executed, as was normally the case, under the guise of a studio. All the same, it is certain that the almost 80 paintings that have survived and have been attributed to her indicate that she continued to paint until well after 1630. A final picture, dated 1657, was also attributed to Clara Peeters, but it has not survived. Even so, Clara Peeters signed at least 30 paintings. We have no information at all about her artistic training. Nonetheless it can be assumed that such a young talent must have served an apprenticeship under a recognized master. This could have been the still-life painter Osias Beert, who was based in Antwerp.

A further point of reference is the marriage year of 1639, also recorded in the Register of Baptisms, with a certain Henri Joosen. Later on she is thought to have worked in Amsterdam and The Hague.

Exquisite Still-Lifes

There is no doubt that Clara Peeters was a successful artist. In many of her paintings we find representations of valuable porcelain vases and cut glass, exotic shells, and gleaming gold coins. All these precious objects were to be found in the "cabinets of curiosities" of the noblemen of the time. The aristocratic collections, expensive items, and Peeters' large-format paintings indicate that she worked for wealthy collectors.

In *Still-Life with Fish and Cat*, the objects are executed precisely and with a remarkable attention to detail. Skillfully, she adds spots of light and surrounds objects with mysterious shadows. The soft fur of

the cat is almost tangible as it lies in wait, having caught a slippery fish. Beside it, on a gleaming silver tray, lies an opened oyster with its rough shell and soft flesh. The contrasting surfaces of the different objects seem to compete with each other. It is remarkable how the space maintains an impression of depth despite the fact that very few items overlap each other. Arrangements like these do in fact recall the works of Clara Peeters' supposed teacher, Osias Beert, while further clues seem to point to the circle around Jan Brueghel the Elder.

In her elaborately detailed self-portrait, Clara Peeters studies the exclusive objects that we find in her paintings, while the artist herself gazes earnestly and thoughtfully out of the picture. Here Clara Peeters adeptly links the genre of the self-portrait with that of the still-life. In doing so she produces a convincing analysis of herself as an artist and a connoisseur.

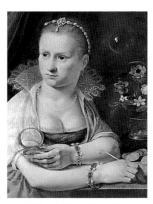

C. 1594 Born in the Netherlands. Believed to have studied in Antwerp under Osias Beert. Died probably during the first half of the 17th century.
1639 Marries Henri Joosen.

FURTHER READING:
Pamela Hibbs Decoteau, *Clara Peeters, 1594–ca. 1640: And the Development of Still-Life Painting in Northern Europe*, Luca Verlag, Lingen, 1992

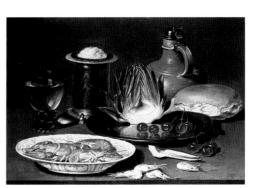

left:
Still-Life with Artichoke, undated, oil on panel, 33 x 46 cm, Private collection

above:
Self-Portrait, undated, oil on panel, 37.5 x 50.2 cm, whereabouts unknown

1634 b. Marie-Madeleine
de Lafayette, French
writer

1618-1648 Thirty Years' War

1475–1600 HIGH RENAISSANCE BAROQUE 1600–1700

1560 1565 1570 1575 1580 1585 1590 1595 1600 1605 1610 1615 1620 1625 1630 1635 1640 1645

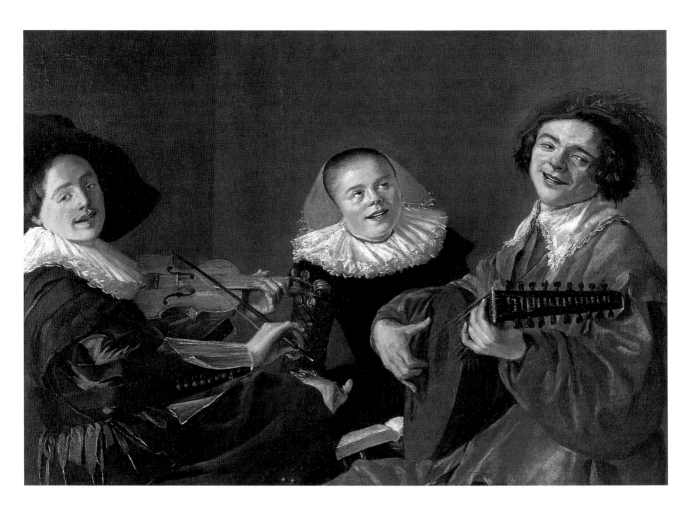

The Concert, c. 1631–1633, oil on canvas,
60.9 x 86.3 cm, Wallace and Wilhelmina
Holladay Collection, Washington DC

JEAN-ANTOINE WATTEAU

643 Louis XIV becomes King of France ("The Sun King")

1668 Building of Versailles commences

1655 Britain starts trading with the West Indies

1685 b. Johann Sebastian Bach, German composer

1648 Netherlands gains independence from Spain

1672 Building of St. Paul's Cathedral in London commences

1689 Peter I the Great becomes Tsar of Russia

1600–1700 BAROQUE ROCOCO 1700–1780

1650 1655 1660 1665 1670 1675 1680 1685 1690 1695 1700 1705 1710 1715 1720 1725 1730 1735

JUDITH LEYSTER

Singers, musicians, comedians, and drinkers in congenial company seem to enjoy life to the full in the paintings of Judith Leyster. Although the Netherlandish painter was very successful during her lifetime, she was later forgotten and for many years her paintings were thought to have been the work of Frans Hals.

"There are numerous women with artistic experience who are famous to this day, and whose work stands up favorably to comparison with that of men. Among them, however, it is above all Judith Leyster whose name is mentioned with great respect. She really was a lodestar in the art world …" That was how Theodorus Schrevellius described the painter Judith Leyster in 1647 in his book about the city of Haarlem. She was born there in 1609 as the youngest of eight children of a man who was both a cloth-maker and brewery owner.

Merry Musicians
Looking at Leyster's pictures, it is easy to imagine how she, the daughter of a brewery owner, must have watched the merry feasting in the inns, recording the moment as a true-to-life portrayal in her cheerful genre pictures. Slightly tipsy journeymen toast each other, singing a song to the sounds of lute and fiddle and flirting with the girls. She also liked to paint children, as can be seen in *Boy Playing the Flute* of c. 1635.

As we can clearly see in the painting *The Concert*, despite all the movement the gestures and expressions of the figures are not random, but rather are consciously and lovingly executed. The musician looks cheekily out of the picture and holds the long neck of the lute so pointedly towards the viewer that it adds depth to the composition. The faces are individually and emotionally portrayed but are quite lacking in coarse features. The figures emerge from dark monochrome backgrounds, and are often illuminated by candlelight.

In her self-portrait of c. 1630, Leyster presents herself to posterity as a self-confident woman, whose cheerful gaze draws the viewer's attention to the picture of the musicians at which she points with her paintbrush. In fact she seems to have been a courageous woman: at the age of 24 she was the first woman artist to apply for admission to the Guild of St. Luke, opening her own studio directly beside the marketplace despite the fierce competition. Business was good, and she was even able to afford to take on two apprentices.

In the Shadow of Frans Hals
It is assumed that Leyster studied for three years under Pieter de Grebber, a painter of historical pictures and portraits, before she started to work in the studio of the famous master of the Haarlem School, Frans Hals. Her early paintings are strongly influenced by him, but also by his younger brother, Dirck Hals, who was famous for his high-spirited genre paintings.

It is thought that it was in the studio of Frans Hals that Leyster met the painter Jan Miense Molenaer, whom she married in 1636 and with whom she then moved to Amsterdam. From this point she seems to have supported more actively her husband in the family studio, as well as their joint art dealer business. Most of the paintings attributed to her today were produced before her marriage.

After her death in 1660, she was almost entirely forgotten, despite the remarkable success she enjoyed during her lifetime. Many of her works were thought to have been lost or were initially attributed to Frans Hals, until 1893, when the Louvre discovered Leyster's monogram under the master's signature. Thus she was gradually given the attention she deserves.

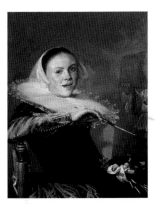

1609 Born in Haarlem as the eighth child of the cloth-maker and brewery owner Jan Willensz. Leyster, and baptized on 28 July. Served an apprenticeship under the painter Pieter de Grebber.

1628 First mention of her in Samuel van Ampzing's *Description and Praise of the City of Haarlem in Holland*.
Works in the studio of the painter Frans Hals.

1633 Becomes a member of the Guild of St. Luke in Haarlem.

1636 Marries Jan Miense Molenaer, and they move to Amsterdam.

1648 They return to live in Haarlem, and then in Heemstede near Amsterdam.

1660 Dies in Heemstede, funeral being held on 10 February.

FURTHER READING:
Frima Fox Hofrichter, *Judith Leyster: A Woman Painter in Holland's Golden Age*, Davaco, Doornspijk, the Netherlands, 1989
James A. Welu and Pieter Biesboer, *Judith Leyster: A Dutch Master and Her World*, Yale University Press, New York, 1993

Self-Portrait, c. 1630, oil on canvas, 75 x 66 cm, National Gallery of Art, Washington DC

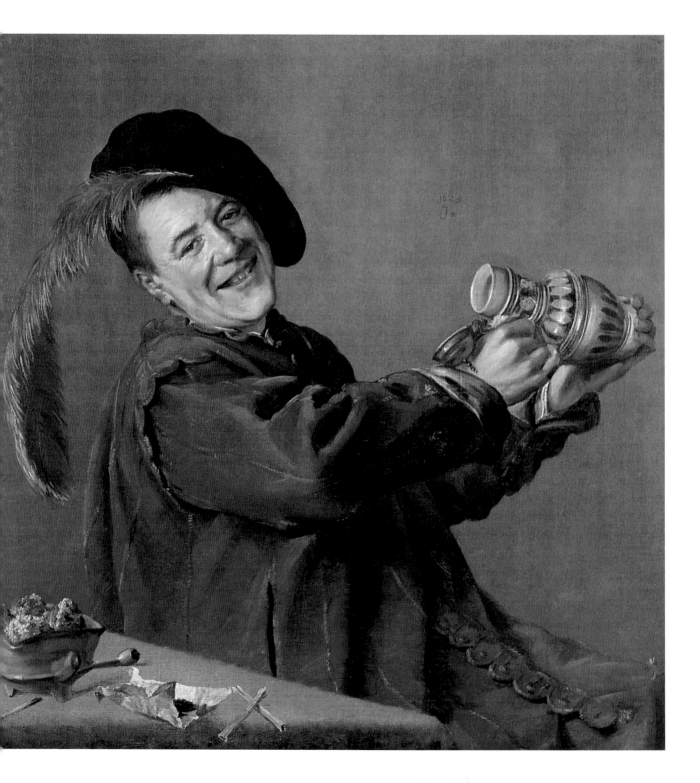

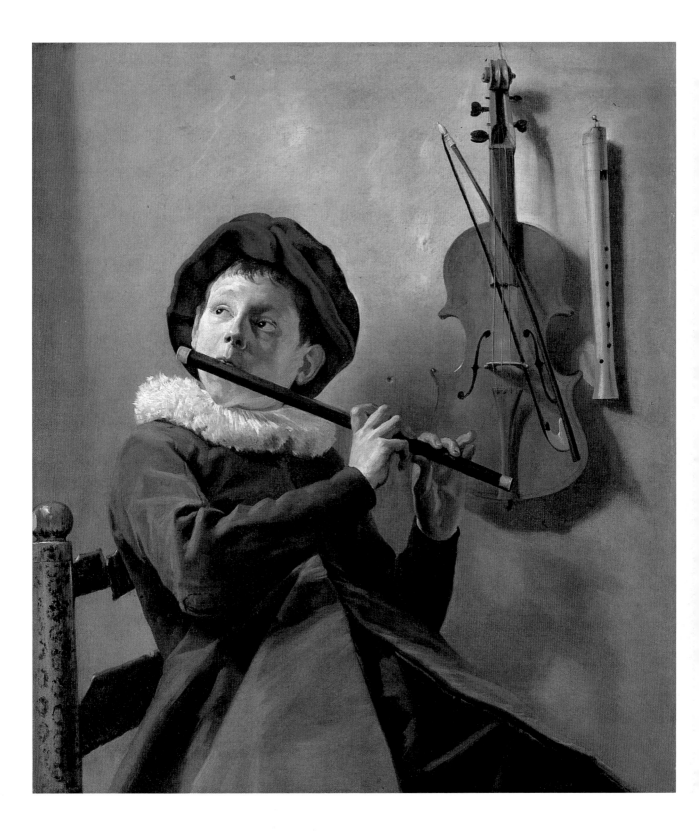

DIEGO VELÁZQUEZ

JUDITH LEYSTER

1668 Building of
Versailles
commences

1637 First public opera house
opened, in Venice

1618 Start of Thirty Years' War

1655 Britain starts trading with the West Indies

HIGH RENAISSANCE BAROQUE 1600–1700

1590 1595 1600 1605 1610 1615 1620 1625 1630 1635 1640 1645 1650 1655 1660 1665 1670 1675

1745 Maria Theresa of Austria becomes
Holy Roman Empress

1718 *Oedipus* (Voltaire)

1749 b. Johann Wolfgang von Goethe,
German writer

1687 *Oroonoko* (Aphra Behn)

1721 *Brandenburg Concertos*
(Johann Sebastian Bach)

1756 b. Wolfgang Amadeus
Mozart, Austrian
composer

1600–1700 BAROQUE ROCOCO 1700–1780

1700–1780 ROCOCO CLASSICISM 1750–1790

1680 1685 1690 1695 1700 1705 1710 1715 1720 1725 1730 1735 1740 1745 1750 1755 1760 1765

ELISABETTA SIRANI

Elisabetta Sirani was one of the most productive and most admired artists of her day: in a period of just 13 years she produced nearly 200 pictures. She formed a group of female assistants who collaborated on her works and often completed them.

Elisabetta Sirani was born in 1638 in Bologna, where her father Giovanni Andrea Sirani was likewise an artist and an assistant to Guido Reni. He only noticed Elisabetta's extraordinary talent for drawing when his attention was repeatedly drawn to it by critic Count Carlo Cesare Malvasia. Sirani's father became her first teacher. When he had to give up painting because of arthritis, Elisabetta took over as head of the workshop. She soon had her two sisters Barbara and Anna Maria learning the trade, and gathered around her more than a dozen other female pupils.

Guido Reni as Inspiration

A large proportion of Sirani's pictures have religious subjects, but she also did portraits and mythological scenes. Particularly common subjects in her work are the Virgin and Child and the Holy Family. In many of these works, her admiration for Guido Reni is evident, but there are also echoes of Caravaggio, the Carracci, and Francesco Albani. An example is the *Madonna and Child with St. John the Baptist,* an almost playful rendering of the young Jesus on his mother's arm, talking to young St John the Baptist. The group is set against a dark background, so that the Madonna, shown in semi-profile, has an almost aristocratic elegance. The whole scene is lit with a diffuse light that lends the figures pearl-colored flesh tones. The child Jesus touches his mother's neck with his right hand, while in his other hand he holds a willow rod with a banner saying *Ecce qui tol[lit peccata] mundi,* referring to his role as Redeemer. The picture appears to be harking back to Reni's late work, but in its execution it is more sentimental and collected.

Mysterious Death

Elisabetta Sirani kept a chronological catalogue of her pictures, which ends with entry 182; she died in August 1665 aged only 27. The rumor quickly spread that she had been poisoned, since she had complained of stomach pains for months. However, the trial of her servant Lucia Tolomelli ended in a not-guilty verdict. An autopsy identified a stomach ulcer as the cause. As a member of the Accademia di San Luca in Rome, Sirani was given a civic funeral by the city of Bologna. Her premature death did nothing to impair her fame, and the first biography of her was published little more than ten years after her death.

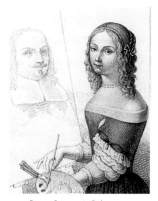

1638 Born 8 January in Bologna.
Trains with her father Giovanni
Andrea, and later takes over his
studio.
Becomes a member of the
Accademia di San Luca in Rome.
Keeps a catalogue of her works,
which ends at entry 182.
1665 Dies in Bologna aged 27.

FURTHER READING:
Anne Sutherland Harris and Linda
Nochlin, *Women Artists: 1550–1950,*
Los Angeles County Museum of Art /
Knopf, New York, 1976
Adelina Modesti, *Elisabetta Sirani:
Una virtuosa del Seicento bolognese,*
Editrice Compositori, Bologna, 2004

left page:
*Madonna and Child with St. John
the Baptist,* undated, oil on wood,
98 x 73 cm, Galleria dei Dipiniti Antichi
della Cassa di Risparmio di Cesena

above:
Luigi Matelli, *Self-Portrait of Elisabetta
Sirani Painting her Father,* 19th century,
copperplate engraving

DIEGO VELÁZQUES

GIULIA LAMA

1668 Building of Versailles commences

1600–1700 BAROQUE ROCOCO 1700–1780

| 1625 | 1630 | 1635 | 1640 | 1645 | 1650 | 1655 | 1660 | 1665 | 1670 | 1675 | 1680 | 1685 | 1690 | 1695 | 1700 | 1705 | 1710 |

1. *Phalæna ocellata.*
2. *Musa paradisea.*

Banana und Large Yellow Underwing Moth,
sheet XII of *Metamorphosis Insectorum*
Surinamensium, 1705, copperplate engraving

1717 Mary Wortley Montague introduces
inoculation to England

1745 Maria Theresa of Austria becomes
Holy Roman Empress
1749 b. Johann Wolfgang von Goethe,
German writer

1769 James Watt invents the
steam engine
1772 James Cook discovers
the Antarctic

1789 George Washington
becomes first President
of the United States
1789 Start of French Revolution

1700–1780 ROCOCO CLASSICISM 1750–1790 1750–1790 CLASSICISM ROMANTICISM 1790–1840

1715 1720 1725 1730 1735 1740 1745 1750 1755 1760 1765 1770 1775 1780 1785 1790 1795 1800

MARIA SIBYLLA MERIAN

*Fearless, adventurous, and ahead of her time—that was the cosmopolitan all-rounder Maria Sibylla Merian.
As an artist, natural philosopher, businesswoman, and publisher rolled into one, she made a unique contribution
to the visual understanding of flowers and insects in the 17th century.*

Maria Sibylla Merian's unparalleled career evolved at a time when daughters of rich families learnt at most just to read and write. In the Baroque age, a woman's role was limited to running the household, sewing, and praying. But "Merian" was a woman people talked about. She lived in three pace-setting centers of printing and publishing: first Frankfurt, then Nuremberg, and later Amsterdam. Scholars and biologists recognized her greatness. Swedish naturalist Carl von Linné (Linnaeus), the father of modern botanical and zoological classification, read Merian, and referred to her and her artistic but precise illustrations many times in connection with his own work.

The Splendors of Flowers and Insects
It all started with Merian's boundless enthusiasm for flowers and micro-creatures. Even as a young woman, she rescued insects from the dirt and took them back to her own room, pinned out butterflies, preserved pests in brandy, and painted every stage of a butterfly's development from the larva to the glorious creature emerging from a chrysalis. It was incidentally a passion that was awoken by a visit as a 13-year-old to a silkworm factory and culminated in her famous journey to Surinam. When 52, she sailed with her younger daughter to that terra incognita in northern South America, and spent two years there studying the wonders of nature. The result was her major work on insects, the *Metamorphosis Insectorum Surinamesium*, a fantastic world of wonders in watercolors of beguiling delicacy and splendor of color, full of accurate detail and minute renderings of butterflies, beetles, and insects. Having done her research in the heat and rough jungle on the mainland, she drew the pictures on the high seas in the gloom of her cabin.
In *Neues Blumenbuch* (New Book of Flowers), Merian published her observations and illustrations as engravings of watercolors, thereby establishing a reputation to match that of her prematurely

deceased father, engraver Matthäus Merian the Elder. Published between 1675 and 1680 in Nuremberg in three installations of 12 sheets each, the book was so popular that it had to be reprinted. They are flower studies of incomparable elegance, and were used as pattern books for painting and embroidery. Here too Maria Sibylla Merian played a trick on her age, in creating items of commercial art and earning money from them, which was a long way from teaching painting and embroidery to daughters of reputable citizens, as she did in parallel. One aim was certainly not in her mind, i.e. to produce dry, diagrammatic illustrations for scientific purpose. Her output was conceived in quite a different spirit. Her books are an expression of esthetic, scientific edification, with every individual creature being set in context with meticulous precision.

1647 Born 2 April in Frankfurt, the daughter of engraver Matthäus Merian the Elder (1593–1650). Her father dies when she is three, and her mother marries flower painter Jacob Marell, who notices his stepdaughter's talent and encourages it.
1665 Marries architectural painter Johann Andreas Graff.
1670 Sets up a school for painting and embroidery in Nuremberg.
1675–1680 *Neues Blumenbuch*
1679–1683 Publishes both volumes of her scientific book *Der Raupen wunderbare Verwandlung* (The Wonderful Transformation of Caterpillars).
1681 Returns to Frankfurt.
1685 Following her separation from Johann Andreas Graff, she lives an independent life in Holland, bringing up her children by herself.
1699 Travels to Surinam, returning 1701.
1705 Her book on insects published *Metamorphosis Insectorum Surinamesium*.
1717 Dies 13 January in Amsterdam.

FURTHER READING:
Kim Todd, *Chrysalis: Maria Sibylla Merian and the Secrets of Metamorphosis*, Harcourt, Orlando, 2007

Jakob Houbraken after Georg Gsell, *Portrait of Maria Sibylla Merian*, 1717, copperplate engraving

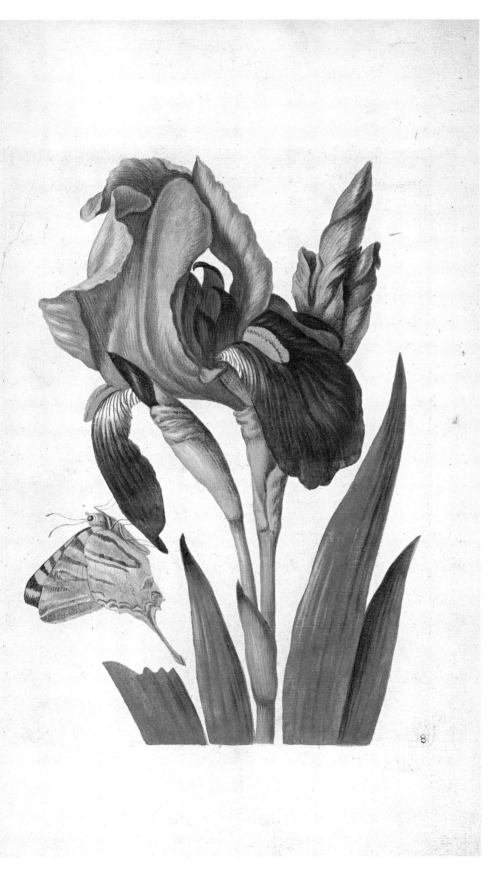

8

Iris germanica L. (German Iris) from the *Neues Blumenbuch,* 1675-1680, copperplate engraving

right page:
Gastropacha populifolia, 1679, watercolor and opaque colors on parchment, 25.5 x 19.3 cm, Archive of the Academy of Sciences, St. Petersburg

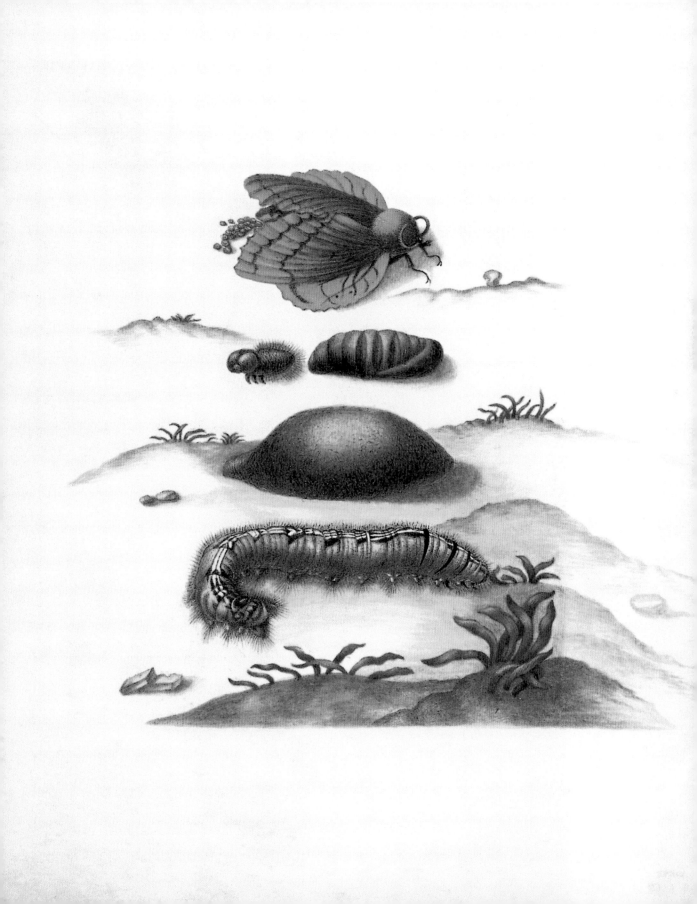

1668 Building of Versailles commences

1626 b. Christina of Sweden

1667 Louis XIV introduces
the Paris Salon

1685 b. Johann Sebastian Bach,
German composer

1600–1700 BAROQUE

1615 1620 1625 1630 1635 1640 1645 1650 1655 1660 1665 1670 1675 1680 1685 1690 1695 1700

1707 Union of England and Scotland
to form Great Britain

699 Austria dominant power in Europe

1703 Building of Buckingham Palace in London commences

OCOCO 1700–1780

1749 b. Johann Wolfgang von Goethe, German writer

1700–1780 ROCOCO CLASSICISM 1750–1790

1705 1710 1715 1720 1725 1730 1735 1740 1745 1750 1755 1760 1765 1770 1775 1780 1785 1790

RACHEL RUYSCH

Magnificent flowers of every imaginable species unfold like a glittering display of fireworks in the carefully arranged flower still-lifes painted by one of the most famous Netherlands artist of the 17th and 18th centuries. She devoted her talents throughout her long life exclusively to flower paintings, which sold well.

Rachel Ruysch's artistic career was not encouraged, as in the case of so many of her fellow female artists, by a painter father. Instead, it was the young woman's powers of scientific observation that her father trained, since he was a famous professor of botany and anatomy in Amsterdam. He wrote the catalogue for the Botanical Garden in Amsterdam, enlarging its stock to make it one of the largest in the world. He also established the first Museum of Natural History, and aroused international interest with his collection of anatomical specimens. It is not surprising, therefore, that his attentive daughter should link all these scientific stimuli with her artistic talent. Her interests lay in flowers and reptiles, and at the age of 15 she was apprenticed to the flower painter Willem van Aelst.

Artistic Flower Arrangements

As if being presented by a magician's hand, the endless variety of flower species in the artistically arranged bouquet seem to float towards the viewer out of a dark background. Accurate observation enabled the artist to record with consummate technical skill the precise appearance of each single petal. At the same time, the conscious artifice of the entire arrangement is not concealed. Ruysch usually skillfully plays off apparent contrasts against each other: cultivated flowers are placed beside wild ones, cold and warm colors jostle, and light and dark are subtly shaded. Dense and loosely packed areas of the picture are arranged round an asymmetrical vertical axis in such a way that they achieve a marked spatial three-dimensionality.

Flower and fruit still-lifes corresponded perfectly to the demands of the time for a heightening and refining of nature through art. Of course, the traditional idea of the *vanitas* (a still-life whose theme is the brevity of life) is also there in the background, hinting at the transience of beauty. This is evident in the different stages of the plants: buds that are just opening, fully opened flowers, and wilting leaves.

Even the delicate butterflies, snails and caterpillars, as well as the fruits and fungi, recall the passage of time.

Member of the Painters' Guild and Court Artist

Her paintings were greatly in demand and sold for unusually high prices. Ruysch, however, despite the demand, remained true to her own high standards. So time-consuming were her still-lifes, that she seldom painted more than two or three per year. This did not change when she married the portrait painter Juriaen Pool in 1695, and bore him ten children. She did not give up her demanding painting, which offered little chance of development. In 1701, she became a member of the Painters' Guild in The Hague.

The powerful, art-loving Elector Palatine Johann Wilhelm in Düsseldorf recognized that Ruysch's bouquets, with their elegant magnificence, were ideally suited to decorate the sumptuous rooms at court or his art cabinet, and in 1708 he appointed her his court artist. However, apart from two visits to her patron, Ruysch never left Amsterdam. She continued to paint even in old age, dying at the venerable age of 86.

1664 Born in Amsterdam, the daughter of Frederick Ruysch, a professor of botany and anatomy. Serves an apprenticeship to the Netherlandish flower painter Willem van Aelst.
1695 Marries the portrait painter Juriaen Pool.
1701 Together with her husband, she becomes a member of the Painters' Guild in The Hague.
1708 Appointed court artist to the Elector Palatine Johann Wilhelm in Düsseldorf.
1750 Dies 21 August in Amsterdam.

FURTHER READING:
M.H. Grant, *Rachel Ruysch, 1664–1750*, F. Lewis, Leigh-on-Sea (UK), 1956

left page:
Convolvulus, Poppies and Other Flowers in an Urn on a Stone Ledge, c. 1745, oil on canvas, 108 x 84 cm, National Museum of Women in the Arts, Washington DC

above:
Godfried Schalcken, *Portrait of Rachel Ruysch*

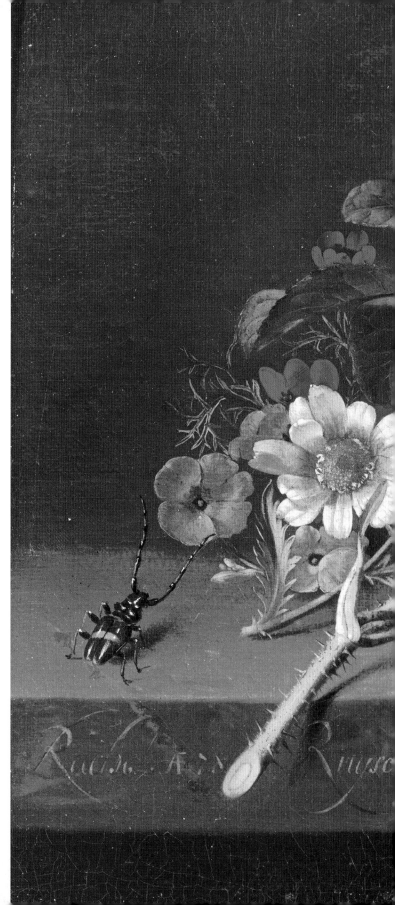

Rose with Beetle and Bee, 1741,
oil on canvas on panel, 20 x 24.5 cm,
Kunstmuseum Basel

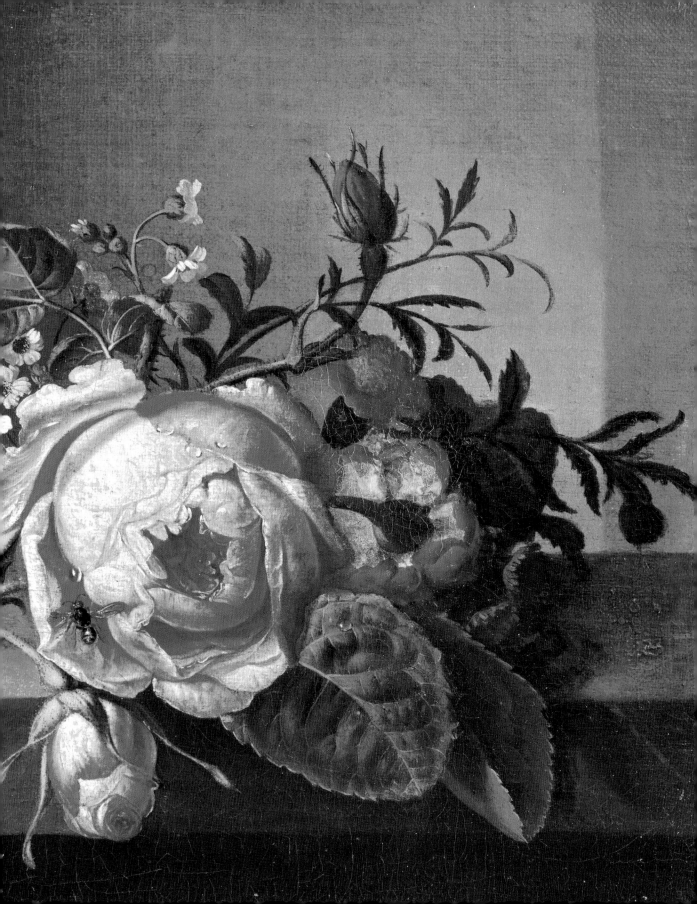

1685 b. George Frederick
Handel, German
composer

1707 Union of England and
Scotland to form
Great Britain

1600–1700 BAROQUE ROCOCO 1700–1780

1625 1630 1635 1640 1645 1650 1655 1660 1665 1670 1675 1680 1685 1690 1695 1700 1705 1710

1724 Completion of Belvedere Palace in Vienna

1769 James Watt invents
the steam engine

1772 James Cook
discovers the
Antarctic

1776 American Declaration of Independence

1777 b. Jeanne Françoise Julie Adelaïde
Récamier, adversary of Napoleon

1781 Start of the American War
of Independence

1700–1780 ROCOCO CLASSICISM 1750–1790 1750–1790 CLASSICISM ROMANTICISM 1790–1840

1715 1720 1725 1730 1735 1740 1745 1750 1755 1760 1765 1770 1775 1780 1785 1790 1795 1800

ROSALBA CARRIERA

Almost everyone who went to Venice on the Grand Tour wanted his or her portrait done by the brilliant "queen of pastels." Without the example of Rosalba Carriera's pioneering pastels in the genre, the work of Quentin de la Tour and Jean-Étienne Liotard would have been inconceivable.

She was no beauty, Italian painter Rosalba Carriera. In fact she was a Plain Jane, quite the opposite of the charming creatures she painted a thousand times in dry, powdery colors, light and scented, with an unprecedented virtuosity of technique. The medium was not new—Leonardo da Vinci had already used it for quick sketches centuries earlier.

Powdery Pastel, Practical Format
In the playful, coquettish era of the Rococo, clients just loved Carriera's masterly but delicate depictions of elegance—ladies in glossy silk robes and a froth of lace, with flowers in soft, flowing hair, and pearls against delicate skin. Yet her portraits of her clients were not overdone. She always managed to capture something of the sitter's individuality, with realism and, in her later work, with a perceptible sense of looking behind the physiognomy. A good example is her self-portrait of 1731, when she was 56, where she paints herself for once as an allegorical figure, tellingly as Winter, in a fur cap and white fur collar. Being a shrewd businesswoman, Carriera exploited the Venetian tourist market highly effectively. Her pastels filled a gap in the market, as "souvenirs." They could be easily packed into a traveler's baggage, or sent by post in serial consignments as a "gallery of beauty"—generally as a memory of a prince's visit to the city.

Good Business in La Serenissima
As a city of festivals and masked balls, Venice was full of travelers looking for adventure, art collectors, and dealers from all over Europe. Not only Venetian painters such as Antonio Pellegrini and Tiepolo had full order books, Carriera did too. Her clientele included, among many others, illustrious figures such as Elector Maximilian of Bavaria and Danish king Frederick IV. In 1739, Elector Frederick Augustus II of Saxony (later the King of Poland) bought Rosalba's entire output of paintings. Thanks to him, the Dresden's Gemäldegalerie Alte Meister now has over 150 of her pastels, some in a special Rosalba Room. With orders of this magnitude, it is not surprising that such a successful painter should need a number of assistants.

Paris and Watteau
In 1715, Carriera made the acquaintance of the French king's banker and treasurer, Pierre Crozat. The encounter reaped her huge successes in France when, five years later, he invited her to Paris, installed her in a large suite in his town house, and introduced her to the Paris art scene and the court. However, as far as her artistic development was concerned, the most important encounter was the one with Jean-Antoine Watteau (1684–1721), the admired master of the *fête galante*, who was by then a dying man. They had long conversations about the use of color and how to make the most of surface appeal. Shortly before his death, she did a portrait of him.

1675 Born 7 October in Venice. Her father has her taught languages and music.
1689 Takes painting lessons from Giuseppe Diamantini (1621–1705).
1700 Wins a reputation as a painter of miniatures and pastels, both among Venetians and tourists. Europe's aristocrats commission portraits from her.
1705 Honorary member of the Accademia di San Luca in Rome.
1706 Prince William of the Palatinate invites her to his court in Düsseldorf, and for years commissions pictures from her.
1720 Becomes honorary member of the Académie Royale de la Peinture in Paris and the Accademia Clementina in Bologna.
1720–1721 At the invitation of banker and collector Pierre Crozat, she makes a successful visit to Paris.
1746 Her sight begins to fail so suddenly that she has to live in "darkest, blackest night." In 1751, she becomes completely blind.
1757 Mentally deranged, she dies 15 April in Venice.

FURTHER READING:
Anne Sutherland Harris and Linda Nochlin, *Women Artists: 1550–1950,* Los Angeles County Museum of Art / Knopf, New York, 1976
Delia Gaze (ed.), *Dictionary of Women Artists*, Fitzroy Dearborn, London and Chicago, 1997

left page:
The Air (from the series: *The Four Elements*), 1746, pastel on paper, 56 x 46 cm, Gemäldegalerie Alte Meister, Dresden

above:
Self-Portrait as Winter, 1731, pastel on paper, 46.5 x 34 cm, Gemäldegalerie Alte Meister, Dresden

1685 b. George Frederick Handel,
German composer

1703 Building of Buckingham
Palace in London
commences

1600–1700 BAROQUE ROCOCO 1700–1780

1630 1635 1640 1645 1650 1655 1660 1665 1670 1675 1680 1685 1690 1695 1700 1705 1710 1715

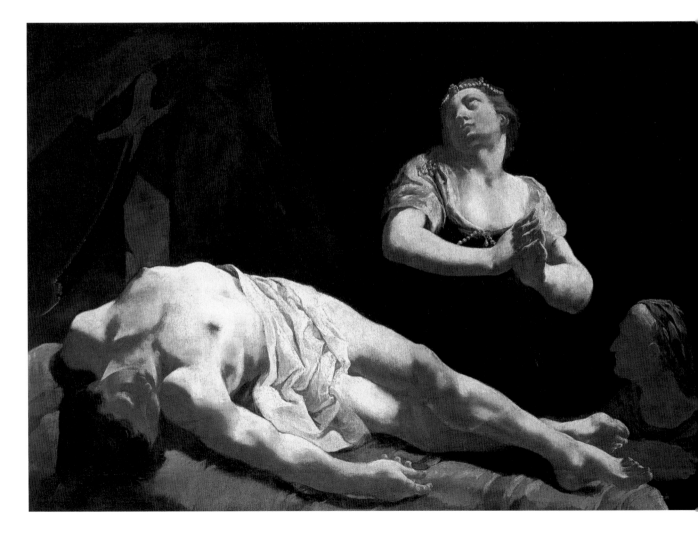

Judith and Holofernes, c. 1730,
oil on canvas, 107 x 155 cm,
Galleria dell'Accademia, Venice

THOMAS GAINSBOROUGH

1749 b. Johann Wolfgang von Goethe, German writer **1769** James Watt invents the steam engine

715 Dorothea Christiane Eixleben becomes first German woman doctor

1756 b. Wolfgang Amadeus Mozart, Austrian composer **1776** American Declaration of Independence

1789 Start of French Revolution

1760 Canada becomes a British colony

1700–1780 ROCOCO CLASSICISM 1750–1790 1750–1790 CLASSICISM ROMANTICISM 1790–1840

1720 1725 1730 1735 1740 1745 1750 1755 1760 1765 1770 1775 1780 1785 1790 1795 1800 1805

GIULIA LAMA

It was a long time before art history rediscovered the Venetian painter Giulia Lama. After her death, she was quickly forgotten and her works were, ironically, attributed to the very same artists with whom she had competed all her life.

"I have discovered here a woman who paints better than Rosalba [Carriera] when it is a matter of large-scale compositions. I was impressed by one of her small works, but at the moment she is working on a large-format painting. The subject of the painting is the Rape of Europa ... The group is full of poetry because this woman is as brilliant a poet as she is a painter, and I find in her poems the same qualities as in the works of Petrarch. Her name is Giulia Lama." This hymn of praise can be found in a letter that Abbot Luigi Conti wrote to a certain Madame de Caylus on 1 March 1728. Conti's lines are one of the few records to tell us anything about the life and works of Giulia Lama. According to the abbot's description, Lama—born in Venice in 1681—was an all-round genius who not only demonstrated great artistic ability but who was also a talented poet and studied mathematics under "famous Pater Maffei. She also does embroidery and has spent much time thinking about the invention of a machine which will produce lace mechanically."

Baroque Drama

We may know little about Giulia Lama, but one thing is clear: her works do not correspond with the gossamer late Baroque and the pastel color schemes of the age in which she lived. Instead, her paintings are dominated by contrasts of light and shade that are full of tension. She shared this predilection with her contemporary Giambattista Piazzetta, with whom—written sources inform us—she was permitted to work. Whether the two artists were linked by a teacher-student relationship, or whether they worked together as colleagues, is uncertain. Conti's letter again makes it clear that Lama's position was not an easy one: "The artists make life very difficult for the poor woman, but her talent triumphs over her opponents. She is intelligent but ugly; and yet she speaks in a charming manner, choosing her words carefully, so that it is easy to forgive her looks ... But she lives a very retiring life."

Giulia Lama's most famous painting hangs today in the Galleria dell'Accademia in Venice. It shows a scene from the biblical story of Judith and Holofernes. Lama did not take as her subject the beheading of Holofernes by the Jewish widow Judith, or Judith with the head of the general after the assassination—both subjects were frequently selected by artists—but rather the moment before the killing. Holofernes' body is presented to the viewer asleep, but already twisted into an unnatural position. The dramatic lighting, which recalls the flickering of a candle, contributes to the gloomy atmosphere. Judith turns one last time to God in prayer before she grasps the sword, visible in the semi-darkness, and beheads the sleeping man.

1681 Born 1 October in Venice, the daughter of painter Agostino Lama.
1747 Dies 7 October in Venice.

No definite documentary evidence for her biography survives.

FURTHER READING:
Anne Sutherland Harris and Linda Nochlin, *Women Artists: 1550–1950*, Los Angeles County Museum of Art / Knopf, New York, 1976
Delia Gaze (ed.), *Dictionary of Women Artists*, Fitzroy Dearborn, London and Chicago, 1997

above:
Giambattista Piazzetta, *Portrait of Giulia Lama*, 1715–1720, oil on canvas, 69.4 x 55.5 cm, Thyssen-Bornemisza Collection, Madrid

1703 Building of Buckingham Palace in London commences

1707 Union of England and Scotland to form Great Britain

1697 b. Friederike Caroline Neuber, one of
the founders of German theater

1756 b. Wolfgang Amadeus
Mozart, Austrian
composer

1600–1700 BAROQUE ROCOCO 1700–1780

1700–1780 ROCOCO CLASSICISM

1670 1675 1680 1685 1690 1695 1700 1705 1710 1715 1720 1725 1730 1735 1740 1745 1750 1755

Self-Portrait, 1776/77,
oil on canvas, 151 x 115 cm,
Gemäldegalerie, Berlin

JOHN CONSTABLE

1776 American Declaration of Independence
1760 Canada becomes a British colony
1789 Start of French Revolution
1769 James Watt invents the steam engine
1789 George Washington becomes first President of the United States
1770 b. Ludwig van Beethoven, German composer
1750–1790 CLASSICISM ROMANTICISM 1790–1840
1790–1840 ROMANTICISM

1760 1765 1770 1775 1780 1785 1790 1795 1800 1805 1810 1815 1820 1825 1830 1835 1840 1845

ANNA DOROTHEA THERBUSCH

Anna Dorothea Therbusch had both the talent and the courage to break with convention. Her career as a painter was extraordinary for her day—she received commissions from leading families, and was among the few female members of the academies in Stuttgart, Bologna, Paris, and Vienna.

The seventh child of Prussian court painter Georg Lisiewski, Anna Dorothea started out with the great advantage of being born into an artistic family. At a time when society ladies were encouraged to indulge in a little painting as a hobby, she was given a thorough training by her father. As he was a portrait painter, his daughter was more or less bound to be the same, portraiture being, moreover, along with still-lifes and miniatures, deemed the most suitable genres for women. History painting, which was more highly ranked, was ruled out in her case, for women were forbidden to do nude studies, though even that prohibition she ignored in the end.

Domestic Duties

After her marriage to Berlin innkeeper Ernst Friedrich Therbusch, she devoted herself to running their household; only a few paintings are known from the early years of her marriage. Part of the problem, it appears, was a strict mother-in-law, whose view was that women were there "to bring children into the world and look after domestic matters," as her first biographer Johann Georg Meusel dryly comments. "After her mother-in-law died, however, she had more freedom to follow her inclinations, as her husband was a man of sound sense and realized it would be difficult to suppress gifts of that sort." However, during the almost 20 years she had devoted to bringing up her children, Therbusch had never lost touch with current developments in art. When she was 40, her reduced family obligations finally allowed her to take up an artistic career.

A Late Start

She launched her professional career, which would rapidly take her far beyond the borders of the German principalities, by setting off for Stuttgart. There she gained commissions from the Württemberg court and was admitted to the academy. After two successful years she moved on to Mannheim, where she soon became painter to the Palatine court. Her subsequent stay in Paris was the crowning step of her career. She was admitted to the most famous academy of the 18th century, the Académie Royale de Peinture et Sculpture, an astonishing achievement for a woman who was not only relatively unknown in France but was also a foreigner. The writer Denis Diderot commented on the artist's passion and "ardent enthusiasm for her profession," and noted that she was "intrepidly" doing nudes as well. After her return to Berlin, Anna Dorothea Therbusch established herself as the top society portraitist in Berlin, working for the Prussian court and the Russian tsarina's court.

Twelve self-portraits of the artist have come down to us. In them, she regards the viewer with cool self-assurance, handsome and proud, displaying single-mindedness and calm self-possession. She painted her Weimar self-portrait when she was sharing a studio with her brother, Christian Friedrich Reinhold Lisiewski. It shows her at the window, with her brother painting in the background. Shortly before her death, she did one of the most famous of artist self-portraits, in which she gazes at us disconcertingly through a large monocle. Books, globe, and brush leave no doubt as to the breadth of her education. It is a very public statement by an acknowledged artist.

1721 Born Anna Dorothea Lisiewski in Berlin 23 July, the seventh child of portrait painter Georg Lisiewski.
1742 Marries Ernst Friedrich Therbusch.
1761 Travels to Stuttgart, and works for Duke Carl Eugen of Württemberg.
1762 Becomes honorary member of the Stuttgart Academy of Arts (8 March); then a member of the Academy in Bologna.
1764 Appointed court painter to the court of Elector Palatine Karl Theodor. Returns to Berlin.
1765–1768 Lives in Paris, making the acquaintance of writer and philosopher Denis Diderot. Admitted to the Académie Royale de Peinture et Sculpture.
1767 Exhibits at the Salon in Paris.
1768 Admitted to the Academy of Fine Arts in Vienna.
1769 Returns to Berlin.
1772 Her husband dies.
1773 She and her brother Christian are commissioned by Russian Tsarina Catherine II to do seven life-size portraits.
1782 Dies 9 November in Berlin.

FURTHER READING:
Katharina Küster and Beatrice Scherzer, *Der freie Blick. Anna Dorothea Therbusch und Ludovike Simanowitz*, exhibition catalogue, Städtisches Museum Ludwigsburg, Heidelberg, 2002

Self-Portrait, c. 1773–1779, oil on canvas, 146,5 x 116 cm, Kunstsammlungen, Weimar

1756 b. Wolfgang
Amadeus
Mozart, Austrian
composer

1775 b. Jane Austen,
English writer

ROCOCO 1700–1780

1700–1780 ROCOCO CLASSICISM 1750–1790

| 1690 | 1695 | 1700 | 1705 | 1710 | 1715 | 1720 | 1725 | 1730 | 1735 | 1740 | 1745 | 1750 | 1755 | 1760 | 1765 | 1770 | 1775 |

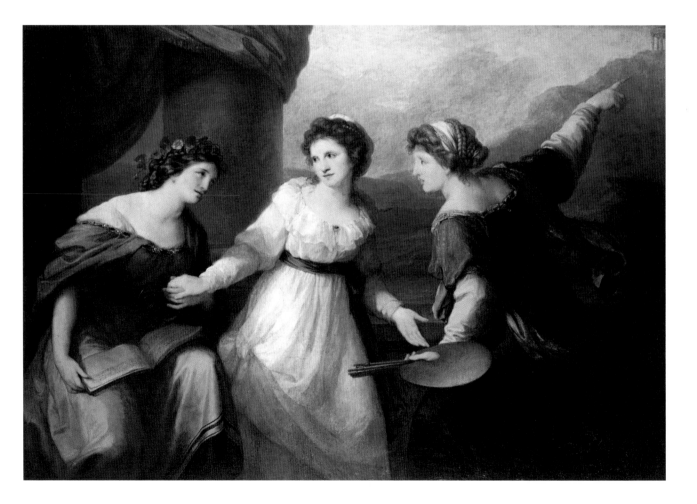

*Self-Portrait Torn Between Music and
Painting*, 1792, oil on canvas, 151 x 212 cm,
Pushkin Museum of Fine Arts, Moscow

76 American
Declaration of
Independence

1789 Start of French
Revolution

1804 Napoleon Bonaparte becomes
Emperor of France

1826 First photograph

1830 Railroad between Liverpool and Manchester completed

1750–1790 CLASSICISM ROMANTICISM 1790–1840

1790–1840 ROMANTICISM

1780 1785 1790 1795 1800 1805 1810 1815 1820 1825 1830 1835 1840 1845 1850 1855 1860 1865

ANGELICA KAUFFMANN

Angelica Kauffmann had the polite world of Europe at her feet. She turned out a huge number of portraits and history paintings in a style strongly influenced by both neo-classicism and fashionable sensibility.

Born in Chur (Switzerland) in 1741, Angelica Kauffmann (or Kauffman) was considered an artistic child prodigy even as a young girl. Her father, portrait and fresco painter Johann Joseph Kauffmann, provided her with an unusually broad training for a girl, in Como and Milan. She was fluent in four foreign languages and was famous for her singing. As she later depicted dramatically in her painting *Self-Portrait Torn Between Music and Painting* (1792), she was long undecided whether to pursue a career in music or in painting.

Study Tours in Italy

In 1758, she and her father set off for Italy to study the works of old masters. The early influence of Italian art on her work remained evident even in her late oeuvre, but leading figures of early neo-classicism such as Winckelmann, Scottish painter Gavin Hamilton, Austrian "Roman" painter Anton von Maron, and Italian artists Pompeo Battoni and Piranesi also left their mark. In 1762, Kauffmann settled in Rome, where she found a considerable clientele among distinguished travelers visiting Italy. Many of these were Englishmen on the Grand Tour, and her much-praised portrait of actor David Garrick (1764) gained her a reputation in England.

"The whole world is Angelica-mad" (Danish ambassador in 1781)

Finally, in 1766 she moved to London for 15 years, her career being greatly assisted by the celebrated Sir Joshua Reynolds. There she led a lively social life in her salon with her aristocratic contacts and earned a handsome living with her paintings. Apart from portraits, her great interest was history painting, the highest academic genre, nominally the preserve of men. She made an astute selection of subjects in spotlighting favorite heroines of classical history such as Lucretia, Iphigenia, Virginia, and Penelope. These all represented admired female virtues such as fidelity, patience, selflessness, pity, and

self-sacrifice. As the only woman practicing in this genre, she featured among the founding members of the Royal Academy in 1768. By then, she was already a member of similar academies in Bologna, Florence, and Rome, and later Venice joined the list.

In 1781, Kauffmann married Venetian *veduta* painter Antonio Zucchi, and returned with him to Rome, where she acquired painter Anton Raphael Mengs' studio. Here she was a great favorite with visiting intellectuals such as Goethe and Herder and painted portraits of numerous court figures.

Even in her lifetime and among early historians of art, Kauffmann's works were considered to be the quintessence of "female art," the painter herself a symbol of femininity. Particularly in Weimar circles, she was stylized into a *schöne Seele* (beautiful soul) and a model of sensibility, which gave her uncommon cachet. In Rome in 1786, Goethe wrote: "It is very

1741 Born 30 October in Chur, Switzerland, and spends her childhood in Morbegno in the Valtellina Valley, Italy. She is taught the basics of painting by her father, Johann Joseph Kauffmann.
1757 Her mother dies, and she moves with her father to Schwarzenberg in Bregenzerwald (Vorarlberg), Austria.
1758 She and her father set off for Italy.
1762 Arrives in Rome.
1766 Settles in London.
1768 Becomes a founding member of the Royal Academy in London.
1781 Marries Antonio Zucchi (second marriage), returns to Rome.
1807 Dies 5 November in Rome.

FURTHER READING:
Wendy Wassyng Roworth (ed.) and others, *Angelica Kauffman: A Continental Artist in Georgian England*, Reaktion Books, London, 1992
Angela Rosenthal, *Angelica Kauffman: Art and Sensibility*, Yale University Press, London and New Haven, 2006

left:
Portrait of Giovanni Volpato, 1795, oil on canvas, 62.5 x 51.2 cm, Private collection

above:
Self-Portrait with Drawing Pencil and Folder, 1784, oil on canvas, 64.8 x 50.7 cm, Neue Pinakothek, Munich

pleasant to look at pictures with Angelica because her eye is well trained and her mechanical knowledge of art is very great. At the same time she is very sensitive to all that is beautiful, true and delicate, and yet incredibly modest. … She has an incredible and—for a woman—huge talent." Kauffmann herself was shrewd enough to act up to this ideal of femininity. Her inexhaustible industry, her skill in choosing subject matter suited to her market, and countless engravings and reproductions of her works enhanced her popularity to such an extent that the style of a whole period is still associated with her name.

Cornelia, Mother of the Gracchi, 1785, oil on canvas, 101.6 x 127 cm, Virginia Museum of Fine Arts, Richmond

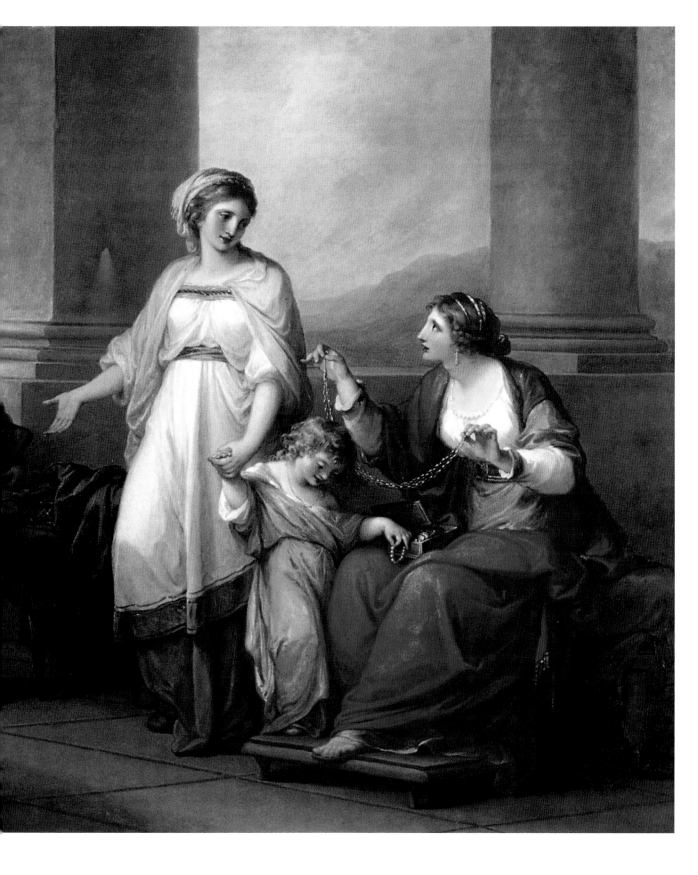

ADÉLAÏDE LABILLE-GUIARD

FRANCISCO DE GOYA

WILLIAM TURNER

1755 b. Marie-Antoinette,
Queen of France and
Navarre

1776 American Declaration
of Independence

1770 b. Ludwig van Beethoven,
German composer

ROCOCO 1700–1780

1700–1780 ROCOCO CLASSICISM 1750–1790

1750–1790 CLASSICIS

1700 1705 1710 1715 1720 1725 1730 1735 1740 1745 1750 1755 1760 1765 1770 1775 1780 1785

*Portrait of Louise-Elisabeth of France,
Duchess of Parma, and Her Son Ferdinand,
1788, oil on canvas, 113 x 88.5 cm, Musée
National du Château et des Trianons,
Versailles*

1789 Start of French Revolution	**1804** Napoleon Bonaparte becomes Emperor of France	**1826** b. Marie Goegg-Pouchoulin, first campaigner for women's rights in Switzerland	
1792 *Vindication of the Rights of Woman* (Mary Wollstonecraft)	**1815** Napoleon defeated at Waterloo	**1848** *Communist Manifesto* (Karl Marx, Friedrich Engels)	

ROMANTICISM 1790–1840 1790–1840 ROMANTICISM IMPRESSIONISM 1860–1910

1790 1795 1800 1805 1810 1815 1820 1825 1830 1835 1840 1845 1850 1855 1860 1865 1870 1875

ADÉLAÏDE LABILLE-GUIARD

She never achieved the fame of her rival, Élisabeth Vigée-Lebrun, who was six years her junior, and yet she earned for herself a firm place in the history of art: above all, Adélaïde Labille-Guiard was an indefatigable fighter for the recognition of women artists.

Born in 1749 in Paris, Adélaïde took lessons as a young girl from the miniature painter François-Élie Vincent, who was a close friend of her father, Claude-Edme Labille. Later she studied pastel drawing under Maurice-Quentin de La Tour, and then eventually transferred to François-André Vincent, the son of her first teacher, who introduced her to the secrets of oil painting. She soon established a reputation as a talented portrait painter and was commissioned to paint ministers, fellow artists, and members of the royal family. Her career took a major step forward when she was accepted into the Académie Royale in Paris, which at that time included only two women as members. The works submitted by Labille-Guiard convinced the Académie of her skill, as did those presented by her contemporary, Élisabeth Vigée-Lebrun, who was admitted on the same day: the date, 31 May 1783, has been recorded. The Académie reacted immediately to this rapid increase in the number of women members by limiting to four the number of places available for female artists.

A Glittering Career

A series of triumphs followed in the Paris Salon, where the paintings she exhibited were received with favorable comments. Among her most famous works is a self-portrait from the year 1785, which shows Labille-Guiard sitting in front of her easel. Behind her stand two of her pupils, Marie Gabrielle Capet and Mademoiselle Carreaux de Rosemond. From her early years as an artist, Labille-Guiard regarded the teaching of other women artists as one of her most important duties. She married the tax official Nicolas Guiard when she was 20, but the marriage remained childless, so that she was able to devote all her energies to her own painting and the training of her pupils. In the early 1790s, Labille-Guiard was the first woman artist to be permitted to set up a studio for herself and her pupils in the Louvre building complex; she was long refused because, it was claimed, the presence of women artists would corrupt the morals of the artists already working there.

Although Labille-Guiard painted numerous members of the royal family and was even appointed "Painter of the Princesses of France," a position which entitled her to a royal pension, she became an avowed supporter of the French Revolution. Her previous royal connections did not prove to be disadvantageous: the country's new rulers, including Maximilien de Robespierre, let her paint their portraits.

As she grew older, Labille-Guiard withdrew increasingly from the public eye. She enjoyed a period of happiness late in life when she married her former teacher, François-André Vincent, once the separation from her husband, which had taken place many years before, finally became legal. She died three years later, on 24 April 1803, in Paris.

1749 Born 11 April in Paris
Studies with François-Élie Vincent, Maurice-Quentin de La Tour, and François-André Vincent.
1769 Marries Nicolas Guiard.
1783 Admitted to the Académie Royale.
1800 Second marriage, to François-André Vincent.
1803 Dies 24 April in Paris.

FURTHER READING:
Delia Gaze (ed.), *Dictionary of Women Artists*, Fitzroy Dearborn, London and Chicago, 1997
Frances Borzello, *Seeing Ourselves: Women's Self-Portraits*, Thames and Hudson, London, 1998

Salon

The Salon, an exhibition of works by living artists, was initiated during the late 17th century by the French court, and took place regularly. A jury, consisting on occasion exclusively of members of the Académie Royale, determined which artists would be admitted and which works would be displayed. For an artist to be recognized, it was essential that he or she should have exhibited in the Salon. From the mid-19th century, as a protest against the conservative selection procedures of the official Salon, counter-exhibitions were held including the Salon des Refusés (Salon of the Refused) and the Salon des Indépendants (Salon of the Independents).

Self-Portrait with Two of Her Pupils, Marie Gabrielle Capet and Mademoiselle Carreaux de Rosemond, 1785, oil on canvas, 210 x 151 cm, The Metropolitan Museum of Art, New York

ÉLISABETH VIGÉE-LEBRUN ══════════════════════════════

FRANCISCO DE GOYA ══════════════════════════════

ANGELIKA KAUFMANN ══════════════════════════════

1731 b. Sophie La Roche, German poetess

1724 b. Immanuel Kant, German philosopher

1761 *Julie* (Jean-Jacques Rousseau)

1789 Start of French Revolution

1700–1780 ROCOCO CLASSICISM 1750–1790

1750–1790 CLASSICISM

1705 1710 1715 1720 1725 1730 1735 1740 1745 1750 1755 1760 1765 1770 1775 1780 1785 1790

1797 b. Franz Schubert, Austrian composer

1789 George Washington becomes
first President of the USA

1814 *Fidelio* (Ludwig van Beethoven)

1804 Napoleon Bonaparte becomes Emperor of France

1859 Second Italian War of Independence
(Giuseppe Garibaldi)

1862 *The House of the Dead*
(Fyodor Dostoyevsky)

ROMANTICISM 1790–1840 1790–1840 ROMANTICISM IMPRESSIONISM 1860–1910

1795 1800 1805 1810 1815 1820 1825 1830 1835 1840 1845 1850 1855 1860 1865 1870 1875 1880

ÉLISABETH VIGÉE-LEBRUN

Forced into exile for many years following the French Revolution, Élisabeth Vigée-Lebrun was a portrait painter in the neo-classical style who was famous for her beauty. She pursued a glittering career in the salons of the international aristocracy between Paris and Rome, Vienna, St. Petersburg, and London.

As in the case of Angelica Kauffmann, Élisabeth Vigée's artistic talent was discovered at a very early age. She was instructed initially by her father, the painter Louis Vigée, and she soon attracted attention with her portraits of members of the aristocracy. Her paintings reflected the elegance and lifestyle of the nobility at the end of the 18th century.

Two years after her marriage to the artist and art dealer Jean-Baptiste-Pierre Lebrun, she was eventually summoned to Versailles to paint the portrait of Queen Marie-Antoinette. The latter was so delighted that Vigée-Lebrun became her favorite artist, and she produced more than 20 portraits of the Queen of France and her children. This friendship opened to her the doors of the Académie Royale, where she successfully exhibited her works.

European Exile

As a result of her close relationship with the aristocracy, at the outbreak of the French Revolution in 1789 she was forced to flee, initially to Italy. She had no idea that she would spend the next 12 years in exile, returning to Paris only in 1802. Her confident manner in the presence of the nobility, her diligence, and her skills secured for Élisabeth Vigée-Lebrun not only fame and numerous commissions from the courts of Europe, but also five honorary memberships in the academies concerned. She spent six years in St. Petersburg, where she was patronized by the family of the Czarina Catherine II. The numerous portraits that she was commissioned to paint permitted her to acquire a considerable fortune.

The Portrait Painter of "Sensibility"

Vigée-Lebrun's portraits of women reveal her predilection for the simple, natural elegance of the new reformed fashion, which rejected the stiff and artificial attitudes of court etiquette. This corresponded with the current concept of "sensibility," a "back to Nature" mood, that was propagated at the time by the influential writer Jean-Jacques Rousseau. In her famous self-portrait, Vigée-Lebrun represents herself as a loving and caring mother embracing her daughter.

Élisabeth Vigée-Lebrun produced a total of more than 600 portraits, which represent a considerable proportion of her total oeuvre of 800 paintings. Unusually for a woman of her time, she self-confidently published her memoirs in three volumes in 1835. Despite their nostalgic tone, the *Souvenirs*, as she called them, provide an interesting insight into the political and artistic events of the time.

1755 Born Marie-Élisabeth-Louise
 Vigée 16 April in Paris, the
 daughter of the painter Louis
 Vigée.
 Takes her first painting lessons,
 from her father.
1776 Marries the painter and art dealer
 Jean-Baptiste-Pierre Lebrun.
1783 Accepted by the Académie Royale
 in Paris.
1789 Leaves Paris after the outbreak of
 the Revolution and flees to Italy.
1794 Divorced from Jean-Baptiste-
 Pierre Lebrun.
1795 Works in St. Petersburg, where
 she spends the next six years.
1802 Returns to Paris, but leaves for
 London shortly afterwards.
1835 Publishes *Souvenirs*.
1842 Dies 30 March in Paris.

FURTHER READING:
The Memoirs of Elisabeth Vigée-Le Brun,
translated by Siân Evans, Camden
Press, London, 1989
Mary D. Sheriff, *The Exceptional
Woman: Elisabeth Vigée-Lebrun and the
Cultural Politics of Art*, University of
Chicago Press, Chicago, 1996

left page:
Portrait of Countess Golovin, c. 1800,
oil on canvas, 84 x 67 cm, The Barber
Institute of Fine Arts, University of
Birmingham, UK

above:
Self-Portrait, 1800, oil on canvas,
78.5 x 68 cm, Hermitage Museum,
St. Petersburg

Neo-Classicism

The painters of the late 18th century, especially the French artists Jacques-Louis David and his pupil Jean-Auguste-Dominique Ingres, produced in their works a determined reaction to the playfulness and opulence of the Baroque and Rococo eras, styles with which the aristocracy had demonstrated their love of pomp and which had fallen out of favor since the French Revolution. Painting was now dominated by the simple forms of Greek and Roman antiquity, and by a clear and unadorned approach to both line and color. Apart from David and Ingres, famous painters of the neo-classical period include Joseph Anton Koch, Angelica Kauffmann, and Raffael Mengs.

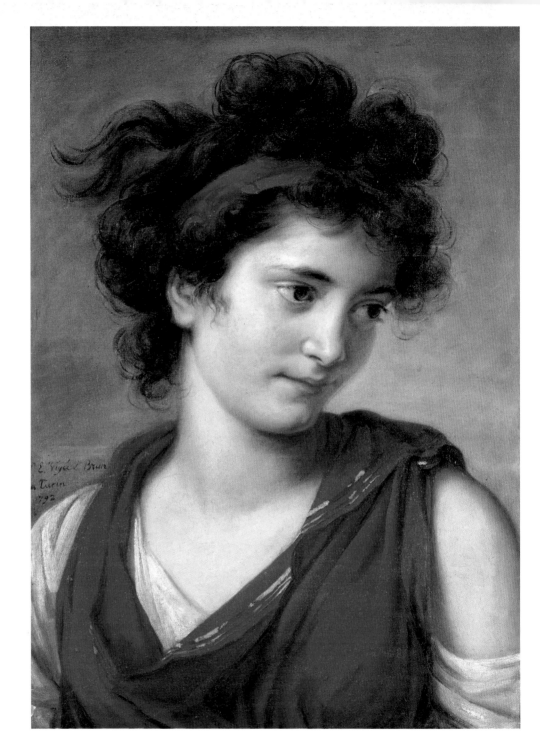

above:
Portrait of Margherita Portorati, 1792,
Galleria Sabauda, Turin

right page:
Self-Portrait with Daughter, 1786,
oil on panel, 105 x 85 cm, Musée du
Louvre, Paris

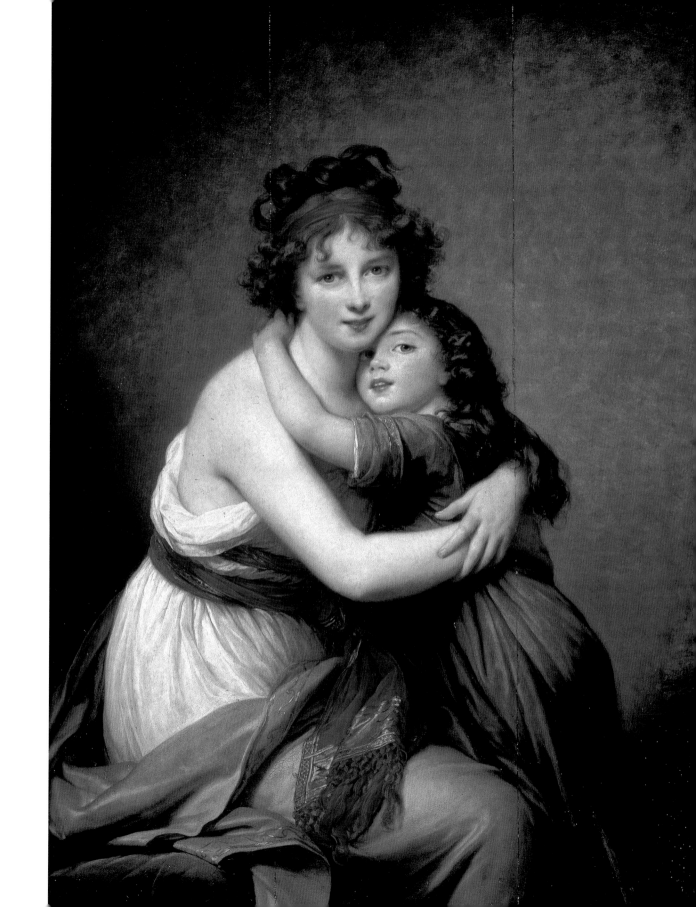

MARGUERITE GÉRARD

J.M.W. TURNER

JACQUES LOUIS DAVID

1729 b. Catherine II (the Great),
Empress of Russia

1761 *Julie* (Jean-Jacques Rousseau)

1785 b. Bettina von Arnim,
German poetess and
campaigner for female
emancipation

1700–1780 ROCOCO CLASSICISM 1750–1790

1750–1790 CLASSICISM ROMANTICISM

1710 1715 1720 1725 1730 1735 1740 1745 1750 1755 1760 1765 1770 1775 1780 1785 1790 1795

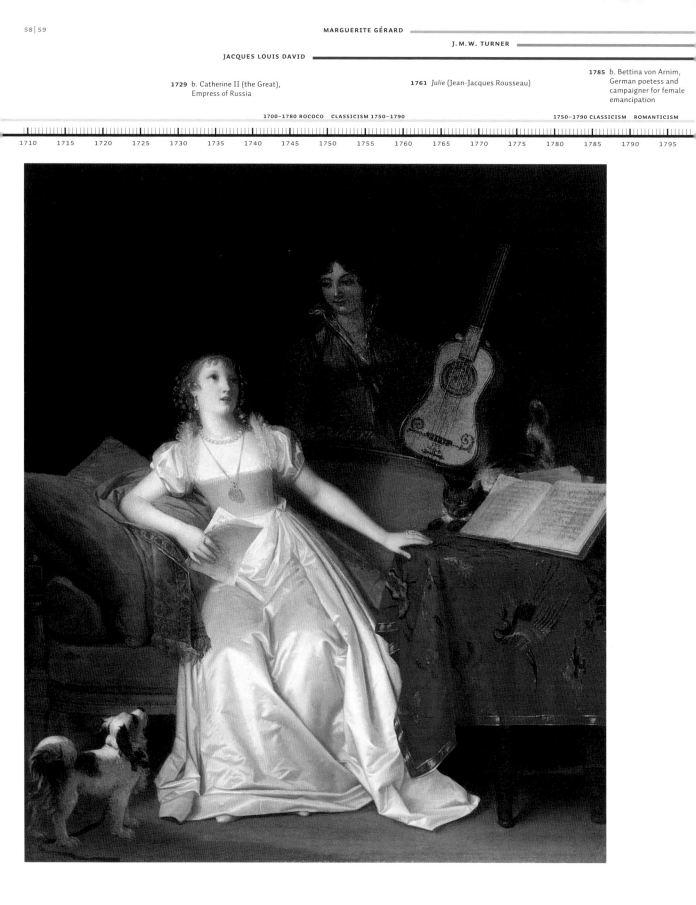

1801 *The Nude Maja* (Francisco de Goya)

1809 b. Charles Darwin, English natural scientist

1800 Establishment of the United Kingdom of
Great Britain and Ireland

1790–1840 ROMANTICISM

1848 *Communist Manifesto* (Karl Marx,
Friedrich Engels)

1863 Civil rights for blacks
in the United States

IMPRESSIONISM 1860–1910

1879 b. Albert Einstein

1884 Robert Koch
identifies
cholera
bacterium

1800 1805 1810 1815 1820 1825 1830 1835 1840 1845 1850 1855 1860 1865 1870 1875 1880 1885

MARGUERITE GÉRARD

A talent for art often runs in families, even if only by marriage. Marguerite Gérard certainly profited greatly from her brother-in-law Jean-Honoré Fragonard, who took her under his wing in her early years.

Born in 1761 in Grasse in southern France as the daughter of the perfumer Claude Gérard, Marguerite Gérard moved to Paris at the age of 14, where she lived in the family of her sister Marie-Anne. The latter was married to no less a person than Jean-Honoré Fragonard, one of the masters of French Rococo. Fragonard, famous for his light-hearted, charming, and frequently risqué pastoral and bathing scenes, taught the young Marguerite initially drawing and etching, and later instructed her in the art of oil painting.

Gérard took as her model not only the art of her famous brother-in-law, but also studied the works of Dutch painters such as Gabriel Metsu and Gerard ter Borch, who had achieved considerable international fame during the 17th century. Like them, Gérard developed a taste for intimate domestic genre scenes, which she recorded with an eye for detail and a particular talent for the portrayal of different surfaces and fabrics on canvas. Even during her lifetime, she enjoyed great success: from the 1790s she was able to exhibit her works in the Paris Salon and received commissions from wealthy patrons. She seems, however, to have shown scant respect for conventions: she never married and was apparently decidedly lacking in ambition when it was a matter of becoming a member of the venerable Académie Royale.

Making Music

One of the most frequent motifs in Gérard's works is of women making music, as in the painting completed around 1810 entitled *Prelude to a Concert*. In Gérard's time, it was customary for wealthy families to ensure that their daughters received an education in the various arts. However, this genre painting can also be interpreted in a variety of ways: thus it appears as if there is more between the seated woman and the man standing behind her than the title and setting of the scene would seem to indicate. Details like the little dog at the bottom left, a popular symbol of faithfulness, and the cat sitting on the table, which can be seen as a symbol of promiscuity, provide sufficient room for ambivalence.

1761 Born 28 January in Grasse, France.
1775 Moves to Paris to live with her sister Marie-Anne and brother-in-law Jean-Honoré Fragonard, whose pupil she becomes.
1799 First exhibits at the Salon in Paris.
1837 Dies 18 May in Paris.

FURTHER READING:
Sally Wells-Robertson, *Marguerite Gérard: 1761–1837*, thesis, New York University, 1978
Delia Gaze (ed.), *Dictionary of Women Artists*, Fitzroy Dearborn, London and Chicago, 1997

Genre Painting

Genre painting is dedicated to depicting scenes of everyday life. Frequently, chosen subjects include groups of people celebrating together or domestic interiors, often presented in a way that allows for a moral significance to be read. Genre painting experienced a high point in 17th-century Dutch art, where masterpieces by artists such as Gerard ter Borch and Jan Vermeer of Delft left a lasting impression on the form.

left page:
Prelude to a Concert, c. 1810, oil on canvas, 56.5 x 47.6 cm, National Museum of Women in the Arts, Washington DC

above:
François Dumont, *Portrait of Marguérite Gérard*, 1793, Wallace Collection, London

1789 Start of French
Revolution

1793 The Death of Marat
(Jacques-Louis David)

1776 American Declaration
of Independence

1791 Construction of Branden-
burg Gate in Berlin

1804 Napoleon Bonaparte
becomes Emperor of Fr

1700–1780 ROCOCO CLASSICISM 1750–1790

1750–1790 CLASSICISM ROMANTICISM 1790–1840

1725 1730 1735 1740 1745 1750 1755 1760 1765 1770 1775 1780 1785 1790 1795 1800 1805 1810

The Dream of Happiness, 1819, oil on
canvas, 97 x 146 cm, Musée du Louvre,
Paris

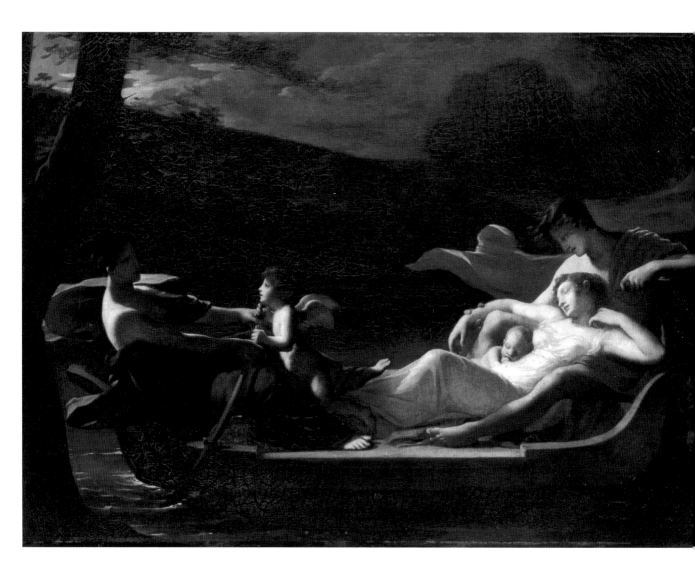

5 Battle of Trafalgar

1815 Napoleon defeated at
Waterloo

1830 b. Marie von Ebner-Eschenbach,
Austrian-Moravian poet

1848 *Communist Manifesto* (Karl Marx,
Friedrich Engels)

1877 Queen Victoria becomes
Empress of India

1790–1840 ROMANTICISM IMPRESSIONISM 1860–1910

1815 1820 1825 1830 1835 1840 1845 1850 1855 1860 1865 1870 1875 1880 1885 1890 1895 1900

CONSTANCE MAYER

The name of French painter Constance Mayer is closely linked with that of Pierre-Paul Prud'hon, whose pupil and lover she was. Many of her pictures, especially genre scenes and portraits, were sold under this name, and even today a correct attribution is often difficult.

Constance Mayer was born in Paris in 1775, the daughter of a customs official. She was taught by the leading genre painter Jean-Baptiste Greuze, and for a brief time even worked in the studio of the celebrated Jacques-Louis David, though his heroic manner was not to her taste. It was quite different with Pierre-Paul Prud'hon, whom she met in 1802. Although she was by then in her late 20s, had finished her training and had already had works exhibited at the Salon in Paris since 1796, she was keen to go on studying with him. The teacher-pupil relationship soon developed into a love affair. Constance Mayer was besotted, and in 1810 moved to the Sorbonne in Paris, where a studio apartment had been made available to Prud'hon, so as to be nearer to him. Seventeen years his junior, Mayer became his closest collaborator, partner, and lover. When Prud'hon's wife had a nervous breakdown in 1803 and was shut away in a closed institution, Constance Mayer looked after the couple's children, ran Prud'hon's household, and supported him financially.

It is not easy to distinguish her work from that of her former teacher. Often they worked together on a painting, Prud'hon doing sketches and Mayer doing the painting from them. This procedure was not at all uncommon at the time, but in this case led to Constance Mayer as a painter disappearing behind the figure of her paragon.

Dream of Happiness

Her picture *The Dream of Happiness* of 1819 was likewise the result of this collaboration, Prud'hon having done the sketches here, too. Lit by the light of the moon in a boat gliding smoothly over the water, a young woman rests on the arm of her husband, with a sleeping child at her breast. A female figure, Fortuna, assisted by Cupid, rows the boat. Exhibited at the Salon in 1819, the picture had an accompanying text: "Love and happiness navigate a boat over the river of life. A young man sits at the stern, holding his wife and sleeping child in his arms."

Possibly this allegorical scene contained some of Constance Mayer's own dreams and longings. Her artistic output and devotion to Prud'hon brought her no fulfillment, and led to severe depression and panic. Worse, after the death of his wife Prud'hon refused to marry her. On 26 May 1821, she committed suicide in her studio, cutting her own throat. Shaken by her death, Prud'hon completed her last works and the following year put on a retrospective of her work at the Salon.

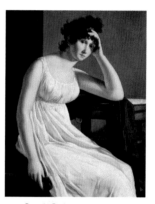

1775 Born in Paris.
Studies with Greuze, and briefly collaborates with Jacques-Louis David.
1796 Exhibits at the Paris Salon for the first time.
1802 Meets Pierre-Paul Prud'hon, whose pupil (and later lover) she becomes.
1821 Kills herself 26 May in Paris.

FURTHER READING:
Anne Sutherland Harris and Linda Nochlin, *Women Artists: 1550–1950*, Los Angeles County Museum of Art / Knopf, New York, 1976
Delia Gaze (ed.), *Dictionary of Women Artists*, Fitzroy Dearborn, London and Chicago, 1997

Self-Portrait, undated, oil on canvas, Bibliothèque Marmottan, Boulogne-Billancourt, Paris

1815 Napoleon defeated at Waterloo

1824 Start of restoration and trans-
formation of Windsor Castle

1837 Victoria becomes Queen of England

1842 China cedes Hong
Kong to the British

1850 b. Sofia Kovalevskaya, firs
female mathematics profe

1750–1790 CLASSICISM ROMANTICISM 1790–1840

1790–1840 ROMANTICISM

1770 1775 1780 1785 1790 1795 1800 1805 1810 1815 1820 1825 1830 1835 1840 1845 1850 1855

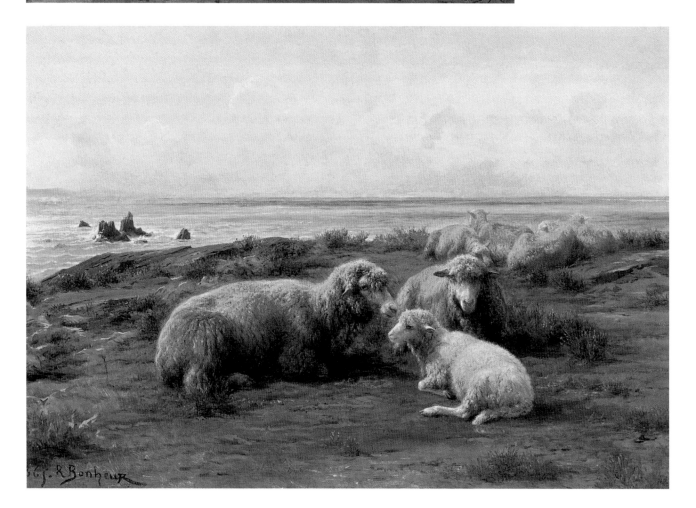

left:
Study for The Horse Market, 1853–1855, oil
on canvas, 28 x 61 cm, Private collection

below:
Sheep by the Sea, 1865, oil on panel,
32.4 x 45.7 cm, National Museum of
Women in the Arts, Washington DC

1861–1865 American Civil War

1888 *Sunflowers* (Vincent van Gogh)

1900 *The Interpretation of Dreams* (Sigmund Freud)

1883 First skyscraper in Chicago
1883 *Treasure Island* (Robert Louis Stevenson)

IMPRESSIONISM 1860–1910 1860–1910 IMPRESSIONISM CUBISM 1910–1920 EXPRESSIONISM 1920–1940

1860 1865 1870 1875 1880 1885 1890 1895 1900 1905 1910 1915 1920 1925 1930 1935 1940 1945

ROSA BONHEUR

Even as a young girl, Rosa Bonheur drew in the parks, horse market, and abattoirs of Paris. Her studio at 56 Rue de l'Ouest, a sensational menagerie, attracted countless visitors. She is considered the most famous animal painter of the 19th century.

Rosa Bonheur was very fortunate in her parents. They allowed the little tomboy with short-cropped hair and trousers to roam freely round the Bordeaux countryside. Though artistically gifted, Rosa had problems with reading, so she was allowed to paint an animal for every letter of the alphabet as a visual aid, even on the walls of her nursery. Rosa's father, a drawing master, sent her to a boys' school with her brothers, and finally taught her himself.

Living Unconventionally
This freedom of action would determine her whole life. She would not let herself be constrained by corsets, either literally or metaphorically, not even in post-1829 Paris. Granted official permission, she went around where necessary in comfortable, practical male attire to do her studies of animal anatomy. As a teenager copying in the Louvre or later in her mid-20s in her own studio, she was always on the ball, very much to the benefit of her press reputation. No one interfered, since she was valued as an artist who could do sensationally authentic portraits of animals. Her early work features complicated compositions and skillfully choreographed movements, while the later works are sublime and entirely appropriate to the species. Even when she shared a household with Nathalie Micas from her mid-30s or in her later years with young American painter Anna Klumpke, it did not make the headlines. Instead, a critic wrote after the Salon of 1847: "Mademoiselle Rosa paints almost like a man."

International Fame at a Gallop
It was a gripping, animated composition of monumental dimensions—over 244 by 507 cm (8 by 16 feet)—that caught an enraptured public's eye in Paris in 1853. Critics were as enthusiastic. *The Horse Fair* shows a crowd of splendid black horses and mettlesome grays careering past our eyes full of mischief and churning up dust, the stable boys trying to control some of them by the bridle. Dramatic clouds in the background reinforce the intense coloration and light effects to produce a tense atmosphere.

A Dealer's Stroke of Genius
Thanks to dealer Ernst Gambart, Rosa Bonheur's reputation extended well beyond France. He bought the monumental work for 40,000 francs, together with reproduction rights, with a brilliant marketing concept in mind. He had *The Horse Fair* duplicated as an engraving, and, after Queen Victoria had given it her blessing at a private viewing in Windsor Castle in 1855, put his prize possession on show in London. The 33-year-old artist became famous overnight, even in America. To crown his campaign, he auctioned the painting to a collector, on the remarkable condition that he allow the work to be shown for three years in a touring exhibition!

Lions in Country House
Bonheur brought back not just sketches from her promotional tours with Gambart. Living or stuffed, cows and eagles, a horse, sheep, and a number of smaller creatures shared Bonheur's studio. Mobbed by fans, the now financially successful Bonheur could afford a country retreat, Château By on the edge of the forest of Fontainebleau. Two lionesses were also in residence, one of them as tame as a lamb—a gift from Gambart. As Bonheur grew older, painting bison became a favorite subject.

1822 Born 16 March in Bordeaux, the eldest of four children.
1829 Her family moves to Paris.
1835 Her father, landscape painter Raymond Bonheur, teachers his children after the death of his wife. Bonheur copies works of Poussin and Paulus Potter at the Louvre in Paris.
1841 Exhibits at the Salon in Paris for the first time (two paintings).
1845 To study animals at close hand, she lives on a farm for some months.
1848 Awarded her first medal, for *Oxen of the Cantal*.
1853 Wins an international reputation overnight with *The Horse Fair*. She buys Château By, and lives there with Nathalie Micas.
1865 Awarded the Cross of the Légion d'Honneur.
1899 Dies 25 May in Château By.

FURTHER READING:
Reminiscences of Rosa Bonheur, Theodore Stanton (ed.), Hacker Art Books, New York, 1976
Dore Ashton, *Rosa Bonheur: A Life and a Legend*, The Viking Press, New York, 1981
Robyn Montana Turner, *Rosa Bonheur*, Little, Brown, Boston, 1991

Rosa Bonheur, c. 1865

BERTHE MORISOT

ÉDOUARD MANET

VINCENT VAN GOGH

1826 First photograph

1837 Victoria becomes Queen of England

1871 German troops capture Paris

ROMANTICISM 1790–1840 1790–1840 ROMANTICISM IMPRESSIONISM 1860–1910

1790 1795 1800 1805 1810 1815 1820 1825 1830 1835 1840 1845 1850 1855 1860 1865 1870 1875

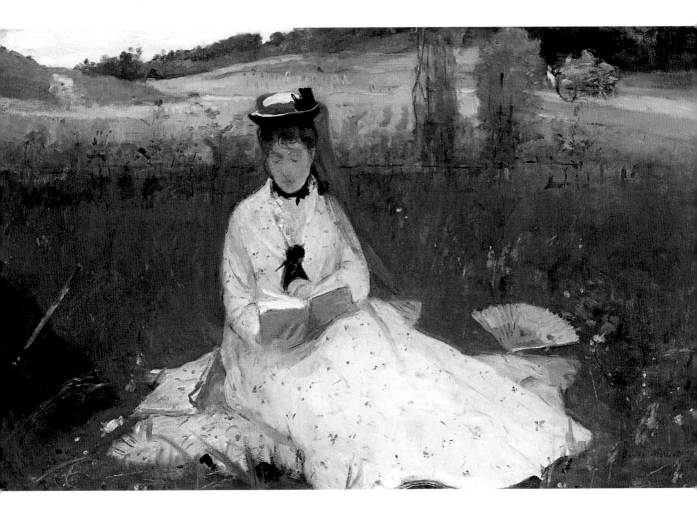

Reading, 1873, oil on canvas,
45.1 x 72.4 cm, The Cleveland Museum
of Art, Donated by the Hanna Fund

1887–1889 Construction of the Eiffel Tower in Paris

1888 *Sunflowers* (Vincent van Gogh)

1911 Marie Curie awarded the Nobel Prize for Chemistry

1914–1918 World War I

1905 Foundation of the artists' association "Die Brücke"

1927 Charles Lindbergh flies across the Atlantic

1860–1910 IMPRESSIONISM CUBISM 1910–1920 EXPRESSIONISM 1920–1940 ABSTRACT EXPRESSIONISM 1940–1960

1880 1885 1890 1895 1900 1905 1910 1915 1920 1925 1930 1935 1940 1945 1950 1955 1960 1965

BERTHE MORISOT

French painter Berthe Morisot was the first woman to exhibit with the Impressionists. Her first biographer, Armand Fourreau, wrote of her: "Her life was like an enclosed lake, never churned up by storms, calm, linear, and at one with her work."

Berthe Morisot was born in Bourges in 1841, the third child of a government official's four children. The father moved posts several times, and in 1852 the family resettled in Paris. There, Berthe and her sisters Yves and Edma had their first drawing lessons. However, the sisters soon found the academic art teaching they got from Geoffroy-Alphonse Chocarne inadequate. Yves gave up painting, but Berthe and Edma asked for a new teacher, and Joseph Guichard was the man they got. Under his guidance, they copied old masters in the Louvre. The distinguished landscape painter Camille Corot lent them some of his works to copy, and in summer 1861 they painted at his country house in Villa d'Avray, which was an opportunity for doing a lot of *plein-air* painting. In 1867 came a decisive encounter, when she met Édouard Manet. She soon formed part of his circle, which included Pissarro, Degas, Cézanne, Sisley, Monet, and Renoir. The Morisot and Manet families were also in close contact, so that Berthe gained permission to sit for Manet. This artistic co-operation went on for several years, and the friendship was not shaken by the rough handling that art critics gave Manet's 1873 portrait of her, *Le Repos*. Manet had promised Berthe that she would not be recognizable in the picture, but she was. The critics panned the picture as immoral, even calling Berthe a "queen of slovenliness" for the way she sat.

Admiration and Criticism

Manet remained a key reference point, even so. Under his influence, Berthe turned to new subject matter, painting everyday scenes and portraits. In 1874, she had nine paintings in the first Impressionist exhibition, and after that showed at every Impressionist exhibition until 1886, except in 1879. The same year, she married Manet's brother, Eugène. One painting she showed at the first Impressionist exhibition was her oil painting *Reading*, showing a woman in a white dress reading in a landscape. The picture was also admired for the lightness in the handling of color, but nonetheless was savaged by critics. Her former teacher even said she should apologize to Correggio for trying to do something in oil that could only be done in watercolors. Berthe Morisot refused to be put off. By the end of the 1870s she had found her own voice, producing oil paintings of great transparency and refinement. Her first solo show in 1892 was a great success.

Berthe Morisot died of pneumonia in Paris on 2 March 1895.

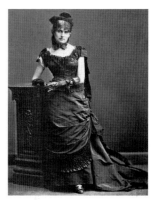

1841 Born 14 January in Bourges, the third of four children.
1852 The family moves to Paris, where Berthe has drawing and painting lessons.
1864 Exhibits at the Salon for the first time.
1867 Meets Manet, and then Pissaro, Degas, Cézanne, Monet, and Renoir.
1874 Marries Manet's brother, Eugène.
1878 Daughter Julie born.
1892 First solo show at the Galerie Boussod et Valadon.
1895 Dies 2 March in Paris.

FURTHER READING:
Kathleen Adler and Tamar Garb, *Berthe Morisot*, Phaidon, London, 1995
Margaret Shennan, *Berthe Morisot: The First Lady of Impressionism*, Sutton, Throup, Stoud, Gloucestershire (UK), 1996
Russell T. Clement, Annick Houzé, and Christiane Erbolato-Ramsey (eds.), *Women Impressionists: A Sourcebook*, Greenwood Press, Westport, CT, 2000

Impressionism

Impressionism got its name from Claude Monet's picture *Impression, Sunrise* (1872), a dawn scene of the port of Le Havre. Critic Louis Leroy used the term to denigrate all the Impressionist painters showing at the 1874 exhibition, and the term stuck. The Impressionists preferred to paint in the open (*en plein air*) to capture different effects of light and atmosphere, applying paint straight to canvas with rapid brushstrokes. Leading representatives of the style beside Monet include Renoir, Degas, Manet, Pissaro, and Sisley.

Berthe Morisot, undated

Woman at Her Toilette, c. 1875, oil on
canvas, 60.3 x 80.4 cm, The Art Institute
of Chicago

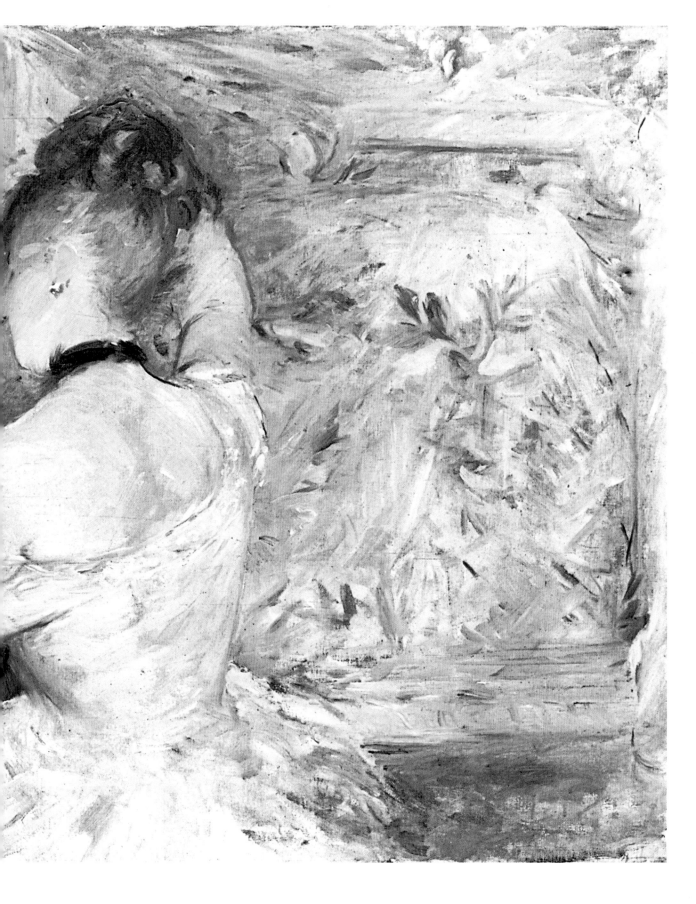

MARY CASSATT

CLAUDE MONET

GEORGES SEURAT

1857 *Madame Bovary* (Gustave Flaubert)

1830 b. Emily Dickinson,
American poet

1871 German troops
capture Paris

ROMANTICISM 1790–1840 1790–1840 ROMANTICISM IMPRESSIONISM 1860–1910

| 1795 | 1800 | 1805 | 1810 | 1815 | 1820 | 1825 | 1830 | 1835 | 1840 | 1845 | 1850 | 1855 | 1860 | 1865 | 1870 | 1875 | 1880 |

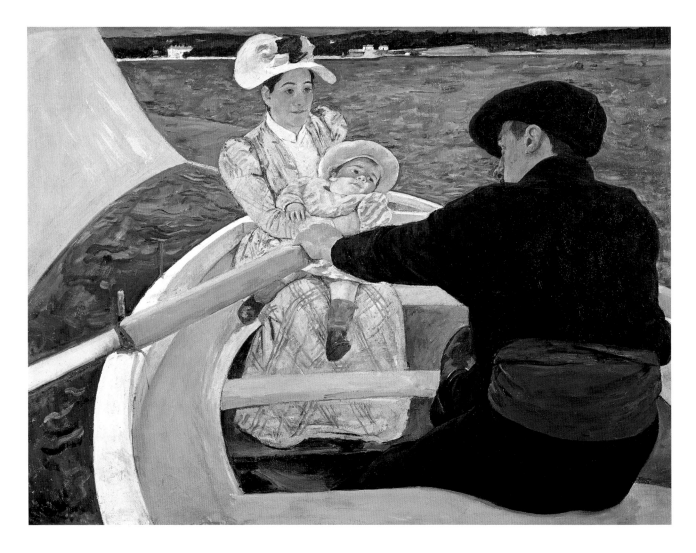

The Boating Party, c. 1893/94, oil on
canvas, 90 x 117 cm, The National Gallery
of Art, Washington DC

1905 Foundation of the artists' association
"Die Brücke"

1887–1889 Construction of the Eiffel Tower in Paris **1914–1918** World War I

1897–1899 *Water Lilies* (Claude Monet) **1920** Women awarded voting rights in the United States

1921 Albert Einstein awarded Nobel Prize

1860–1910 IMPRESSIONISM **CUBISM 1910–1920** **EXPRESSIONISM 1920–1940** **ABSTRACT EXPRESSIONISM 1940–1960** **POP ART 1960–1975**

| 1885 | 1890 | 1895 | 1900 | 1905 | 1910 | 1915 | 1920 | 1925 | 1930 | 1935 | 1940 | 1945 | 1950 | 1955 | 1960 | 1965 | 1970 |

MARY CASSATT

American painter Mary Cassatt joined the Impressionist group of artists in Paris. As a graphic artist she did exquisite drypoints, and is considered one of the most important American artists of her time.

In 1861, Mary Cassatt studied at the Academy of Fine Arts in Philadelphia, continuing her studies in Paris four years later. After numerous study trips to Rome, Parma, Madrid, and Antwerp, where she studied old masters with great discipline, she finally settled in Paris in 1874. There her work was soon accepted for exhibition at the Salon, but at the personal request of Edgar Degas, with whom she had become firm friends, she switched to the new salon put on by the "Indépendants," later known as the Impressionists: "I was delighted to accept ... I rejected conventional art. I began to live."

The stylistic influences of Degas are unmistakable in Cassatt's paintings, which is hardly surprising since he followed her artistic development almost as a teacher. Cassatt loved scenes set in the glittering world of theater and opera lit by artificial light. The response in the press to the 12 works she exhibited in the 1879 Impressionists exhibition was considerable. Not only oils such as *Woman in a Loge* were praised, but also the pastel pictures, where pastels were mixed with metallic oils to depict the brilliant atmosphere of nightlife. Her delight in experimentation is evident. In the 1870s, Mary Cassatt also did much as a practical intermediary between the Impressionists and the American public, particularly helping Degas and Monet to sell in the USA.

The Development of Color Drypoints
From 1880, Cassatt invested great energy in graphic work. Fellow artists such as Degas, Édouard Manet, and Camille Pissarro were also doing the same, and all of them now experimented with various printing techniques, in some cases amazing combinations of etching, drypoint, aquatints, and other techniques. However, the publication of her series for the journal *Le Jour et La Nuit* was never concluded. Deeply impressed by the large-scale exhibition of Japanese woodcuts at the École des Beaux-Arts in 1890, Cassatt translated traditional Japanese printing techniques into contemporary French style by

means of flat, clearly delineated shapes and delicate coloration. In particular, she did a series of ten color drypoint prints (now known as *The Ten*) produced in a highly elaborate technique. They are elegant, and unmistakably her work. The series was an important component of her very important solo exhibition at Durand-Ruel in 1893.

The Mother and Child Theme
Around the same time, and perhaps influenced by differences of opinion over the Dreyfus Affair in 1894, Cassatt and Degas broke off their friendship. Cassatt turned to a subject that other contemporary female artists had also taken up—the life of middle-class women, often mother and child—and painted many pictures on the subject.
Mary Cassatt had to stop painting in 1915, when her sight began to fail.

1845 Born 22 May in Allegheny, near Pittsburgh.
1861 Becomes a student at the Academy of Fine Arts in Philadelphia, continuing her studies after 1865 in Paris, from where she makes numerous study tours around Europe.
1874 Settles in Paris.
1879 Takes part in Impressionist exhibitions (till 1886).
1894 Buys Château Beaufresne on the Oise.
1904 Admitted to the Légion d'Honneur.
1914 Awarded the Pennsylvania Academy of the Fine Arts' gold medal.
1915 Has to stop painting due to failing eyesight.
1926 Dies 14 June in Mesnil-Théribus, France.

FURTHER READING:
Gerhard Gruitrooy, *Mary Cassatt: An American Impressionist*, Todtri, New York, 1996
Georgette G. Gouveia, *The Essential Mary Cassatt*, Harry N. Abrams, New York, 2001
Griselda Pollock, *Mary Cassatt*, Chaucer, London, 2005

Mary Cassatt, undated

below:
The Bath, 1891, etching,
31.4 x 24.4 cm

right page:
Woman in a Loge, 1878/79,
oil on canvas, 80.2 x 58.2 cm,
Philadelphia Museum of Art

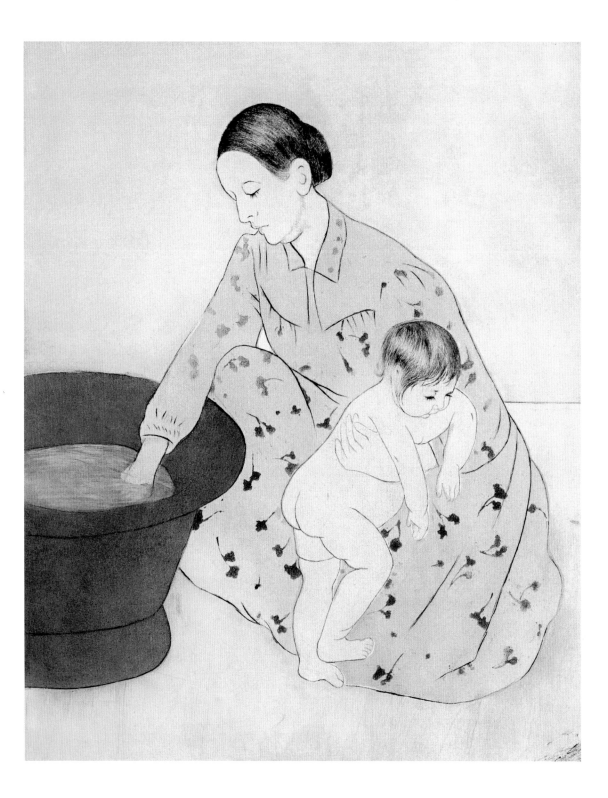

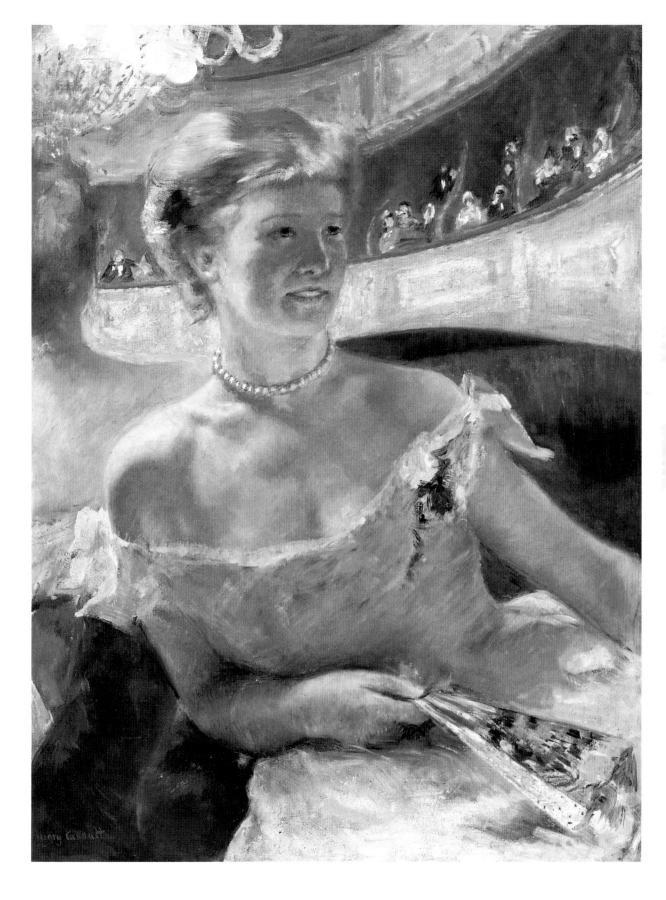

EVA GONZALÈS

VINCENT VAN GOGH

WASSILY KANDINSKY

1826 First photograph

1830 b. Auguste Schmid, writer and joint founder
of the women's movement in Germany

1871 German troops capture Paris

1886 First cars with inter
combustion engine

1790–1840 ROMANTICISM

IMPRESSIONISM 1860–1910

| 1800 | 1805 | 1810 | 1815 | 1820 | 1825 | 1830 | 1835 | 1840 | 1845 | 1850 | 1855 | 1860 | 1865 | 1870 | 1875 | 1880 | 1885 |

Early Wakening, c. 1877/78, oil on canvas,
81.5 x 100 cm, Kunsthalle Bremen

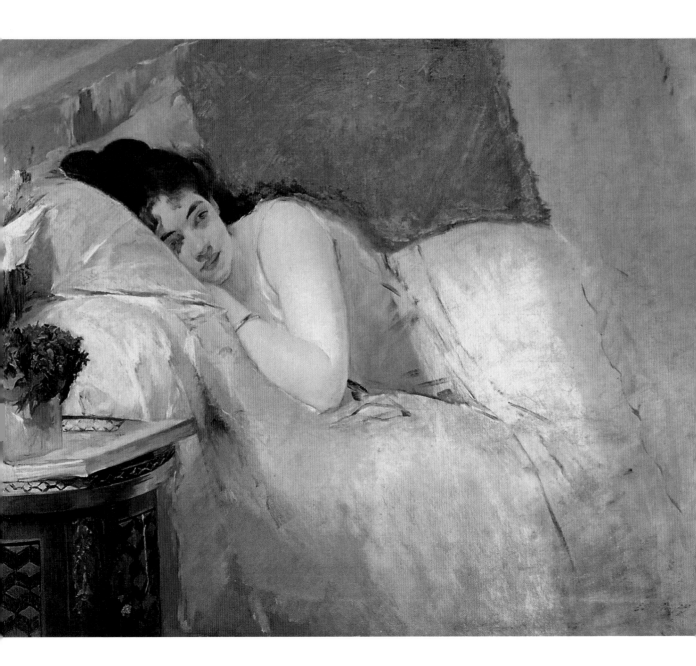

1888 *Sunflowers* (Vincent van Gogh) 1906 Finnish women are the first in Europe
to receive full voting rights

1905 Foundation of the artists' 1914–1918 World War I 1933 Adolf Hitler comes to power
association "Die Brücke" 1921 Albert Einstein awarded Nobel Prize

1860–1910 IMPRESSIONISM CUBISM 1910–1920 EXPRESSIONISM 1920–1940 ABSTRACT EXPRESSIONISM 1940–1960 POP ART 1960–1975

1890 1895 1900 1905 1910 1915 1920 1925 1930 1935 1940 1945 1950 1955 1960 1965 1970 1975

EVA GONZALÈS

The Parisian artist Eva Gonzalès died at the age of only 34—too early for her to have developed her personal style to maturity. Although she was long overshadowed by Édouard Manet, who was greatly admired by many young artists, her genre paintings and pastels were nonetheless highly regarded.

How difficult it must have been in the late 19th century for a woman with artistic ambition to step out of the shadow of her teacher, all too often a famous personality, and no longer to be seen merely as a pupil, model, or mistress! Berthe Morisot and Mary Cassatt, who were painting at the same time as Eva Gonzalès, had to fight against the same problems as she did. As the daughter of the famous novelist Emmanuel Gonzales and the musician Marie Céline Ragut, she grew up at the heart of the Parisian intellectual and artistic scene. At the early age of 17 she decided to devote herself to art, and from 1866 onwards she studied under the portraitist Charles Chaplin. Energetic and confident, she set up her own studio at the same time.

In the Shadow of Manet

Three years later she met the artist Édouard Manet, a controversial figure at the time, whose painting technique had a lasting effect on the Impressionists. Gonzalès became his only pupil and, like Berthe Morisot, his model.

Eva Gonzalès could not avoid becoming involved in Manet's constant struggle for the recognition of his art in the conservative Paris Salon. In 1870, after she had been working for a year in Manet's studio, she succeeded in having three of her paintings exhibited in the all-powerful Salon. The works followed Manet's style very closely, and, fatally, the latter exhibited at the same time, of all things, his *Portrait of Eva Gonzalès*. The painting was sharply criticized; everyone was talking about the lovely model in Manet's unsuccessful painting, but no one took her seriously as an artist.

She continued to exhibit her works regularly in the Salon and finally achieved recognition for a series of large-format genre paintings for which her sister Jeanne had acted as model. Some of her paintings from the 1870s retain stylistic elements of Impressionism, although she never belonged to that group.

Airy Pastels and a Tragic Death

She was highly successful above all with her pastels. On the occasion of the retrospective two years after her death, the critic Philippe Burty enthusiastically claimed that he had never seen anything lighter and more delicate, nothing that was more typical of the characteristics of pastel painting, than the fine tones of the works of Eva Gonzalès.

Eva Gonzalès died unexpectedly in 1883 following the birth of her son, five years after her marriage to the graphic artist Henri Guérard, presumably of puerperal fever. Her death acquired a special poignancy through the fact that it occurred exactly five days after that of her teacher, Édouard Manet.

Although Gonzalès' creative development was interrupted so suddenly, she is considered to be one of the most important woman painters of the late 19th century, alongside Berthe Morisot and Mary Cassatt.

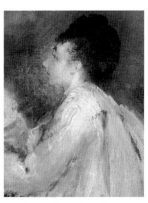

1849 Born 19 April in Paris, the daughter of the writer Emmanuel Gonzalès and the musician Marie Céline Ragut.
1866 Begins to study under the portrait painter Charles Chaplin.
1869 Meets Édouard Manet, and becomes his pupil and model.
1870 Exhibits at the Paris Salon for the first time.
1879 Marries graphic artist Henri Guérard.
1883 Dies 5 May in Paris.

FURTHER READING:
François Mathey, *Six Femmes Peintres: Berthe Morisot, Eva Gonzalez, Seraphine Louis, Suzanne Valadon, Maria Blanchard and Marie Laurenc*, Les Éditions du Chêne, Paris, 1951
Russell T. Clement, Annick Houzé, and Christiane Erbolato-Ramsey (eds.), *Women Impressionists: A Sourcebook*, Greenwood Press, Westport, CT, 2000

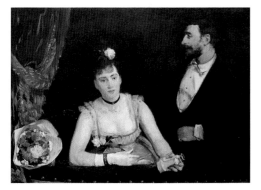

left:
A Loge in the Théâtre Italien, c. 1874, oil on canvas, 98 x 130 cm, Musée d'Orsay, Paris

above:
Self-Portrait, c. 1875, oil on canvas, 21 x 12.5 cm, Private collection

1813 b. Giuseppe Verdi, Italian composer

1855 *Hiawatha* (Longfellow)

1876 *Tom Sawyer* (Mark Twain)

1790–1840 ROMANTICISM

IMPRESSIONISM 1860–1910

1805 1810 1815 1820 1825 1830 1835 1840 1845 1850 1855 1860 1865 1870 1875 1880 1885 1890

1905 Bertha von Suttner awarded Nobel Peace Prize

1907 Hague Convention 1914–1918 World War I

1906 *Les Demoiselles d'Avignon* (Pablo Picasso)

1940 *The Great Dictator* (Charlie Chaplin)

1933 Adolf Hitler comes to power

1948 Universal Declaration of Human Rights before UN General Assembly

1966 Indira Gandhi becomes Prime Minister of India

1860–1910 IMPRESSIONISM CUBISM 1910–1920 EXPRESSIONISM 1920–1940 ABSTRACTER EXPRESSIONISM 1940–1960 POP ART 1960–1975

1895 1900 1905 1910 1915 1920 1925 1930 1935 1940 1945 1950 1955 1960 1965 1970 1975 1980

CECILIA BEAUX

By the time she was 30, Cecilia Beaux was one of the leading portrait painters in America. The double portrait of her sister and nephew inspired by Whistler and called Les Derniers Jours d'Enfance (1883) *won the Mary Smith Prize at the Pennsylvania Academy of Fine Arts. It was also accepted for the Paris Salon in 1887, which sealed her reputation as an artist of international standing.*

Cecilia Beaux was born in Philadelphia in 1855, the youngest daughter of Jean Adolphe Beaux, a silk manufacturer originally from Provence, France, and teacher Cecilia Kent Leavitt. The sudden death of her mother 12 days after her birth hit her father so hard that he left Cecilia and her three-year-old sister with their grandmother and returned to France for two years. At 16, Cecilia had her first art lessons from artist Catharine Ann Drinker, later going on to the school run by the Dutch painter Francis Adolf van der Wielen for a further two years.

A Penchant for Portraits

On finishing her studies at Van der Wielen's, she began her career, as she was now in a position to earn a living from art. She painted portraits of children, produced lithographs, painted pottery, and gave lessons at Miss Sanford's School. Meantime she sporadically attended portrait and costume classes at the Pennsylvania Academia, but decided against the progressive artist Thomas Eakins as a teacher. In 1888 she spent 18 months studying in Paris at the *académies* Julian and Colarossi. The same year, while working in Concarneau with American artists Alexander Harrison and Charles Lasar, she made a firm decision to become a portraitist. In a letter to her uncle Will, she wrote: "People seem to interest me more than anything in the world, and that's the reason for my success."

"Unsimple simplicity"

Cecilia Beaux's interest in the human figure and expressions is particularly reflected in portraits she painted of less well-known people and their friends. Among her outstanding works is *Reverie*, a portrait of her friend Caroline Kilby Smith. Beaux's favorite sitters were beautiful women with dark hair and dark eyes. Generally her sitters are shown in unconventional poses; in *Reverie*, the sitter looks absent mindedly at the viewer, her face leaning against both hands, her elbows propped on the arms of her chair. A critic described the work as an "odd work of unsimple simplicity, with a nervous, almost loud expression of the figure in its apparent tranquility." Her empathetic portraits made Cecilia Beaux a favorite portraitist for writers, politicians, and artists. In 1924 she injured herself badly in an accident in Paris, which restricted her ability to work. She died at a venerable age in September 1942.

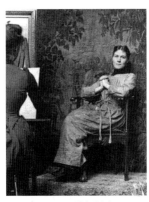

1855 Born 1 May in Philadelphia. Takes first art lessons at the age of 16.

1877 Sporadically attends classes at the Pennsylvania Academy of the Fine Arts.

1888 Studies at the Académie Julien and Académie Colarossi in Paris.

1893 Admitted to the Society of American Artists.

1895 Takes up teaching post at the Pennsylvania Academy of the Fine Arts.

1942 Dies 7 September in Gloucester, Massachusetts.

FURTHER READING:
Alice A. Carter, *Cecilia Beaux: A Modern Painter in the Victorian Age*, Rizzoli, New York, 2005

left page:
Reverie, 1894, oil on canvas, 83.8 x 63.5 cm, The Butler Institute of American Art, Youngstown, Ohio

above:
Cecilia Beaux in her Studio, c. 1890

1840 b. Peter Tchaikovsky, Russian composer

1871 German troops capture Paris

1879 *Daisy Miller* (Henry James)

1790–1840 ROMANTICISM IMPRESSIONISM 1860–1910

1810 1815 1820 1825 1830 1835 1840 1845 1850 1855 1860 1865 1870 1875 1880 1885 1890 1895

The Minuet, 1892, oil on canvas,
124 x 94 cm, Penlee House Gallery
and Museum, Penzance

1906 Maria Montessori opens her first Children's House	**1927** Charles Lindbergh flies across the Atlantic		
1914–1918 World War I	**1937** "Degenerate Art" exhibition in Munich		
1907 b. Grace Hopper, American computer pioneer and first female Rear Admiral of the US Navy Reserve	**1933** Adolf Hitler comes to power	**1939–1945** World War II	

1860–1910 IMPRESSIONISM CUBISM 1910–1920 EXPRESSIONISM 1920–1940 ABSTRACT EXPRESSIONISM 1940–1960 POP ART 1960–1975

1900 1905 1910 1915 1920 1925 1930 1935 1940 1945 1950 1955 1960 1965 1970 1975 1980 1985

ELIZABETH ARMSTRONG FORBES

The artists' colony in Newlyn, on the southern coast of England, became the second home of the Canadian artist Elizabeth Armstrong Forbes. Not only did she meet her future husband there, she also founded with him a school of painting that propagated painting in the open air.

Elizabeth Adela Armstrong was born in 1859 in the province of Ontario, Canada, but she moved to Europe with her mother while still a child. After several years in England, where she received her first artistic training at the South Kensington Schools, she returned to Canada. Soon after that she settled in New York City, where she studied at the Art Students League. She was influenced above all by her teacher William Merritt Chase, an American Impressionist whose style influenced an entire generation of artists. Chase had lived in Europe for many years, mainly in Munich and Venice. Elizabeth Armstrong also decided to return to Europe. After a period of study in Chase's former stamping ground, Munich, she spent a year in Pont-Aven in Brittany. The little community, which would later attract such famous names as Paul Gauguin and Émile Bernard, inspired her to try her hand at the *plein-air* painting that was the preferred approach of the French Impressionists.

In 1883, Armstrong left Pont-Aven for London and began to experiment with printing techniques. In the same year she was elected as a member of the Society of Painter Etchers. However, it was not until 1885, when she moved to the picturesque fishing village of Newlyn in Cornwall, that she finally settled down. Since the early 1880s, the little village had been a favorite destination of artists, who found the fishermen's cottages and the daily lives of the rural population provided attractive motifs. Another advantage was the light in the seaside town, which made it ideal for painting in the open air.

It was in Newlyn that Elizabeth Armstrong met the painter Stanhope Alexander Forbes, who had also come to Newlyn to paint outdoors. The pair married in 1889. Ten years later, in 1899, they established the Newlyn Art School, whose aim was to encourage interest in open-air painting. Elizabeth Forbes herself concentrated above all in her search for motifs on the village inhabitants and devoted herself especially to the representation of children. Although she

was one of the founders of the school of painting, and thus one of the driving forces in the artists' community with its ideal of *plein-air* art, it was considered unseemly for a woman to set up her easel out in the open air. Thus Forbes surrounded herself with her models and painted sensitive pictures of the people in her vicinity.

The "Queen of Newlyn," as she was called in her obituary, was not only a passionate artist who exhibited more works during her lifetime than her husband, including at the Royal Academy and the Royal Institute of Painters in Watercolours. She also published a periodical, *The Paperchase*, which became the mouthpiece of the Newlyn artists. She wrote poems, and her children's book *King Arthur's Wood*, with illustrations in the Pre-Raphaelite style, was published in 1904. She dedicated it to her only son, Alec. Elizabeth Armstrong Forbes died in 1912 at the early age of 53.

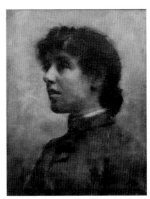

1859 Born 29 December in Kingston, Ontario, Canada.
Receives first artistic training at the South Kensington Schools in London, later at the Art Students League in New York, where she studies with William Merritt Chase.
1883 Moves to London.
1885 Moves to Newlyn, Cornwall, where she meets Stanhope Alexander Forbes.
1889 Marries Forbes.
1904 Publishes her children's book *King Arthur's Wood*.
1912 Dies 22 March in Newlyn.

FURTHER READING:
Caroline Fox, *Stanhope Forbes and the Newlyn School*, David and Charles, Newton Abbott, 1993
Deborah Cherry, *Beyond the Frame: Feminism and Visual Culture, Britain 1850–1900*, Routledge, London and New York, 2000

Plein-air Painting

In *plein-air* painting, the artist does not work in a studio but paints outdoors, directly in front of the motif, surrounded by natural light. The artists of the Barbizon School were early representatives of *plein-air* painting. Their name derives from the village near Paris where Théodore Rousseau, Camille Corot, Jean-François Millet, and others gathered in order to spend the summer months preparing studies for landscape paintings in the Forest of Fontainebleau. The Fontainebleau School is regarded as one of the precursors of Impressionism.

Stanhope Forbes, *Elizabeth Adela Armstrong Forbes*, 1890, oil on canvas, Collection of Newlyn Art Gallery on loan to Penlee House Gallery and Museum, Penzance

PAULA MODERSOHN-BECKER

VINCENT VAN GOGH

FRIDA KAHLO

1901 b. Marlene Dietrich

1887–1889 Construction of the Eiffel Tower in Paris

1790–1840 ROMANTICISM IMPRESSIONISM 1860–1910 1860–1910 IMPRESSIONISM

1825 1830 1835 1840 1845 1850 1855 1860 1865 1870 1875 1880 1885 1890 1895 1900 1905 1910

*Self-Portrait on Her Sixth Wedding
Anniversary*, 1906, oil on card,
101.5 x 70.2 cm, Paula Modersohn-Becker
Museum, Bremen

1914–1918 World War I 1939–1945 World War II 1955 Beginnings of Pop Art
1927 Charles Lindbergh flies across the Atlantic 1969 US moon landing
1937 *Guernica* (Pablo Picasso) 1945 Atom bombs dropped on Hiroshima and Nagasaki

UBISM 1910–1920 EXPRESSIONISM 1920–1940 ABSTRACT EXPRESSIONISM 1940–1960 POP ART 1960–1975

1915 1920 1925 1930 1935 1940 1945 1950 1955 1960 1965 1970 1975 1980 1985 1990 1995 2000

PAULA MODERSOHN-BECKER

Long before the Blauer Reiter or Brücke groups came into being, Paula Modersohn-Becker was already considered highly avant-garde. Posthumously, she became the best-known artist of the Worpswede artists' colony internationally, but during her life her work remained unappreciated.

Paula "hates the conventional and now is falling into the trap of making everything angular, ugly, bizarre and wooden instead. The color is wonderful—but the shapes? The expression? Hands like spoons, noses like conks, mouths like wounds …" Even Paula's husband Otto failed to appreciate her, as this diary entry for 1903 indicates. But Paula was fascinated by "ugliness," and the wooden and the bizarre made sense. Her notion of art, always with a keen awareness of what the pioneers were doing in Paris, had nothing in common with the initial intentions of the Worpswede artists' colony.

Art on the Moors

Around the turn of the 20th century, Worpswede was a village at the back of beyond, inhabited by peasants in a barren landscape of peat and bog. But there artists could get on with painting, living simply, without being far from Bremen. It was a long way from academic pressures and prescribed models, it was outside in the fresh air, and easel and brush were what mattered. So painters Fritz Mackensen, Otto Modersohn, and Heinrich Vogeler set about getting nature down on to canvas, looking in part for realism, in part for lyrical moods. Paula, who joined the colony at the age of 22, was something else. Her landscapes seemed banged on to the canvas, divided into small, hard-edged flat sections. The colors remained muted and earthy. "It's a strange feeling how all the colorful, studied and affected elements … fall away," she wrote enthusiastically in 1899. As a graduate of the Verein der Berliner Künstlerinnen's art school, her purpose in going to Worpswede was to have supplementary lessons from Fritz Mackensen. They proved superfluous, because she soon perfected her individual style of plain renderings of people and landscapes focusing on the essentials, an approach that met with blank incomprehension among her fellow Worpswede artists.

Paris and Her Own Style

As she was able to confirm in Paris, she was not alone in her search for the primeval and primitive. Cézanne's landscapes, composed of simple shapes and strong colors, together with the South Sea pictures of Gauguin, left an indelible impression on her, not to mention her studies at the Écoles des Beaux-Arts. Once back in Worpswede, Modersohn turned to women, children, and nature for her subject matter, rendering them as both coarse and beautiful, strong and subtle. She applied paint thickly, treating it as matter. She strove to capture a subject's essence, painting forms that were rough and angular in large flat areas delineated with bold outlines.

A constant theme is woman and motherhood. In her self-portraits, she shows herself pregnant, naked, frontal, elemental, and courageous. Were these acts of liberation? Certainly they were a declaration of self-belief.

Paula Modersohn-Becker's career lasted only seven years. An early maturing artist unnoticed by her fellow artists in Worpswede, she produced in that time over 700 paintings and 1,000 drawings before dying aged only 31, a few days after the birth of her longed-for child. She is supposed to have said on her deathbed: "What a pity."

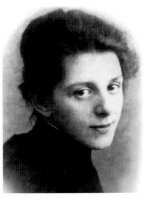

1876 Born 8 February in Dresden, the third of six children.

1892 Visits relatives in London and has her first drawing lessons there. Starts a two-year teacher-training course in Dresden, meantime attending drawing classes given by painter Bernhard Wiegandt.

1896 Studies at the Verein Berliner Künstlerinnen (Society of Women Artists) art school.

1897 Visits Worpswede for the first time.

1898 Moves to Worpswede and has lessons with Fritz Mackensen. Makes friends with Clara Westhoff, who soon marries poet Rainer Maria Rilke.

1900 Travels to Paris and enrolls for courses at the École des Beaux Arts. Marries Otto Modersohn.

1906 Decides to put the Worpswede idyll behind her for good.

1907 Returns to Worpswede. Dies of an embolism on 20 November, shortly after the birth of her daughter.

FURTHER READING:
Gillian Perry, *Paula Modersohn-Becker: Her Life and Work*, Women's Press, London, 1979
J. Diane Radycki (ed.), *The Letters and Journals of Paula Modersohn-Becker*, Scarecrow Press, Metuchen, NJ, 1980

Paula Becker, c. 1895

below:
Avenue of Birches, 1900, oil on card,
37 x 46.6 cm, Paula Modersohn-Becker
Stiftung, Bremen

right page:
Self-Portrait, 1906, oil on card,
62.2 x 48.2 cm, Private collection

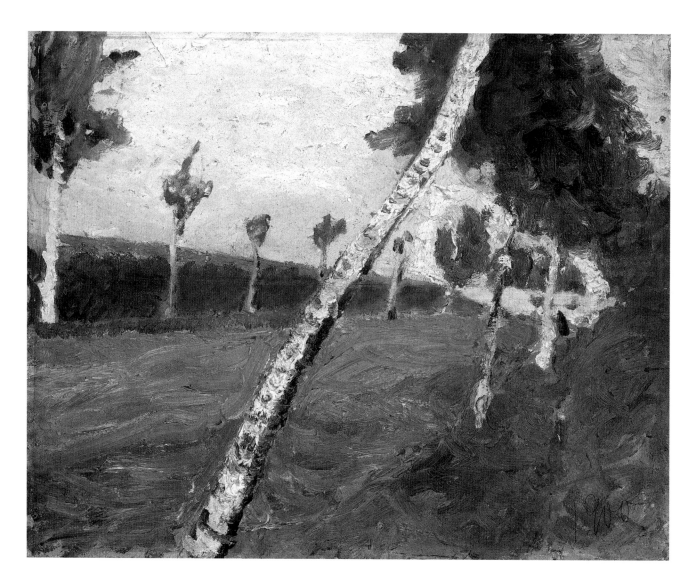

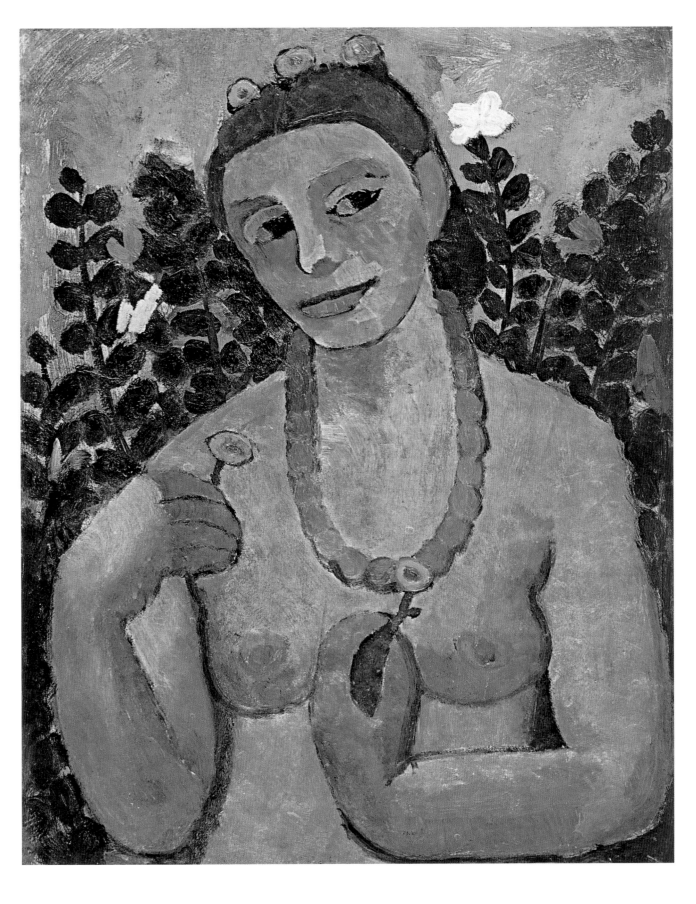

1894 Completion of the
Reichstag in Berlin

1886 First cars with internal
combustion engine

1790–1840 ROMANTICISM IMPRESSIONISM 1860–1910

1815 1820 1825 1830 1835 1840 1845 1850 1855 1860 1865 1870 1875 1880 1885 1890 1895 1900

Valse (The Waltz), 1891–1905, bronze,
height 25 cm, Neue Pinakothek,
Munich

The Interpretation of
Dreams (Sigmund Freud)

1908 b. Simone de Beauvoir, French writer
1914–1918 World War I

1939–1945 World War II

1960 John F. Kennedy becomes
President of the United States

1983 Barbara McClintock
awarded Nobel Prize
for Medicine

1905 Foundation of the artists'
association "Die Brücke"

1933 Adolf Hitler comes to power

IMPRESSIONISM CUBISM 1910–1920 EXPRESSIONISM 1920–1940 ABSTRACT EXPRESSIONISM 1940–1960 POP ART 1960–1975

1905 1910 1915 1920 1925 1930 1935 1940 1945 1950 1955 1960 1965 1970 1975 1980 1985 1990

CAMILLE CLAUDEL

Camille Claudel is widely considered the first important European woman sculptor. Her works in plaster, bronze, and marble, plus various drawings and paintings, have ensured her an important place in the history of art.

Camille Claudel was born in 1864 in the little French town of Fère-en-Tardenois. In 1881, her family moved to Paris to enable the gifted Camille to study at the Académie Colarossi, one of the few private art academies that also admitted female students. She began her first portrait studies in a studio of young women sculptors under the direction of Alfred Boucher.

Encounter with Rodin

In 1893, Auguste Rodin took over responsibility for teaching the group. At that point, Camille Claudel was 19 years old, while Rodin was 43 and already a successful artist. He discovered her talent, and Claudel became his workshop partner, lover, and muse. She sat for numerous portraits, one of the best known being Rodin's *Pensée*. She also helped him with his commissioned works, and modeled, among other things, the celebrated hands of the *Burghers of Calais*.

Claudel first exhibited her own works in 1885, and caused a stir with her sculpture of *Vieille Hélène* at the Salon of the Société des Artistes Français—more than all other branches of art, the sculptors' guild was considered a purely male domain. Her greatest success was with the *Valse* group, done in several versions: a couple dancing that expresses in masterly fashion their absorption in the music. A further masterpiece alludes to Claudel's real-life situation: *Âge de la Maturité* shows three nude figures, and constitutes a symbol of the triangular relationship with Rodin, who did not want to leave his long-standing partner Roset Beuret. Claudel was also accused of being artistically dependent on Rodin.

The Struggle for Recognition

In 1898, Claudel left Rodin and fought for her artistic and social independence. She retreated to her studio, lived in utmost poverty and was overcome by a emotional crisis, which meant an undesirable scandal for her family. She did her last sculpture in 1906, and in the same year destroyed a large proportion of her works, accusing Rodin of plagiarism. In 1913, just a few days after the death of her father, who was the only one in the family to back her, her diplomat brother Paul Claudel, a major poet, had her incarcerated in a psychiatric clinic. Camille Claudel spent the remaining 30 years of her life in institutions at Ville-Èvrard near Paris and at Montdevergues near Avignon. "Never forget that your sister languishes in prison. In prison with nothing but lunatics making faces the whole day and incapable of saying three sensible words." The desperate letters to her brother trying to obtain her release were ignored.

1864 Born 8 December 1864 in Fère-en-Tardenois, France. At 11, she begins to work with clay.
1881 Becomes a student at the private art school, the Académie Colarossi, in Paris.
Supported by sculptor Alfred Boucher.
1883 Meets Auguste Rodin.
1892 Takes part in an exhibition at the Société Nationale des Beaux Arts.
1898 Claudel and Rodin break up for good.
Moves into a studio on Quai Bourbon on the Île-St-Louis, where she lives a secluded and impoverished existence.
1913 After her father's death, her brother Paul Claudel has her committed to the Ville-Evrard psychiatric institution near Paris.
1943 Dies in the Montdevergues asylum near Avignon.

FURTHER READING:
Angelo Caranfa, *Camille Claudel: A Sculpture of Interior Solitude*, Bucknell University Press, Lewisburg, 1999
J.A. Schmoll / Eisenwerth, *Rodin and Camille Claudel*, Prestel, Munich and New York, 1999
Odile Ayral-Clause, *Camille Claudel: A Life*, Harry N. Abrams, New York, 2002

César, Camille Claudel, 1884

1883 *Also sprach Zarathustra* (Nietzsche)

1790–1840 ROMANTICISM IMPRESSIONISM 1860–1910

1815 1820 1825 1830 1835 1840 1845 1850 1855 1860 1865 1870 1875 1880 1885 1890 1895 1900

Mother with Her Dead Child, 1903,
etching, 42.5 x 48.6 cm, Akademie
der Künste, Berlin

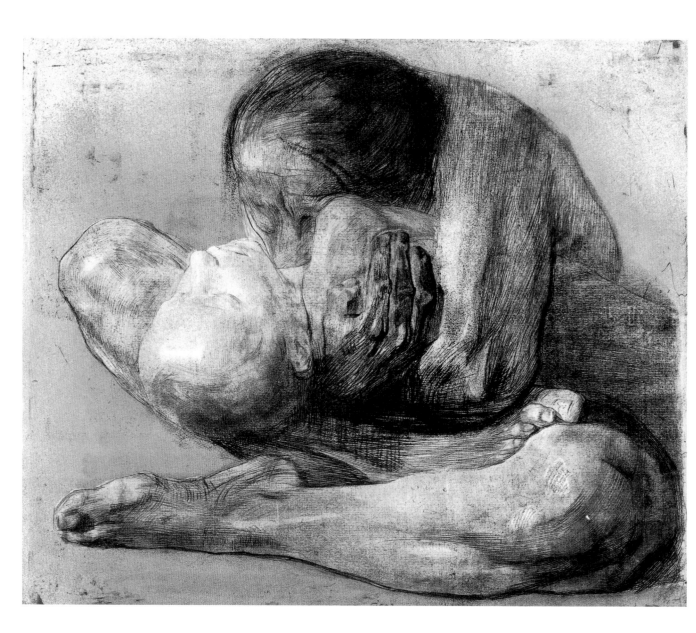

1911 Foundation of the artists'
association "Der Blaue Reiter"

1919 b. Evita Peron, First
Lady of Argentina

1931 b. Sofia Gubaidulina, Russian composer

1937 "Degenerate Art" exhibition in Munich

1914–1918 World
War I

1927 Charles Lindbergh flies
across the Atlantic

1937 *Guernica* (Pablo Picasso)

1939–1945 World War II

1961 Construction of the Berlin Wall

IMPRESSIONISM CUBISM 1910–1920 EXPRESSIONISM 1920–1940 ABSTRACT EXPRESSIONISM 1940–1960 POP ART 1960–1975

1905 1910 1915 1920 1925 1930 1935 1940 1945 1950 1955 1960 1965 1970 1975 1980 1985 1990

KÄTHE KOLLWITZ

"I want to achieve something in this time, when people are at such a loss and need help." Käthe Kollwitz

In her 60-year career, Käthe Kollwitz produced an extensive output of prints and drawings, plus 20 sculptures that often took years to complete. Her artistic work was combined with social and political commitment. She was born in Königsberg (East Prussia) in 1867, and experienced two wars, social wretchedness, and human suffering, which she reflected in her work.

Responses to the Events of Her Time

The great series of prints that assured her work an outstanding position in the development of 20th-century printed graphics began with *A Weavers' Revolt* (1893–1897). As the title indicates, she was attracted first of all to historical themes, in this case the weavers' revolt in Silesia, but later cycles such as *War* (1921–1922) and *Proletariat* (1925) reflected current political and social developments. The lithograph *Seed Grain Should not be Ground*, a quote from Goethe's *Wilhelm Meister's Apprenticeship,* was her last print, and developed from her interest in the mother-and-child theme.

Käthe Kollwitz's style was always representational, and stylistically independent of modernism. The sculptures date from 1910 onwards, and were largely inspired by the work of Ernst Barlach. Some years earlier, Kollwitz had spent two months in Paris to learn the basics of sculpture at the Académie Julian. The *Father and Mother* figures she worked at almost without interruption for almost 20 years reflect her personal grief after the death of her youngest son Peter, who had been killed in the war in 1914 aged 18. The separate kneeling figures bear the features of the mourning parents, Karl and Käthe Kollwitz. A somewhat larger version of the sculpture, *Pietà*, a seated mother with her dead son between her knees, has been on display at the Neue Wache in Berlin since 1993, as an anti-war monument. Kollwitz's commitment to peace and humanity, which she formulated in a clear, expressive style, is equally evident in the execution of numerous commissioned works for flysheets and posters, such as the famous *Nie Wieder Krieg* (No More War).

In Times of War

When the Nazis came to power, Kollwitz was banned from exhibiting her works. When she signed the *Dringender Appell* (Urgent Appeal) for the establishment of a united workers' front against the Nazis, she was forced to resign from the Prussian Academy of Arts and sacked from her position as head of the master class for print making. In 1944, at the invitation of Prince Ernest Henry of Saxony, she moved from Berlin to Moritzburg near Dresden, where she died on 22 April 1945, a few days before the end of World War II.

1867 Born Käthe Schmidt 8 July in Königsberg, Germany (now Kaliningrad, Russia).
1885 Becomes a student at the women's art school in Berlin.
1888 Studies painting in Munich.
1891 Marries physician Karl Kollwitz and moves to Berlin.
1892 Son Hans born.
1896 Son Peter born.
1904 Studies at the Académie Julien in Paris.
1907 Spends a year in Italy.
1914 Younger son Peter volunteers for the army and is killed in Flanders.
1919 Admitted to the Prussian Academy of Arts, Berlin.
1936 Banned from exhibiting.
1945 Dies 22 April in Moritzburg, Germany.

FURTHER READING:
Mina C. Klein and H. Arthur Klein, *Käthe Kollwitz: A Life in Art*, Holt, Rinehart and Winston, New York, 1972
Renate Hinz (ed.), *Käthe Kollwitz: Graphics, Posters, Drawings*, Pantheon Books, New York, 1981
Elizabeth Prelinger and others, *Käthe Kollwitz*, National Gallery of Art, Washington, DC / Yale University Press, New Haven and London, 1992

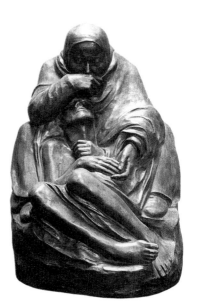

left:
Pietà, 1937–1938, enlarged re-casting 1993, Neue Wache, Berlin

above: Käthe Kollwitz, c. 1883

1861–1865 American Civil War **1891** End of the Indian Wars in the United States

1883 First skyscraper in Chicago

IMPRESSIONISM 1860–1910 1860–1910 IMPRESSIONISM CUBISM

1825 1830 1835 1840 1845 1850 1855 1860 1865 1870 1875 1880 1885 1890 1895 1900 1905 1910

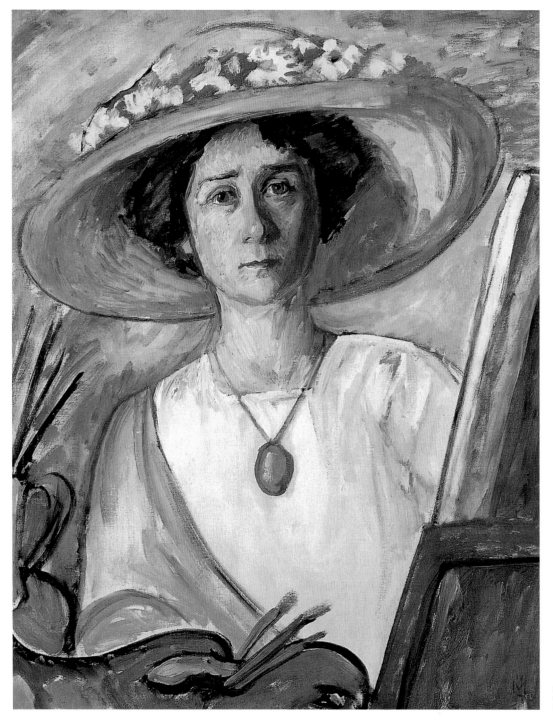

Self-Portrait, c. 1909,
oil on canvas, 76.2 x 58.4 cm,
Private collection

1914–1918 World War I	1939–1945 World War II	1963 Assassination of John F. Kennedy
1919 Women in Germany awarded voting rights	1945 Atom bombs dropped on Hiroshima and Nagasaki	
	1950 End of racial segregation in the United States	1981 First flight by the Columbia space shuttle
1923 b. Maria Callas, American-Greek opera singer	1952 Elvis Presley rises to fame	

EXPRESSIONISM 1920–1940 ABSTRACT EXPRESSIONISM 1940–1960 POP ART 1960–1975

1915 1920 1925 1930 1935 1940 1945 1950 1955 1960 1965 1970 1975 1980 1985 1990 1995 2000

GABRIELE MÜNTER

Gabriele Münter was the pupil and lover of Wassily Kandinsky, and one of the principal forerunners of Expressionism. The members of the artists' group Der Blaue Reiter (The Blue Rider) discussed pioneering innovations on the corner bench of the house in Murnau in which Münter and Kandinsky lived.

The famous artists' love story began in 1902 with painting expeditions. "Ella" was 25 when, free of the restrictions of the Munich Academy, she and the avant-garde Russian painter Wassily Kandinsky traveled by rail and bicycle into the charming Alpine foothills of Bavaria with Kandinsky's Phalanx painting class, their rucksacks full of painting equipment. Against panoramic views of the far horizon, they studied the sunny meadows and grazing cows. The new approach to art led Münter away from the accurate representation of reality towards simplification, towards a pure expression of color, and towards abstraction.

She wrote in 1908 about her time in Murnau: "While I was there … I made a huge leap forward—away from copying nature, more or less in the Impressionist manner…" In a diary entry from 1911 she noted that her aim was not "to reproduce nature … but to capture its essence." Gabriele Münter took as her motifs village streets and barns, mountains and wind, clouds and graveyard crosses as well as still-lifes, interiors, and portraits. She radically reduced both content and expression to the essential, to the bare minimum, surrounding her patches of color with black contours. In her pictures, she consciously juxtaposed brilliant colors that were far removed from those of nature. The path to her progressively more abstract art led, among other things, to her interest in folk customs, and in particular the Bavarian tradition of reverse-glass painting. She learned the technique from the glass painter Heinrich Rambold, who worked in Murnau at the time. Fascinated, she adopted for her own work the interplay of powerful black contours reminiscent of woodcuts, and the generous, brilliant areas of color.

Yellow Cows and the "Russian House"

On 21 August 1909, Gabriele Münter used the money she had inherited from her parents to purchase what would become known as the celebrated "Münter-haus." The locals scathingly referred to it as the "Russian House," the place where the artistic avant-garde met informally. Today, authentically restored and now a museum, it offers a poignant evocation of that time.

They all stayed there: Franz Marc, August Macke, Alexej von Jawlensky, and Marianne von Werefkin. So did the composer Arnold Schönberg and members of the Neue Künstlervereinigung München (New Artists' Association of Munich). There, the artists deliberated on non-representational art over glasses of beer, sometimes in the garden. The artists, for their part, were misunderstood by the art critics of the time, insulted as "incompetents" who produced "grayish paint soup" because they shocked the public with their images of yellow cows painted with coarse brushstrokes.

Münter's Legacy: the Million-Dollar Collection

For many years Münter avoided the "Russian House"; it was linked with too many memories. Her beloved Kandinsky, who at first wrote enthusiastic letters to his talented "Ellacken," moved in 1914, on the outbreak of World War I, first to Stockholm and then to Moscow. Münter, his eternal fiancée, remained at home alone and waited. In vain. For in the meantime, Kandinsky had married someone else. He never came back, and he never offered an explanation.

In the early 1930s art returned to the "Russian House," together with Gabriele Münter; she remained there until her death in 1962. It's a huge gain for art history that, at considerable personal risk, she preserved Kandinsky's paintings, which were persecuted during the Nazi period as "degenerate art," alongside her own works.

On her 80th birthday, she left all her treasures to the Lenbachhaus, which was owned by the City of Munich: reverse-glass paintings, tempera sheets and drawings, her own artifacts, more than 250 studies, more than 90 oil paintings by Kandinsky, and all the works by the Blauer Reiter artists in her possession.

1877 Born 19 February in Berlin.
1897 Receives her first painting lessons in Düsseldorf.
1901 Joins the Association of Women Artists in Munich, then transfers to the Phalanx school run by Wassily Kandinsky.
1903–1915 She and Wassily Kandinsky live together as lovers.
1909 Purchases the "Russian House" in Murnau. Became a member of the New Artists' Association of Munich.
1911–1912 First exhibition of the *Blauer Reiter*.
1915–1920 Lives in Sweden. Returning to Germany, she commutes for years between Berlin, Elmau Castle near Garmisch, Murnau, and Munich.
1931 Makes Murnau her home.
1937 Her pictures are censored by the Nazis.
1957 Awarded the Order of Merit of the Federal Republic of Germany.
1962 Dies 19 May in Murnau.

FURTHER READING:
Annegret Hoberg, *Wassily Kandinsky and Gabriele Münter: Letters and Reminiscences 1902–1914*, Prestel, Munich and New York, 2005

Gabriele Münter, 1910

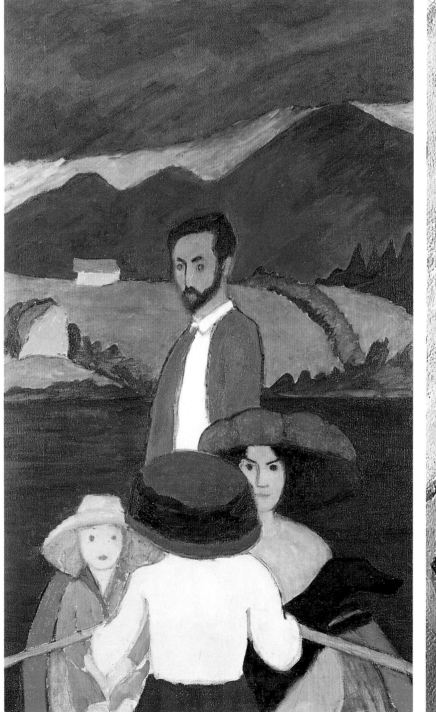

left page:
Boating, 1910, oil on canvas,
122.5 x 72.5 cm, Milwaukee Art Museum,
Gift of Mrs. Harry Lynde Bradley

below:
Jawlensky and Werefkin, 1909, oil on card,
32.7 x 44.5 cm, Städtische Galerie im
Lenbachhaus, Munich

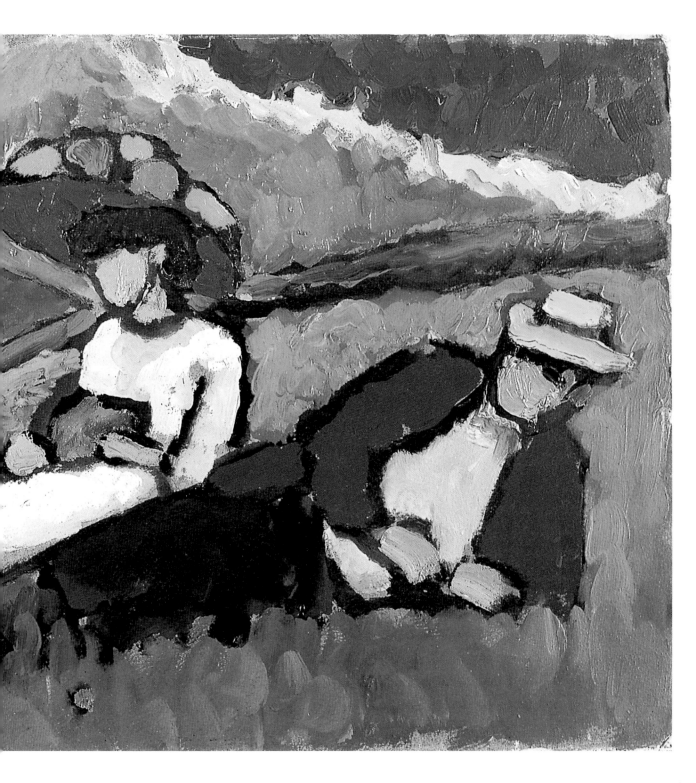

1882 b. Virginia Woolf, English writer

1884 *Adventures of Huckleberry Finn* (Mark Twain)

1914–1918 World War I

IMPRESSIONISM 1860–1910 1860–1910 IMPRESSIONISM CUBISM 1910–1920

| 1835 | 1840 | 1845 | 1850 | 1855 | 1860 | 1865 | 1870 | 1875 | 1880 | 1885 | 1890 | 1895 | 1900 | 1905 | 1910 | 1915 | 1920 |

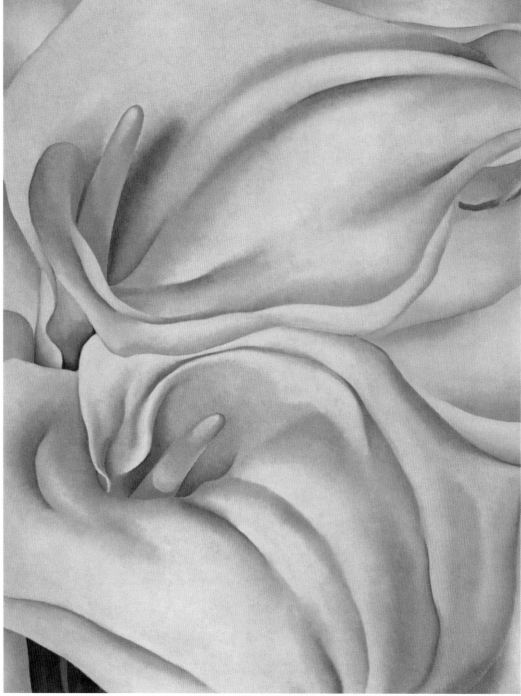

Two Callas on Pink, 1928, oil on canvas, 102 x 76 cm, Philadelphia Museum of Art, Bequest of Georgia O'Keeffe for the Alfred Stieglitz Collection, 1987

1925 *The Great Gatsby*
(F. Scott Fitzgerald)

1939–1945 World War II

1945 Atom bombs dropped on
Hiroshima and Nagasaki

1955 Beginnings of Pop Art

1960 John F. Kennedy becomes
President of the United States

1964 The United States enters the Vietnam War

1969 US moon landing

1981 First flight by the Columbia space shuttle

1990 Reunification of Germany

EXPRESSIONISM 1920–1940 ABSTRACT EXPRESSIONISM 1940–1960 POP ART 1960–1975

1925 1930 1935 1940 1945 1950 1955 1960 1965 1970 1975 1980 1985 1990 1995 2000 2005 2010

GEORGIA O'KEEFFE

The Museum of Modern Art's first exhibition of a woman artist (in 1946) featured the work of Georgia O'Keeffe. As an outsider in the development of 20th-century painting, she developed a style of her own that fluctuates between the representational and the abstract.

Born in 1887, Georgia O'Keeffe grew up with six siblings on a farm in Wisconsin. Her ambition was to be a painter, and she went to famous art schools such as the Art Institute of Chicago and the Art Students League in New York.

Her breakthrough as an artist came when she joined up with the avant-garde group of artists associated with photographer Alfred Stieglitz. Shortly before, she had destroyed a major part of her production to date, aware that her painting was dominated by alien influences. Stieglitz was enthusiastic about her new style of abstract drawings in charcoal, and without telling her organized a show at his Gallery 291, where he had also put on the first exhibition in the USA of works by Picasso, Braque, and Matisse.

The Little Things of Life

O'Keeffe began in New York with clear, reduced paintings of urban views and skyscrapers that described the growth of the metropolis. In the 1930s, flower motifs dominated, and these became her best-known works—greatly magnified open calyces of orchids, lilies, or callas that often appeared to have erotic associations, though O'Keeffe herself rejected such interpretation. Her aim was to simplify form so as to bring out the essence of things. The extreme close-up technique, filling the whole canvas with an image and making use of the opportunities of photographic optics, aimed to draw attention to these "wonders of the world."

Stieglitz, whom she married in 1924, was inspired to take countless nude and portrait photographs of her, which gave her an image of a free-thinking, emancipated woman. After the death of her much older husband in 1946, O'Keeffe moved to New Mexico, whose expansive, unspoiled landscape she had already discovered on earlier trips looking for new material. Her career, based on unconditional self-determination greatly inspired feminist art and art criticism in the 1970s and 1980s.

New Beginnings

In New Mexico, she created images of animal bones and skulls set against desert landscapes, as well as a series of paintings, drawings, and photographs of the interior courtyards of her hacienda. As in most of her pictures, her starting point was precise observation of an object, which she used as a basis for increasing abstraction. In her late work, she turned once again to new subject matter: frequent trips inspired her to do aerial scenes from planes. The last great series, *Sky above Clouds*, dates from 1963–1965, huge landscape formats pictures up to 7 meters (23 feet) wide that show a certain affinity to the works of postwar Abstract Expressionism. Georgia O'Keeffe died in Santa Fé, New Mexico, in 1986. A museum dedicated to her was opened there in 1997.

1887 Born 15 November in Sun Prairie, Wisconsin.
1903 Moves to Virginia.
1905 Becomes a student at the Art Institute of Chicago, then switches to the Art Students League, New York. Subsequently works as a commercial artist.
1917 First solo show at the gallery of photographer Alfred Stieglitz.
1924 Marries Alfred Stieglitz.
1946 Alfred Stieglitz dies, and O'Keeffe moves to New Mexico.
1986 Dies 6 March in Santa Fé.

FURTHER READING:
Katherine Hoffman, *An Enduring Spirit: The Art of Georgia O'Keeffe*, Scarecrow Press, Metuchen, NJ, 1984
Hunter Drohojowska-Philp, *Full Bloom: The Art and Life of Georgia O'Keeffe*, W.W. Norton, New York, 2004
Kathleen Pyne, *Modernism and the Feminine Voice: O'Keeffe and the Women of the Stieglitz Circle*, University of California Press, Berkeley, 2007

Alfred Stieglitz, Georgia O'Keeffe, Profile, 1932

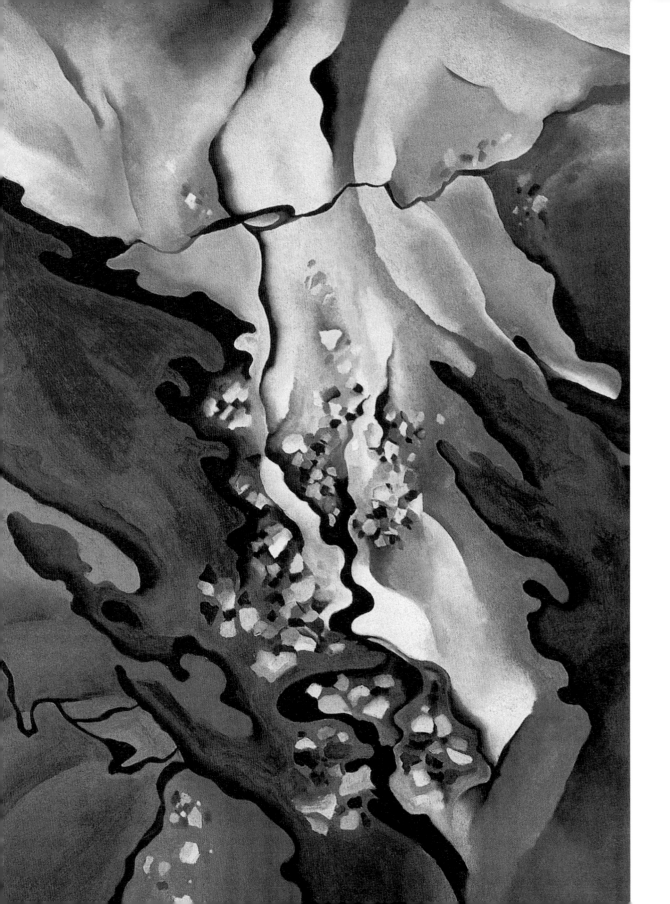

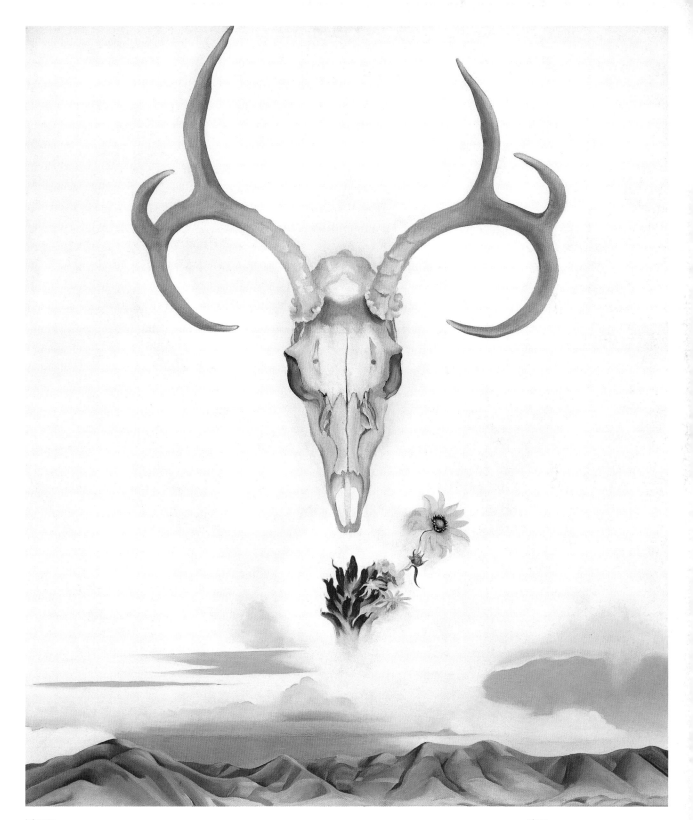

left page:
From the Lake, No. 3, 1924, oil on canvas,
91.4 x 76.2 cm, Philadelphia Museum of
Art, Bequest of Georgia O'Keeffe for the
Alfred Stieglitz Collection

above:
Summer Days, 1936, oil on canvas,
36 x 30 cm, Whitney Museum
of American Art, New York,
Gift of Calvin Klein

1887–1889 Construction of the
Eiffel Tower in Paris

1910 Manifesto of Futurism in Italy
1914–1918 World War I
1905 b. Great Garbo, Swedish actress

IMPRESSIONISM 1860–1910

1860–1910 IMPRESSIONISM CUBISM 1910–1920 EXPRESSIONISM

1840 1845 1850 1855 1860 1865 1870 1875 1880 1885 1890 1895 1900 1905 1910 1915 1920 1925

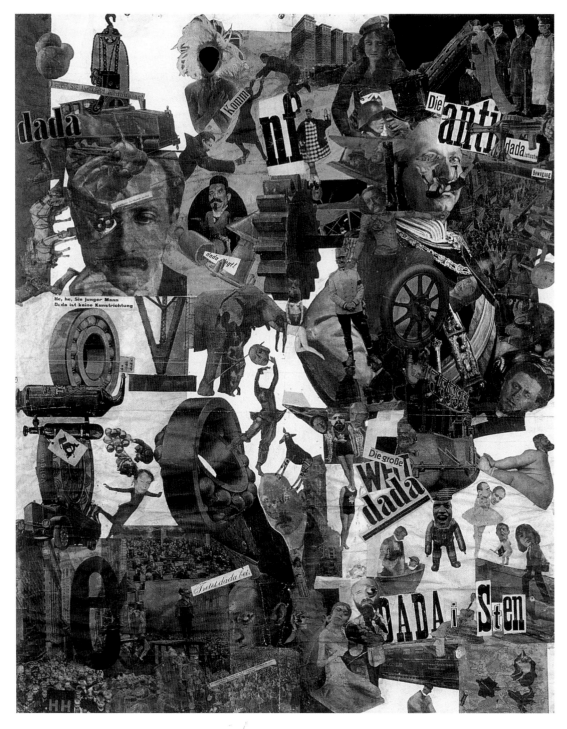

1931 *The Persistence of Memory*
 (Salvador Dalí)

 1939–1945 World War II

ABSTRACT EXPRESSIONISM 1940–1960 POP ART 1960–1975

1979 Margaret Thatcher becomes Prime
 Minister of the United Kingdom

1969 US moon landing **1986** Chernobyl disaster

 1990 Reunification of Germany

1930 1935 1940 1945 1950 1955 1960 1965 1970 1975 1980 1985 1990 1995 2000 2005 2010 2015

HANNAH HÖCH

Hannah Höch is famous above all for the photomontages she produced as a member of the circle of Berlin Dadaists. Her oeuvre shows a continuous search for new forms of expression and freedom of style. "I have done everything and never bothered about signature and characteristics." Hannah Höch

Hannah Höch studied at the Städtische Handwerks- und Kunstgewerbeschule (Municipal College of Applied Arts) in Berlin-Charlottenburg and later, after an interruption caused by the outbreak of World War I, at the Staatliche Lehranstalt des Kunstgewerbe- museums (State College of the Museum of Applied Arts) in Berlin.

"Dada triumphant!"

During her time as a student she met Raoul Hausmann. When he later founded the Berlin Dada movement in 1917, Hannah Höch was the only woman among the Dadaists: Richard Hülsenbeck, Johannes Baader, George Grosz, John Heartfield, and Wieland Herzfelde. Together with Hausmann, her companion, lover, and colleague, she developed photomontage as an independent art form. Höch used this "new and fantastic area for the creative man" to rebel against the conventions of art and society, and to criticize in ironic-sarcastic manner the political conditions of the post-war era. Many works would outlive the action- ism of the Dada group, such as *Schnitt mit dem Küchen- messer DADA durch die letzte Weimarer Bierbauchkultur- epoche Deutschlands* (Cut with the Kitchen Knife DADA through Germany's Last Weimar Beer Belly Culture Era), which was Höch's contribution to the First International Dada Fair in 1920 in Berlin. The critical reflection of the social and socio-political situation of women was a central theme of her work that she referred to here with a map showing in which coun- tries women's suffrage had already been introduced.

After Dada

With the disintegration of Dada, and her separation from Hausmann in the early 1920s, there followed years of intensive cooperation with the international avant-garde, including Theo and Nelly van Doesburg, as well as Piet Mondrian and the De Stijl group. Throughout her life, photomontage and col- lage remained important design elements for Höch. After the Nazis came to power, and she was banned from exhibiting her works in Germany, she withdrew to a little house in Heiligensee on the outskirts of Berlin, where she was able to save many of her own works and those of artist friends. After the end of the war and long years of isolation, she was one of the first to take an active part in the revival of art in Germany. In addition to collages and photomontages she also produced a large number of paintings dis- playing a wide range of drawing and stylistic features. In her late works, too, she also investigated new artistic trends and integrated them, ironically alienat- ed, into her work. The art of Hannah Höch was only rediscovered at a late stage in the re-assessment of Dada. In the 1970s, retrospectives in Berlin, Kyoto, Paris, and London acknowledged the artist's complete output. She died in 1978 in Berlin.

1889 Born Johanna Höch 1 November in Gotha, Germany.
1912 Moves to Berlin, and begins her studies at the Berlin- Charlottenburg College of Applied Arts.
1915 Continues her studies at the Berlin College of the Museum of Applied Arts. Meets Raoul Hausmann.
1919 Takes part in the first Berlin Dada Exhibition.
1920 Takes part in the first International Dada Fair.
1929 Spends three years in The Hague, Holland.
1938 Marries Kurt Matthies.
1978 Dies 31 May in Berlin.

FURTHER READING:
Maud Lavin, *Cut with the Kitchen Knife: The Weimar Photomontages of Hannah Höch*, Yale University Press, New Haven, 1993
Louise R. Noun and others, *Three Berlin Artists of the Weimar Era: Hannah Höch, Käthe Kollwitz, Jeanne Mammen*, Des Moines Art Center, Des Moines, IA, 1994.

left page:
Cut with the Kitchen Knife DADA through Germany's Last Weimar Beer Belly Culture Era, 1919–1920, Photomontage, 114 x 90 cm, Neue Nationalgalerie, Berlin

above:
Hannah Höch, undated

TAMARA DE LEMPICKA

PABLO PICASSO

SALVADOR DALÍ

1914–1918 World War I

1886 First cars with internal combustion engine

1919 Rosa Luxemburg assassinated
in Berlin

IMPRESSIONISM 1860–1910 1860–1910 IMPRESSIONISM CUBISM 1910–1920 EXPRESSIONISM 1920–1940

| 1850 | 1855 | 1860 | 1865 | 1870 | 1875 | 1880 | 1885 | 1890 | 1895 | 1900 | 1905 | 1910 | 1915 | 1920 | 1925 | 1930 | 1935 |

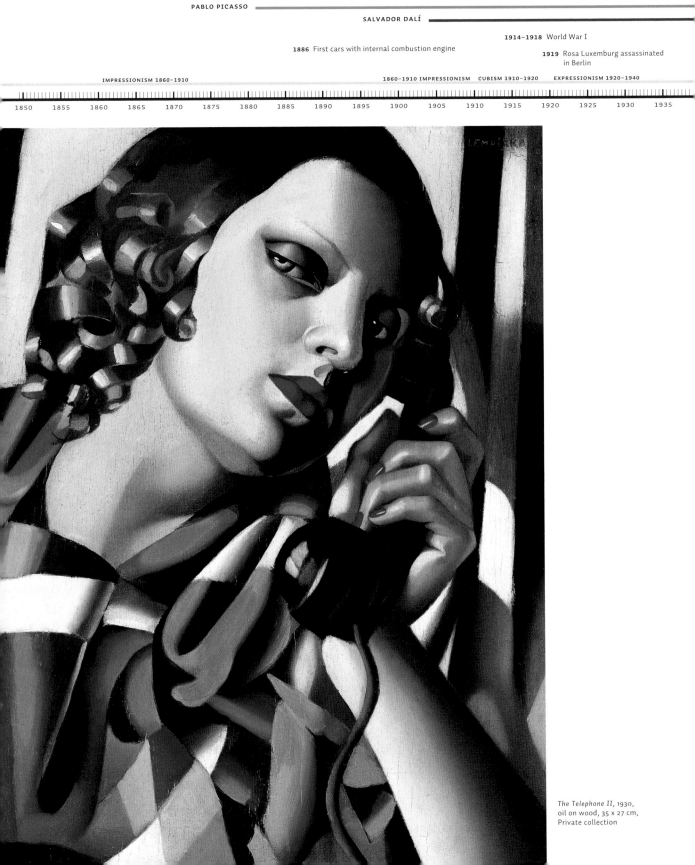

The Telephone II, 1930,
oil on wood, 35 x 27 cm,
Private collection

932 b. Dian Fossey, American zoologist and
 behavioral scientist
1939–1945 World War II
 1945 Atom bombs dropped on Hiroshima and Nagasaki
 ABSTRACT EXPRESSIONISM 1940–1960 POP ART 1960–1975

1960 John F. Kennedy becomes President of the United States
 1964 The United States enters the Vietnam War
 1969 Woodstock music festival
 1981 First flight by Columbia space shuttle

1995 Christo and Jeanne-Claude
 wrap the Reichstag in Berlin

1940 1945 1950 1955 1960 1965 1970 1975 1980 1985 1990 1995 2000 2005 2010 2015 2020 2025

TAMARA DE LEMPICKA

In painting, Art Deco was a style most eloquently expounded by a female artist—Tamara de Lempicka.
Her paintings captured the glamour and decadence of 1920s Paris with great verve.

Tamara de Lempicka was born Tamara Maria Gorska in Warsaw in 1898. After the Russian Revolution, she and her husband, Tadeusz Lempicki, emigrated from St. Petersburg to Paris. There, she continued her art studies with influential teachers such as Maurice Denis at the Académie Ranson and at the studio of the Cubist painter André Lhote.

A Cool Gaze

In the 1920s and 1930s, Lempicka was one of the most sought-after painters of the day. She did nudes and portraits of the American and European elite in a style that made her both famous and commercially successful. She exhibited in the major salons from 1923, and from the early 1930s American museums started buying her work. Tamara de Lempicka put herself across as a glamorous art celebrity, led a smart life, and had numerous affairs with both men and women. A self-portrait from 1925 shows her at the wheel of a Bugatti, with her sporting leather gauntlets, a scarf casually draped around her neck, a racing driver's helmet, scarlet lips, and an ice-cool gaze.

Seductive Aloofness

Going beyond the official avant-garde, her pictures display neo-classical coloration and a manner that embraced the stylistic innovations of Cubism. She is an excellent example of the Art Deco style that prevailed in Paris around 1925, following the famous international exhibition of *Arts Décoratifs et Industriels Modernes* that year.

Among the portraits painted around the same time is the one of the Duchesse de la Salle. As in most of her pictures, the figure is clearly outlined, while the background is rendered in abstract Cubist fashion. The enamel-like gloss of her colors is very forceful. The full-length portrait of the Duchess (whose name and title were made up) shows her in riding dress and with a decidedly self-confident, indeed dominant pose that Lempicka invented for the new image of

emancipated woman. Yet for all the cool aloofness, there is a muted but distinct sensuality and eroticism. Even before World War II broke out, Tamara de Lempicka and her second husband, Baron Raoul Kuffner, emigrated to America and settled in Beverly Hills. She took up new subject matter, trying her hand at abstracts among other things, but she could not recapture her earlier success. She spent her final years in the little town of Cuernavaca in Mexico, where she died in 1980.

1898 Born Tamara Maria Gorska
 16 May in Warsaw, Poland.
1914 Moves to her aunt's in
 St. Petersburg, Russia.
1916 Marries Tadeusz Lempicki.
1918 Flees to Paris following the
 Russian Revolution. Takes
 painting lessons.
1920 Daughter Kizette born.
1925 First solo exhibition in Milan,
 establishes a reputation as a
 portraitist of smart society.
1928 Divorces Tadeusz Lempicki.
1933 Marries Baron Raoul Kuffner.
1939 Settles in the USA, but fails to
 repeat her success as a painter.
1980 Dies 18 March in Cuernavaca,
 Mexico.

FURTHER READING:
Laura Claridge, *Tamara de Lempicka:
A Life of Deco and Decadence*, Clarkson
Potter, New York, 1999
Stefanie Penck, *Tamara de Lempicka*,
Prestel, Munich and London, 2004

Tamara de Lempicka, c. 1927

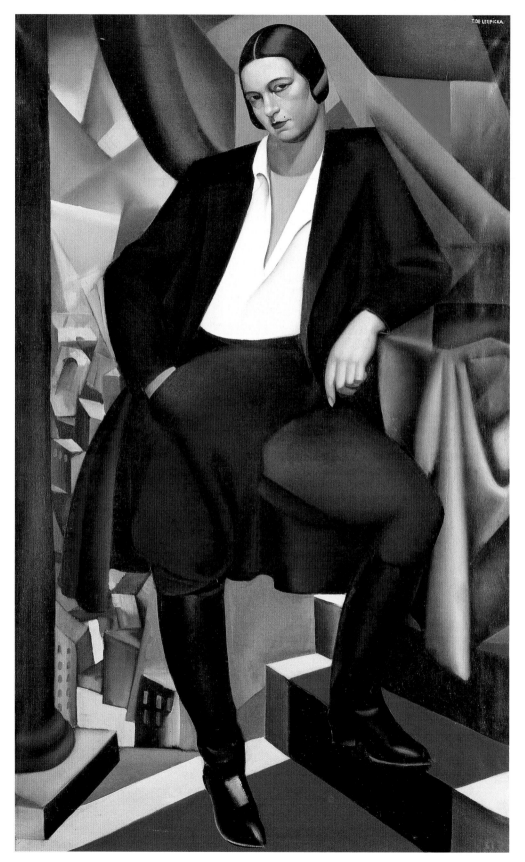

right:
Portrait of the Duchess de la Salle,
1925, oil on canvas, 162 x 97 cm,
Private collection

right page:
Auto-Portrait (Tamara in the Green Bugatti), 1929, oil on wood, 35 x 26 cm,
Private collection

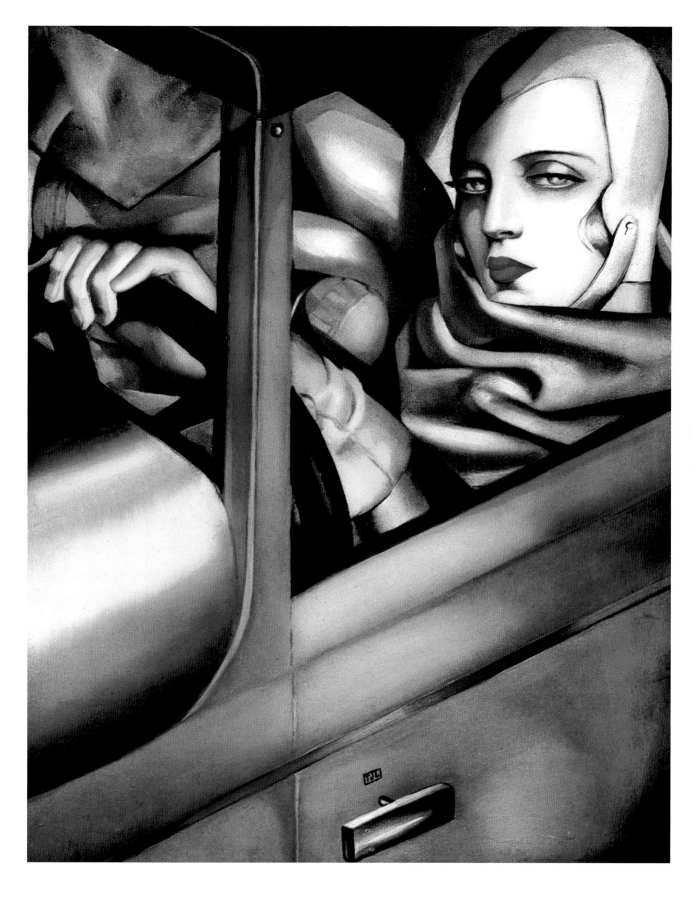

PABLO PICASSO

FRIDA KAHLO

JACKSON POLLOCK

1914–1918 World War I

1906 b. Hannah Arendt,
German-American
philosopher

1918 b. Leonard Bernstein,
American composer
1918 *My Ántonia* (Willa Cather)

IMPRESSIONISM 1860–1910 1860–1910 IMPRESSIONISM CUBISM 1910–1920 EXPRESSIONISM 1920–1940

| 1850 | 1855 | 1860 | 1865 | 1870 | 1875 | 1880 | 1885 | 1890 | 1895 | 1900 | 1905 | 1910 | 1915 | 1920 | 1925 | 1930 | 1935 |

The Two Fridas, 1939, Oil on canvas,
173,5 x 173 cm, Museo de Arte Moderno,
Mexico City

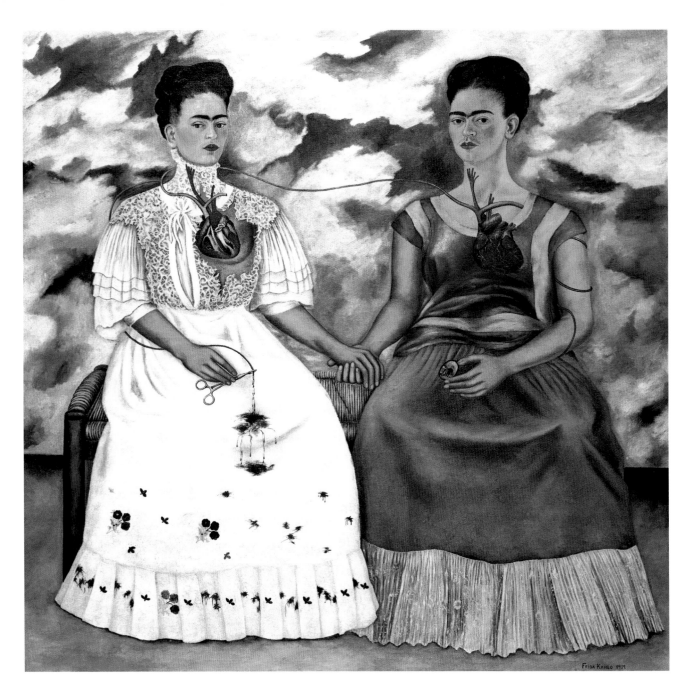

1937 *Guernica* (Pablo Picasso)

1939–1945 World War II

ABSTRACT EXPRESSIONISM 1940–1960

1962 Cuba crisis

1964 The United States enters
the Vietnam War

POP ART 1960–1975

1986 Chernobyl disaster

1990 Reunification of Germany

2001 9/11 attacks on United States

1940 1945 1950 1955 1960 1965 1970 1975 1980 1985 1990 1995 2000 2005 2010 2015 2020 2025

FRIDA KAHLO

"I was considered a Surrealist. That's not right. I've never painted dreams. What I showed was my reality."
Frida Kahlo

The transition from unknown Mexican artist to Frida Kahlo the cult figure began as much as anything out of interest in her tragic life story. Born in Coyoacán, a suburb of Mexico City, in 1907, she had a serious road accident when she was 18. During a collision between a school bus and a tram, an iron grab pole pierced her pelvis. All her life she had to contend with the consequences of her injuries, undergoing countless operations and often being confined to bed for months. In 1929, she married Diego Rivera, one of the best-known painters in post-revolutionary Mexico, who was her great love. It was a difficult marriage, during which they divorced and then remarried. Both of them had extra-marital affairs, but they hit Frida hard, particularly when Rivera had an affair with her young sister.

Life in Pictures

Originally, she had wanted to study medicine. She began to draw and paint while she was in hospital recovering from her accident. Her oeuvre consists of nearly 200 works, usually in small formats, a good one-third of them being self-portraits. *The Broken Column* (1944) shows her in a steel corset with a spine in the form of a fractured column. Her tragic attempts to have children, despite her doctors' prohibition, became the subject of pictures such as the oil painting of *My Doll and I* (1937) and the lithograph of *Frida and the Miscarriage* (1932).

Because of the graphic images of her physical and mental suffering, Frida Kahlo is often seen as the pathetic and self-absorbed "Painter of Sorrows." However, the pictures do have an element over and above the personal suffering. They also constitute allegorical depictions of gender roles and socio-political views. *A Few Little Pricks* (1935) shows a man who has killed his unfaithful wife, firmly believing himself to be in the right.

Her most productive source of inspiration was Mexican folk art. For example, she cites religious votive panels—small images painted on sheet zinc that were hung on church walls. André Breton described her as a Surrealist, but it was a label she never accepted. It was, she stressed, not dreams but always her own reality that she painted. Her first successful solo show was in New York in 1938; the next was in Paris, where the Louvre bought a picture in 1939. It was only in 1953 that she had a solo show in her homeland, and she had to be taken to it in her sick bed. In 1954 she caught pneumonia, from which she never recovered, dying at the age of only 47.

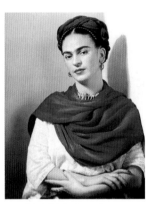

1907 Born 6 July in Coyoacán, near Mexico City.
1925 She is severely injured in a bus accident, and spends the rest of her life dominated by the effects of her injuries. She begins to paint while in hospital.
1929 Marries painter Diego Rivera.
1930 Accompanies Rivera on his lengthy working trips to the USA.
1932 Hospitalized in Detroit after a miscarriage.
1937 Meets Trotsky and has a brief affair with him.
1939 Divorces and then remarries Rivera (1940) in San Francisco.
1953 First solo show of her works in Mexico City.
1954 Dies 13 July in Coyoacán.

FURTHER READING:
Hayden Herrera, *Frida: A Biography of Frida Kahlo*, Perennial, New York, 2002
Carole Maso, *Beauty is Convulsive: The Passion of Frida Kahlo*, Counterpoint, Washington, DC, 2002
Claudia Bauer, *Frida Kahlo*, Prestel, Munich and New York, 2007

Nickolas Muray, Frida Kahlo, 1938/39

below:
Frida and the Miscarriage or *The Miscarriage*,
1932, lithograph, 32 x 23.5 cm, Museum
Dolores Olmedo Patiño, Mexico City

right page:
The Broken Column, 1944, oil on canvas,
mounted on fiberboard, 40 x 30.7 cm,
Museum Dolores Olmedo Patiño, Mexico City

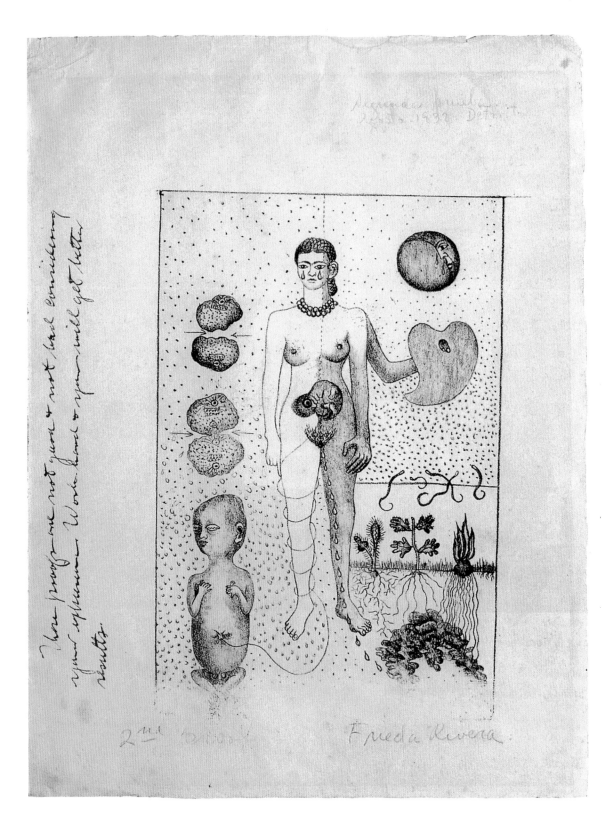

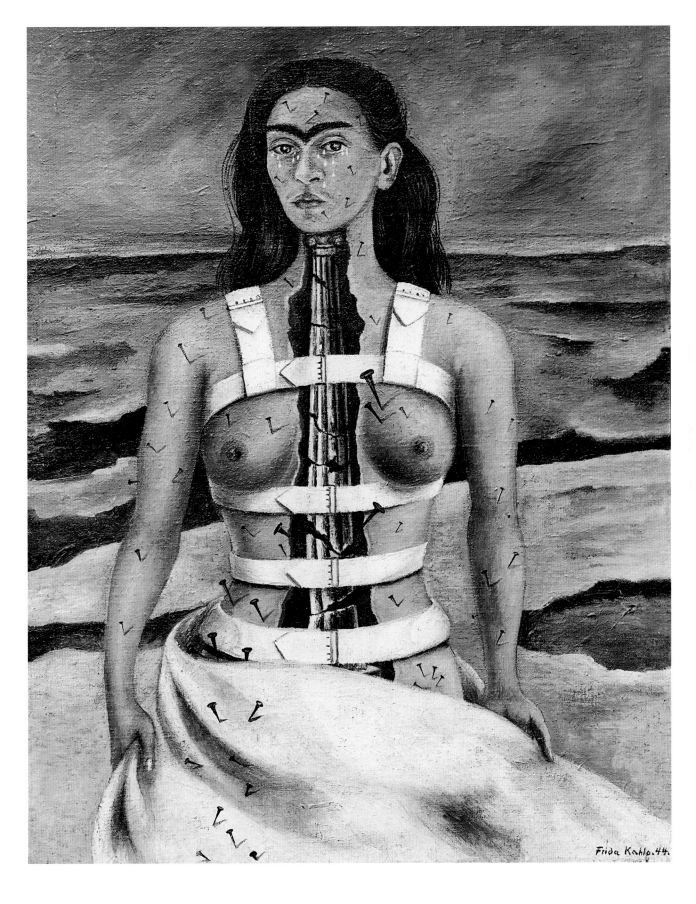

LEE KRASNER

PABLO PICASSO

ANDY WARHOL

1914–1918 World War I

1929 Wall Street Crash
in New York

1926 b. Ingeborg Bachmann,
Austrian writer

1939–1945 World
War II

IMPRESSIONISM 1860–1910

1860–1910 IMPRESSIONISM CUBISM 1910–1920 EXPRESSIONISM 1920–1940

| 1860 | 1865 | 1870 | 1875 | 1880 | 1885 | 1890 | 1895 | 1900 | 1905 | 1910 | 1915 | 1920 | 1925 | 1930 | 1935 | 1940 | 1945 |

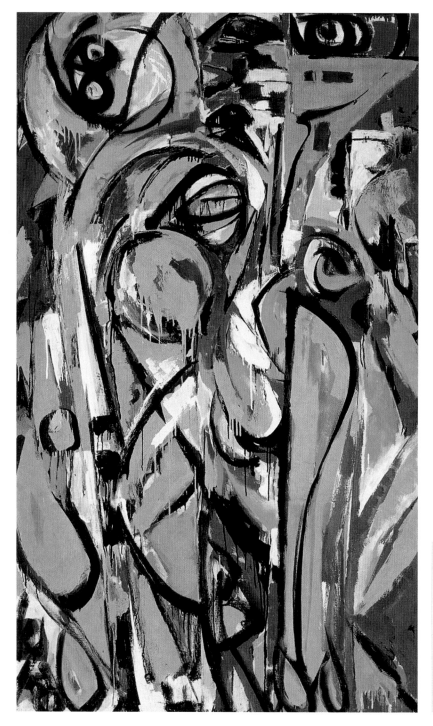

Birth, 1956, oil on canvas,
209.6 x 121.9 cm, Private collection

Abstract Expressionism
During World War II, many American artists
were looking for a new approach to painting.
They wanted to create paintings as images not
of the real world but of an expressive and
autonomous world of their own. The forerun-
ners of this kind of thinking were the European
Expressionists, principally Wassily Kandinsky,
who was the first to take the road to abstrac-
tion. The chief representatives of Abstract
Expressionism were Jackson Pollock, Willem de
Kooning, Franz Kline, and Robert Motherwell.

1980 Ronald Reagan becomes President
of the United States
1961 Construction of the Berlin Wall 2003 The United States invades Iraq
1972 Munich massacre (attack on Israeli 1991 Aung San Suu Kyi awarded
team at the Olympic Games) Nobel Peace Prize
1973 First oil crisis 1990 Reunification of Germany

ACT EXPRESSIONISM 1940–1960 POP ART 1960–1975

1950 1955 1960 1965 1970 1975 1980 1985 1990 1995 2000 2005 2010 2015 2020 2025 2030 2035

LEE KRASNER

Lee Krasner was one of the most important representatives of Abstract Expressionism in New York. But while her colleagues established their own individual style, Krasner never stopped repositioning her work..

Lena Krassner was born in 1908 in the New York district of Brooklyn as the daughter of Orthodox Jewish parents from Odessa. She later changed her given name to Lee Krasner. Between 1926 and 1933 she studied in New York, at the Washington Irvine High School, the Women's Art School at the Cooper Union, at the New York City College, and elsewhere. During her work as a mural painting assistant in the Federal Art Project between 1935 and 1943—a government program designed to support unemployed artists—she attended another course at the School of Fine Arts under the artist Hans Hofmann, who introduced her to the international avant-garde and abstract art.

The Legend of the "Action Widow"

From 1941, Krasner regularly participated in exhibitions by the Association of American Abstract Artists. In the same year she met the up-and-coming artist Jackson Pollock, whom she married four years later. During their marriage, she neglected her own artistic work, though she never regarded herself as inferior or dependent on Pollock. "I personally was not dominated by Pollock," said Krasner, "but the entire art world was." To this day she still bears the title of "Action Widow," which was coined in 1972 by the art critic B.H. Friedman in 1972. He accused the female surviving dependants of Abstract Expressionist artists of displaying an artistic dependence on their partners' works. The works of Pollock and Krasner reveal that they were influenced by each other, with her thoughtful, far-sighted criticism of Pollock's action paintings being of great importance.

Controlled Chaos

When Pollock found himself in a creative crisis in the early 1950s and started drinking heavily, Lee Krasner found a way of escaping the problems in their relationship by putting more energy into her work as an artist, and she became progressively more successful. Following her "black-out period" in the 1940s, when she painted several layers of paint on top of each other, in 1951 Krasner created her own principle for the amalgamation of collage and painting. She cut up works which she had previously created and used parts of them for her new works.

In 1956, Jackson Pollock was killed in an automobile accident. During the same year, Krasner began her first large-format painting, *Birth*, in the series *Earth Green*, in which she takes as her subject the forces of nature. These pictures appear to be almost the exact opposite of her more controlled, small-format *Little Image* series of 1946 to 1949. After her mother's death in 1959, and an operation on an aneurysm on her cerebral artery in 1962, inner unrest became once again the driving force behind her art. She created a number of principal works such as *Gate* (1959) and *Gaea* (1966), which are considered to be among the most important works of Abstract Expressionism. Lee Krasner died in 1984, one year after a number of major retrospectives to mark her 75th birthday, including one in the Museum of Modern Art in New York.

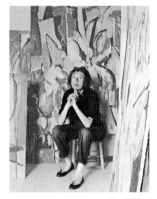

1908 Born Lena Krassner in New York.
1926 Begins her training at the Women's Art School of the Cooper Union, later going on to the Art Students League and National Academy of Design. Pupil of Hans Hofmann, among others.
1941 Meets Jackson Pollock.
1945 Lee Krasner and Jackson Pollock marry and move to Long Island.
1956 Jackson Pollock dies in a road accident.
1984 Dies 19 June in New York.

FURTHER READING:
Robert Hobbs, *Lee Krasner*, Abbeville Press, New York, 1993

left:
Abstract No. 2 (Little Images), 1946–1948, oil on canvas, 52 x59 cm, Instituto Valenciano de Arte Moderna Generalitat Valenciana (IVAM Centre)

above:
Photograph of Lee Krasner, two weeks after Jackson Pollock's death, 30 August 1956

LOUISE BOURGEOIS ▬▬▬▬▬

JOSEPH BEUYS ▬▬▬▬▬

DAVID HOCKNEY ▬▬▬

1939–1945 World War II
1942 *L'Étranger* (Albert Car

1914–1918 World War I

1907 b. Astrid Lindgren, Swedish writer

IMPRESSIONISM 1860–1910 1860–1910 IMPRESSIONISM CUBISM 1910–1920 EXPRESSIONISM 1920–1940

1860 1865 1870 1875 1880 1885 1890 1895 1900 1905 1910 1915 1920 1925 1930 1935 1940 1945

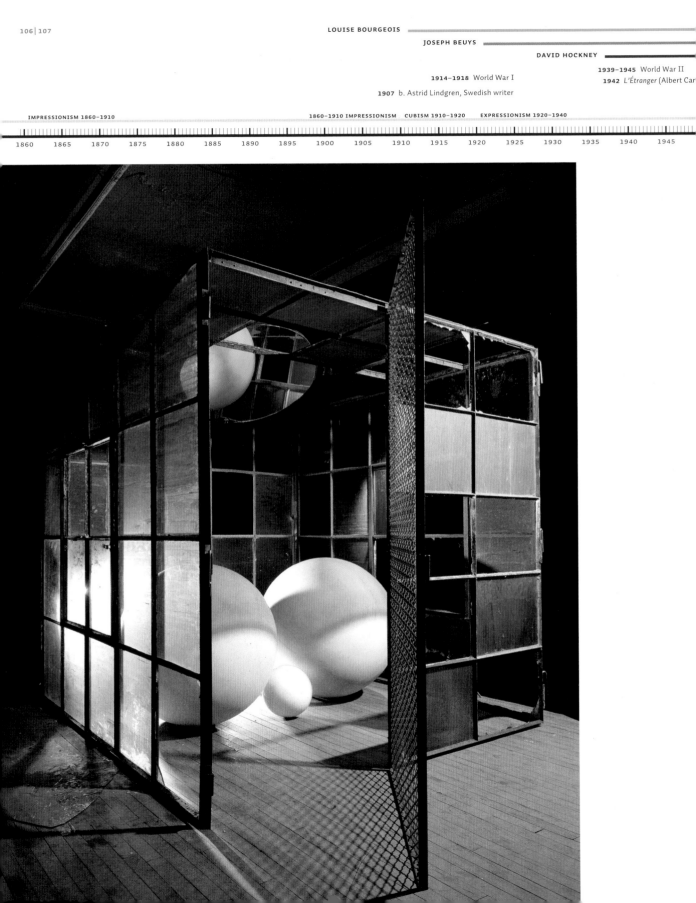

1969 Woodstock music festival

1952 Elvis Presley rises to fame **1986** Chernobyl disaster

1962 Cuba crisis **1973** Watergate Affair **2001** 9/11 attacks on United States

2004 Tsunami flood catastrophe in Asia

ACT EXPRESSIONISM 1940–1960 POP ART 1960–1975

1950 1955 1960 1965 1970 1975 1980 1985 1990 1995 2000 2005 2010 2015 2020 2025 2030 2035

LOUISE BOURGEOIS

"My name is Louise Josephine Bourgeois. I was born 24 December 1911, in Paris. All my work in the past fifty years, all my subjects, have found their inspiration in my childhood. My childhood has never lost its magic, it has never lost its mystery, and it has never lost its drama." Louise Bourgeois, 1994

To this day, Louise Bourgeois, now in her 90s, still bases her artistic output on her own life, with the emphasis being on the shaping of memory, and on drawing on events in her turbulent past. It is her conviction that only those who work autobiographically, focusing on their own person and feelings, who can really be universal and universally understood.

Louise Bourgeois studied mathematics before enrolling at various art colleges, initially in Paris, then (after her marriage to American art historian Robert Goldwater) in New York, at the Art Students League. She worked as a painter, but later took up sculpture. A common theme in her early pictures was *Femmes Maison*—women's bodies whose heads are shut up in a house, a metaphor for the social position of women and their confinement in domestic matters.

Playing with Ambiguity

In her sculptural work, Bourgeois has tried out a wide range of materials. Her early figures were stele-like figures of wood. In the 1960s, she was among the first artists to experiment with amorphous materials such as latex and synthetic resin. The result was women, hybrids, and goddesses modeled on ancient fertility idols. She handled sexual themes and taboos with unusual directness for the time. The mischievous irony with which Bourgeois created her works is evident in a famous photograph by Robert Mapplethorpe, showing her roguishly clutching her phallus-like *Fillette* (1968) under one arm, an impish smile about her lips. As always, there is at the same time a female look about the object.

Emotional Abstraction

One of Bourgeois's best-known works, which dates from 1974, settles scores with her own father, who cheated on his wife for years with the daughter's governess. Called *Destruction of the Father*, it is a room installation like a cave, where only bones are visible. From 1994, her memories of her mother are explored in variations on the theme of a spider; a giant example made of steel, *Maman*, was on show in London at the opening of the Tate Modern in 2000. In the extensive group of works called *Cells* begun mid-1980s, cage-like installations with mysterious furnishings tell of inner realities. Even when the statements Bourgeois makes sound simple, her works are never easy to interpret. That in no way diminishes the fascination of the works of the *grande dame* of contemporary art, who, though well over 90, is still creatively at work.

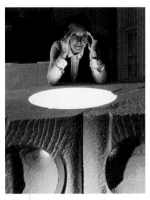

1911 Born 25 December in Paris.
1932 Starts as a student of mathematics in Paris, but switches to art at the École du Louvre, then to the École des Beaux-Arts and the Académie de la Grand Chaumière.
1938 Marries Robert Goldwater and moves to New York, where she studies at the Art Students League. Meets Surrealist artists such as Breton and Ernst.
1945 Has her first solo exhibition.
1973 Robert Goldwater dies.
1977 She is awarded an honorary doctorate by Yale University.
1982 Major retrospective at Museum of Modern Art, New York.
1993 Represents the USA at the Venice Biennale.

Louise Bourgeois lives and works in New York.

FURTHER READING:
Scott Lyon-Wall, *Louise Bourgeois: the Reticent Child*, Cheim and Reed, New York, 2004

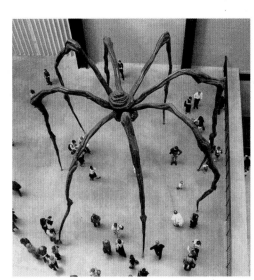

above:
Louise Bourgeois in her studio, 1988

following double page:
Deconstruction of the Father, 1974, plaster, latex, wood, fabric and red light, 237.8 x 362.3 x 248.6 cm, Artist's private collection

left page:
Cell (Three White Marble Spheres), 1993, steel, glass, marble, mirror, 213.3 x 213.3 x 213.3 cm, Saint Louis Art Museum, Missouri

right:
Maman, 1999, steel and marble, 9.27 x 8.92 x 10.24 m, Tate Modern, London, 2000

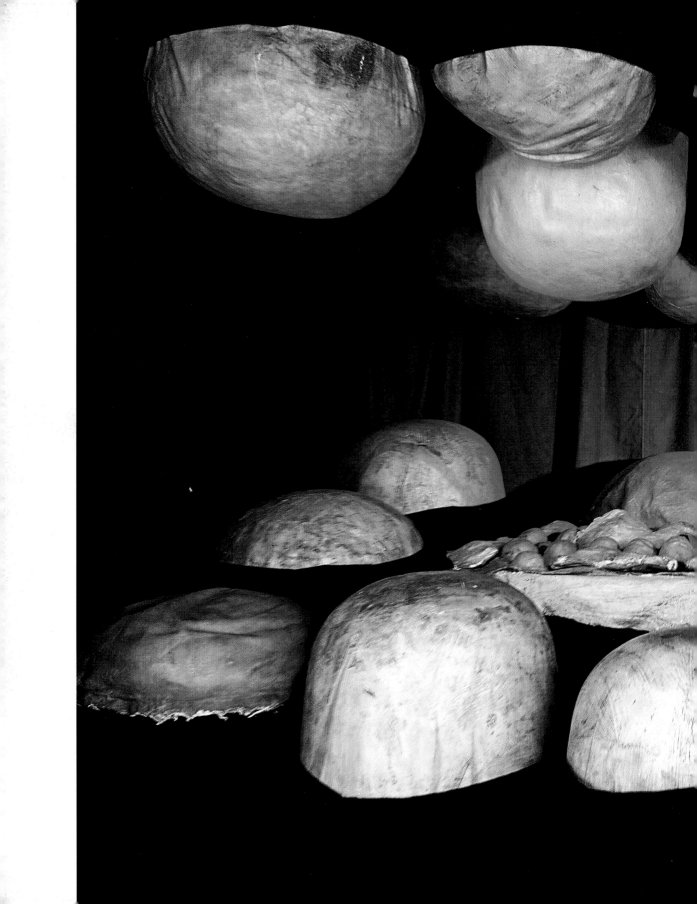

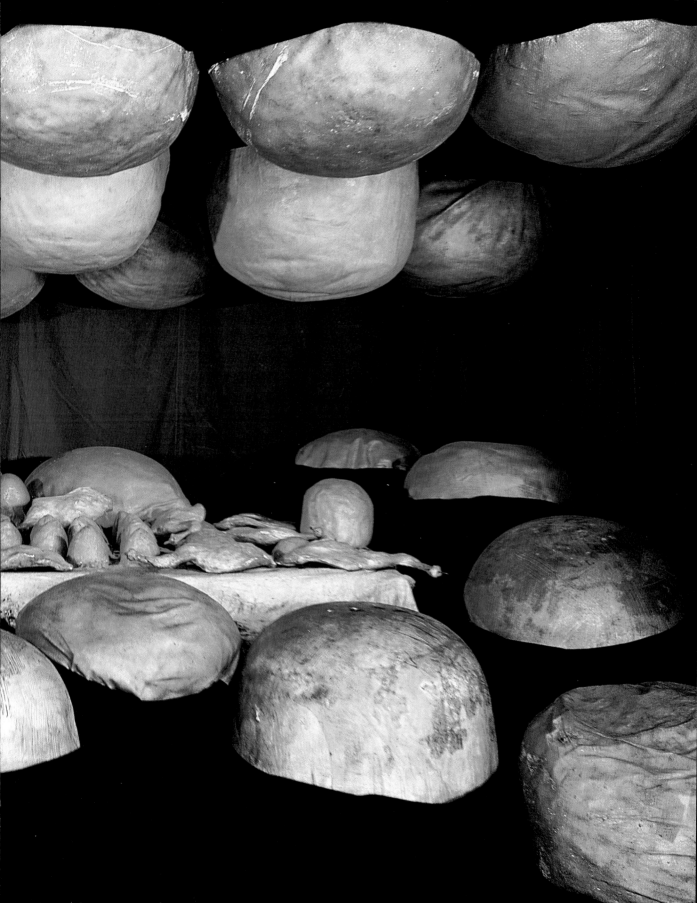

1914–1918 World War I

1917 b. Ella Fitzgerald, American
jazz singer

1939-1945 World War II

1945 b. Jacqueline du Pré,
English cellist

1860–1910 IMPRESSIONISM CUBISM 1910–1920 EXPRESSIONISM 1920–1940 ABSTRACT EXPRESSIONISM

1865 1870 1875 1880 1885 1890 1895 1900 1905 1910 1915 1920 1925 1930 1935 1940 1945 1950

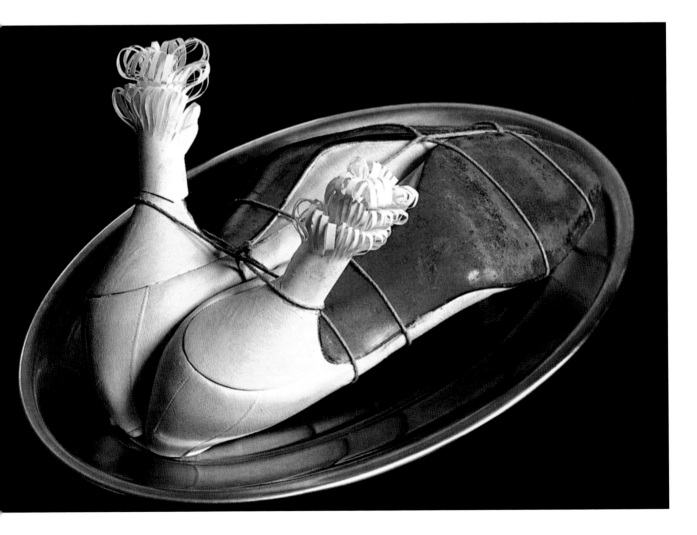

*Ma gouvernante – my nurse – Mein
Kindermädchen*, 1936, metal, leather
and paper, 14 x 21 x 33 cm, Moderna
Museet, Stockholm

52 Elvis Presley
rises to fame

1958 *Memoirs of a Dutiful Daughter*
(Simone de Beauvoir)

1964 The United States enters the Vietnam War

1969 Woodstock music festival

1973 Watergate Affair

POP ART 1960–1975

1986 Challenger space shuttle explodes after takeoff

2001 9/11 attacks on United States

2004 Tsunami flood catastrophe in Asia

1955 1960 1965 1970 1975 1980 1985 1990 1995 2000 2005 2010 2015 2020 2025 2030 2035 2040

MERET OPPENHEIM

"Who covers the soup spoon with precious fur? Little Meret. Who has outstripped us? Little Meret."
Max Ernst describing Meret Oppenheim on an invitation to the first exhibition of her art in 1936

Meret Oppenheim was born in 1913 in Berlin-Charlottenburg. Her mother was Swiss, and her father a German Jewish doctor. In 1932 she briefly attended several art schools in Paris, but mostly worked independently.

Breakfast in Fur

Shortly after her 23rd birthday, she achieved a sensational success with *Object*, a cup, saucer, and spoon covered in the skin of a gazelle. It was purchased in the year of its creation by the Museum of Modern Art in New York. The object rapidly became one of the most-quoted and most-portrayed works of the Surrealist movement. Also *Ma gouvernante – my nurse – Mein Kindermädchen* was created during this period: a pair of women's high-heeled shoes, tied together and draped with paper collars and presented on a silver tray.

Meret Oppenheim moved in Surrealist circles alongside André Breton, Marcel Duchamp, and Max Ernst, with whom she regularly exhibited her works. She was regarded as the muse of the male artists, who were considerably older than she was, a reputation which was strengthened by the photograph *Veiled Erotic* taken by Man Ray in 1933.

In 1937, Oppenheim returned to Basel. After the wide public recognition in Paris, which rapidly reduced the young artist's oeuvre to a single work, she plunged into a deep artistic crisis that accompanied her until the 1950s. During those years she produced only a small number of drawings, and both naturalistic and abstract paintings. Oppenheim either failed to finish many of her works or even destroyed them.

"You will not be granted liberty. You must grasp it for yourself."

A new creative beginning did not occur until 1954, with the creation of poems, drawings, collages and objects that also sometimes harked back to sketches and ideas from her time in Paris. She experimented with techniques and materials without committing herself to any one single style.

In 1959, Oppenheim worked one last time with the Surrealists when they invited her to repeat her *Spring Celebration*, which she had previously staged in private. It consisted of a banquet on the body of a naked woman. Oppenheim believed that her original intentions would be perverted by this creation of a voyeuristic performance for men.

At the end of the 1960s, the works of Meret Oppenheim were rediscovered. When she was awarded the Kunstpreis (Art Prize) of the City of Basel in 1975, she gave a highly regarded speech on the situation of the "female artist," and demanded that "the taboos with which women have been held for thousands of years in a state of subjugation should no longer be regarded as valid. You will not be granted liberty. You must grasp it for yourself." Meret Oppenheim died in Basel in 1985.

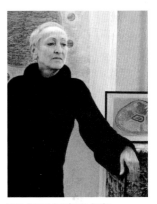

1913 Born 6 October in Berlin.
1932 Sporadically attends classes at the Académie de la Grand Chaumière in Paris, and joins the Paris Surrealists.
1936 The Museum of Modern Art in New York buys her fur-lined teacup.
1937 Moves to Basel, and attends arts and crafts college.
1949 Marries Wolfgang La Roche, moves to Berne.
1985 Dies 15 November in Basel.

FURTHER READING:
Thomas Levy (ed.) and others, *Meret Oppenheim: From Breakfast in Fur and Back Again*, Kerber, Bielefeld (Germany) and New York, 2003
Therese Bhattacharya-Stettler and Matthias Frehner (eds.) and others, *Meret Oppenheim: Retrospective: "an enormously tiny bit of a lot,"* Hatje Cantz, Ostfildern (Germany) and New York, 2007.

Meret Oppenheim, undated

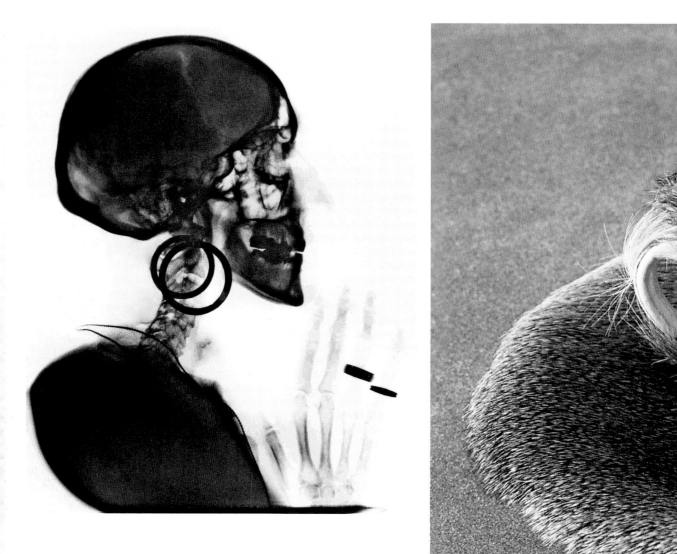

X-Ray, 1964, photograph, 25.3 x 20.5 cm

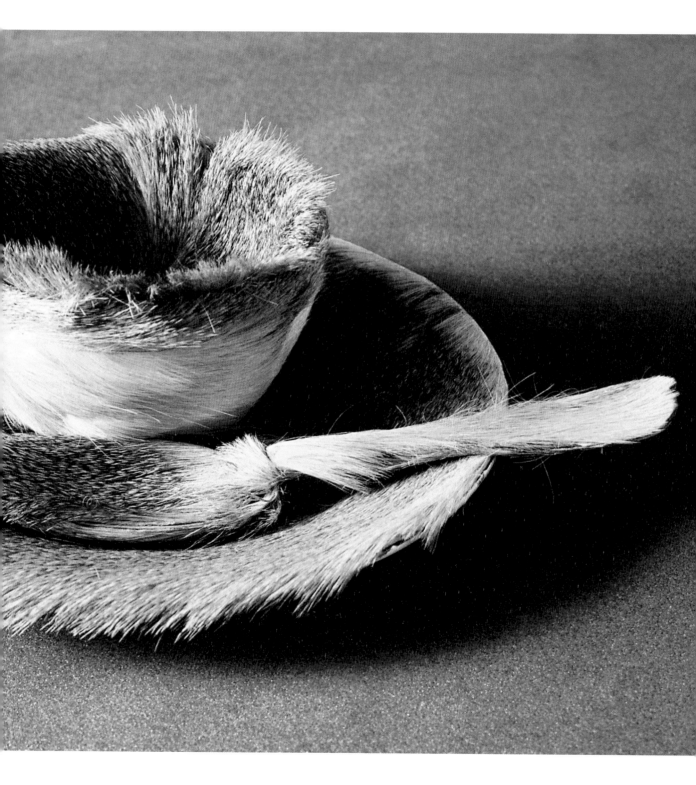

1906 b. Josephine Baker, French-American dancer,
singer, civil rights campaigner

1909 Hilde Domin, German writer

1910 Marie Curie isolates radium

1949 *The Second Sex*
(Simone de
Beauvoir)

1959 *The Tin Drum*
(Günter Grass)

1962 Cuba cris

1860–1910 IMPRESSIONISM CUBISM 1910–1920 EXPRESSIONISM 1920–1940 ABSTRACT EXPRESSIONISM 1940–1960 POP ART 1960–1975

1880 1885 1890 1895 1900 1905 1910 1915 1920 1925 1930 1935 1940 1945 1950 1955 1960 1965

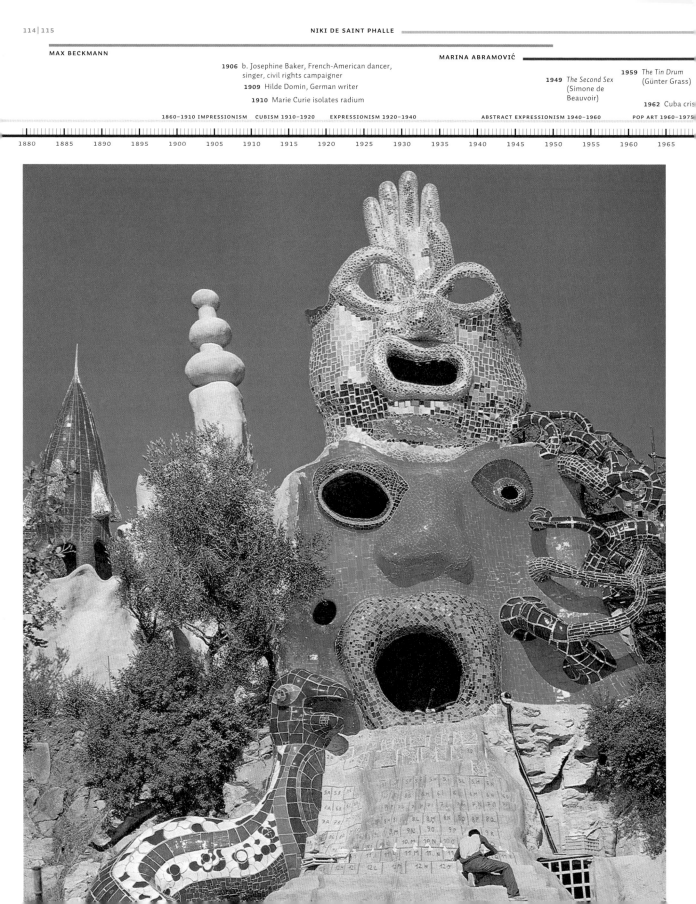

1968 Suppression of "Prague Spring" in Czechoslovakia
1968 Student unrest in Germany and various other European cities
1973 Watergate Affair
1980 Ronald Reagan becomes President of the United States

| 1970 | 1975 | 1980 | 1985 | 1990 | 1995 | 2000 | 2005 | 2010 | 2015 | 2020 | 2025 | 2030 | 2035 | 2040 | 2045 | 2050 | 2055 |

NIKI DE SAINT PHALLE

Niki de Saint Phalle started out as an action artist rebelling against set conventions before she found a highly individual style to express her ideas about being a woman in society—the "nana figures," embodiments of self-aware femininity and irrepressible joie de vivre.

In the early 1960s, a young artist in Paris caused a stir with her spectacular "shootings"—Niki de Saint Phalle, who had initially become known as a photographic model for *Vogue*, *Harper's Bazaar*, and other journals. After a serious nervous breakdown, she turned to full-time art, self-taught, which she found therapeutic.

Executing Art

For Saint Phalle, shooting with a pistol at modeled plaster reliefs was a release of her feelings and aggressions: "I fired at men, at society with its injustice, and at myself." She prepared the targets in advance with concealed bags of paint, which splattered color on the relief when they burst. The works of art thereby arising by chance she called *tirs* (shooting paintings). Among the targets was a Venus de Milo sculpture, a replica of the famous original. Shooting it was an attempt to free herself from the power of the classical sculptural tradition. Her shootings won her acceptance among the French Nouveaux Réalistes group of artists, who included Daniel Spoerri, Yves Klein, Jean Tinguely, and Christo.

Nana Power

The highly adaptable "nana" concept was in effect an alternative art to the shootings. The brightly colored, amply endowed polyester female figures are reminiscent of archaic fertility goddesses, and according to Saint Phalle were "harbingers of a new matriarchal age … I wanted these good, bounteous, happy mothers to take over the world." One of the first of these to establish her reputation was the outsize nana figure exhibited in 1966 at Moderna Museet in Stockholm. Twenty-eights meters (92 feet) long,

the architectural sculpture *Hon–en Katedral* (She–a Cathedral) welcomed visitors in through splayed legs into a kind of pleasure park inside the figure.

The Tarot Garden

In the early 1970s, she decided she would make a sculpture garden. It would include 22 monumental figures based on tarot card figures, and the artist's highly individual style would make the whole place a single work of art. In 1983, the first completed figure—the Empress, a sphinx in the center of the garden—became her home and studio for seven years while she worked there. Eventually, after decades of work, the Giardino dei Tarocchi in Garavicchio in Tuscany opened in May 1998. By then, Niki de Saint Phalle had already retreated to the milder climate of California, her lungs seriously damaged by working with polyesters. She died in 2002 of pulmonary emphysema.

1930 Born Catherine Marie-Agnès Fal de Saint Phalle 29 October in Neuilly-sur-Seine, Paris.
1933 The family moves to Greenwich, Connecticut.
1937 They move to New York City.
1950 She marries Harry Mathews.
1951 Daughter Laura born.
1952 They move to Paris. One year later Niki de Saint Phalle has a serious nervous breakdown. While convalescing, she begins to paint.
1955 Son Philip born.
1960 Meets Jean Tinguely.
1971 Marries Jean Tinguely.
1998 Tarot Garden in Garavicchio, Tuscany, opened. Moves to California.
2002 Dies 21 May in San Diego, California.

FURTHER READING:
Niki de Saint Phalle, *Traces: An Autobiography Remembering 1930–1949*, Acatos, Lausanne (Switzerland), 1999
Carla Schulz-Hoffmann (ed.) and others, *Niki de Saint Phalle: My Art, My Dreams*, Prestel, Munich and New York, 2003

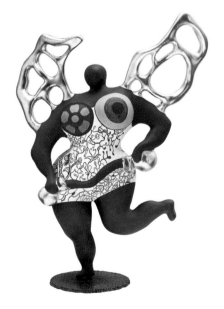

left page:
The Magician and the High Priestess in the Tarot Garden (Giardino dei Tarocchi), 1983, iron frame coated with cement and covered with a mosaic of mirrors, glass and colored ceramics, Tuscany

left:
Moderation, 1985, painted polyester, 72 x 53 x 23 cm, Sprengel-Museum, Hannover

above:
Niki de Saint Phalle, 1980

JOSEPH BEUYS ▬▬▬▬▬

JENNY HOLZER ▬▬▬▬▬

1902 b. Leni Riefenstahl, German film
director and photographer

1939–1945 World War II

1955 *Waiting for Godot*
(Samuel Beckett)

1860–1910 IMPRESSIONISM CUBISM 1910–1920 EXPRESSIONISM 1920–1940 ABSTRACT EXPRESSIONIS 1940–1960 POP ART 1960–197

| 1880 | 1885 | 1890 | 1895 | 1900 | 1905 | 1910 | 1915 | 1920 | 1925 | 1930 | 1935 | 1940 | 1945 | 1950 | 1955 | 1960 | 1965 |

Right After, 1969, fiberglass, polyester
resin, wire, 548.6 x 121.9 cm, three
sections, Milwaukee Art Museum,
Gift of Friends of Art, 1970

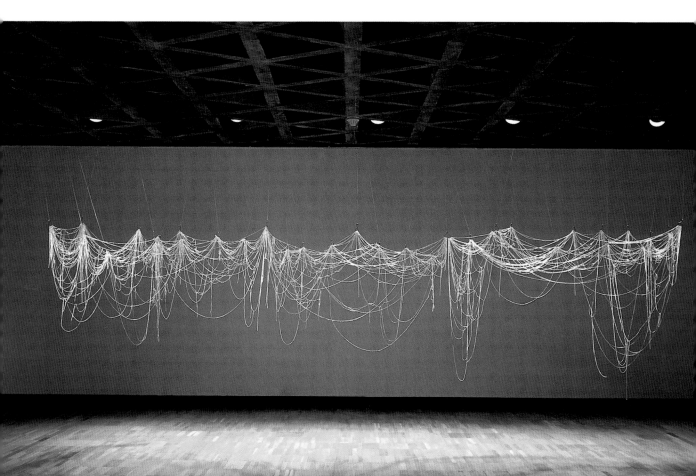

1986 Elie Wiesel awarded Nobel Peace Prize
1994 End of apartheid in South Africa
4 The United States enters
the Vietnam War
1980 Founding of the Solidarność
trade union in Poland
2001 9/11 attacks on United States
2004 Tsunami flood catastrophe in Asia

1970 1975 1980 1985 1990 1995 2000 2005 2010 2015 2020 2025 2030 2035 2040 2045 2050 2055

EVA HESSE

"I remember that I have always worked with contradictions and opposing forms, because they correspond with my idea of life. The entire absurdity of life. For me, life was always full of contradictions." Eva Hesse

In 1970, the cover of the magazine *Artforum* featured photograph of Eva Hesse's work *Contingent*, which had been created the year before. The most important mouthpiece of the avant-garde art scene in New York at the time thus made the artist famous overnight. One month later she died of a brain tumor at the age of 34.

Art or Life
The publication of Eva Hesse's diaries in the early 1970s focused public interest on her tragic life story while at the same time distorting the view of her artistic work. She was born in 1936 in Hamburg as the daughter of a Jewish lawyer; after the Nazis came to power, she was sent to the Netherlands by her parents on a "Kindertransport." In 1939, her family succeeded in emigrating to New York; those relatives who remained behind were killed in various concentration camps. Eva Hesse's mother committed suicide when Eva was ten years old.

A Period of Intense Creativity
After studying art in New York, within a decade Eva Hesse produced some 100 sculptures, more than 850 drawings and over 100 paintings—an oeuvre which occupies a central position in the development of international art during the 1960s. Hesse took up and reinterpreted the paradigms of the two trends that dominated the scene at the time: Minimal Art and Pop Art.
Her early works included self-portraits, gouaches, and collages. During a visit to Germany in 1964–1965 she worked on paintings and a first series of drawings— abstract Expressionist pictures that Hesse characterized as "wild space"—as well as three-dimensional reliefs. This period marks the transition to her later sculptural work that led to her artistic breakthrough as a sculptor. While emphasizing their intrinsic esthetic value she experimented with new materials such as fiberglass, latex, polyester, rubber, and resin.

Chaos and Order
Many of her works hover between painting and sculpture. In *Contingent*, Hesse used lengths of gauze fabric that had been strengthened with fiberglass and dipped in latex as if they were canvases on which, however, nothing has been painted. The materials appear organic and create a decidedly sensuous attraction. By creating a series with slight variations, the artist encouraged the observer to consider the aspect of infinite repetition, which she understood as the way to convey absurdity. In *Right After* (1969), cords which are invisibly fixed to hooks on the ceiling open up in a three-dimensional form that makes clear the narrow distinction between chaos and order. The work was created immediately after an operation on the tumor that caused her death the following year.

1936 Born 11 January in Hamburg, Germany.
1938 She and her sister are put on a children's train (Kindertransport) to Holland.
1939 The family escape to the USA, and settle in New York.
1946 Her mother kills herself.
1954 Starts at the Yale School of Art and Architecture (till 1959).
1961 Marries Tom Doyle.
1966 The couple divorce.
1970 Dies of a brain tumor on 22 May.

FURTHER READING:
Griselda Pollock and Vanessa Corby (eds.), *Encountering Eva Hesse*, Prestel, Munich and New York, 2006
Elisabeth Sussman, Fred Wasserman and others, *Eva Hesse: Sculpture*, Jewish Museum, New York / Yale University Press, New Haven, 2006

Eva Hesse, 1960

below:
Accession II, 1967, steel and rubber,
78.1 x 78.1 x 78.1 cm, The Detroit
Institute of Arts

right page:
Contingent, 1969, fiberglass,
polyester resin, latex, cotton fabric,
350 x 630 x 109 cm (variable), 8 elements,
National Gallery of Australia, Canberra

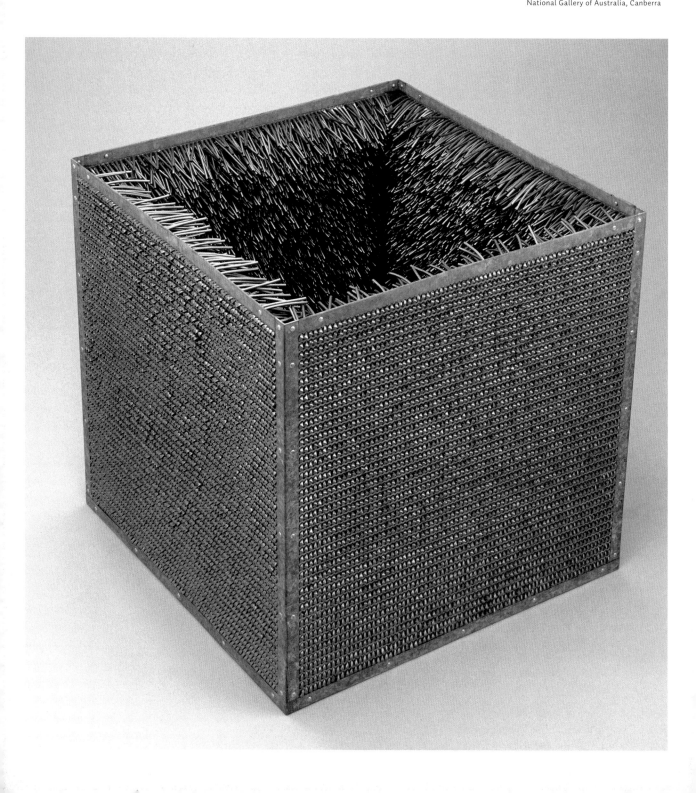

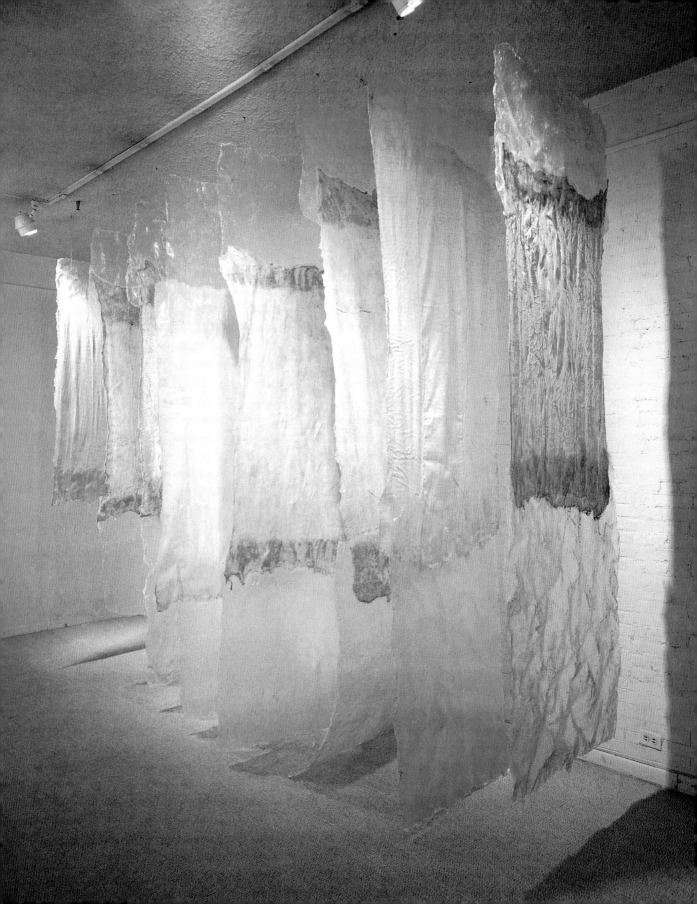

1912 *On the Spiritual in Art* (Wassily Kandinsky)
1917 October Revolution in Russia
1940 Winston Churchill becomes
Prime Minister of the UK
1959 The 14th Dalai
Lama flees into
exile in India
1905 b. Greta Garbo,
Swedish actress
1920 Women's voting rights in
the US and Canada

1860–1910 IMPRESSIONISM CUBISM 1910–1920 EXPRESSIONISM 1920–1940 ABSTRACT EXPRESSIONISM 1940–1960 POP ART 1960–1975

1880 1885 1890 1895 1900 1905 1910 1915 1920 1925 1930 1935 1940 1945 1950 1955 1960 1965

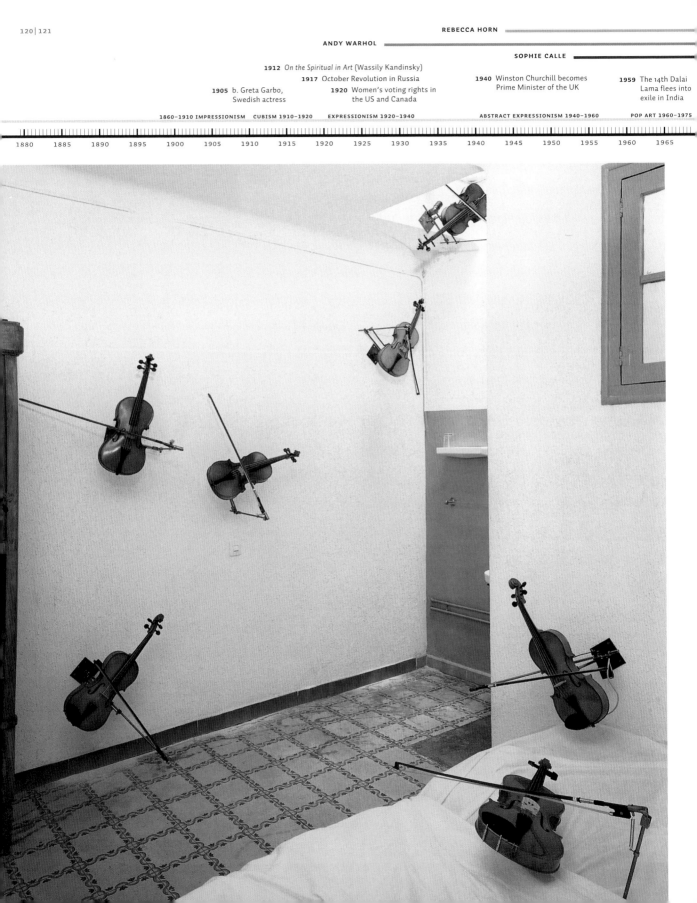

61 *Catch 22* (Joseph Heller)

1975 Andrei Sacharov awarded Nobel Peace Prize

1971 *Death in Venice* 1992 *Sex, Art, and American Culture* (Camille Paglia)
(Luchino Visconti)

| 1970 | 1975 | 1980 | 1985 | 1990 | 1995 | 2000 | 2005 | 2010 | 2015 | 2020 | 2025 | 2030 | 2035 | 2040 | 2045 | 2050 | 2055 |

REBECCA HORN

To this day, Rebecca Horn continues to work on a rigorously developed oeuvre that combines a variety of media: sculpture, performance, video, and film.

During her studies at the Hochschule der Bildenden Künste (Academy of Fine Arts) in Hamburg, Rebecca Horn began creating objects that were adapted to the body. Extra-long gloves, masks made of feathers or fans were designed to extend the awareness of the body and were presented by the artist in performances. Horn described these events as "Personal Art"—they took place without an audience and were planned down to the last detail.

In her room sculpture *The Chinese Fiancée* (1976), which consists of a small room constructed with six entrances, she is also dealing with physical experiences. When the observer enters, the doors close, the light is extinguished, and voices fill the narrow space—until the doors suddenly open again and the visitor is released. Horn's work is concerned with existential experiences such as fear and imprisonment. Many subjects refer to biographical events, in this case a long spell in a sanatorium, which was necessary as a result of the lung damage she suffered from working with polyester.

Horn progressed to producing films via the photographic, film, and video documentation of her actions. Her body sculptures also reappear in *The Dancing Partner* (1978) and her first feature film *Buster's Bedroom* (1990). Some of the props used in the films eventually ended up as autonomous works of art in important collections, including the piano *Concert for Anarchy*, now in Tate Modern in London, from a scene in her cinematographic homage to Buster Keaton.

The Atmosphere of the Room

In the 1980s and 1990s, Horn increasingly produced mechanical works made from everyday objects, as well as installations approximating to a specific place and its history. *The Contrary Concert* (1987) in Münster is reminiscent of a former Nazi prison. Small steel hammers knock constantly like prisoners against the walls of the tower, thus recalling past acts of violence. In *The Tower of the Nameless Ones* Horn refers to the Balkan War, in *Locusts' Chorus* to the Gulf War.

Even in "neutral" places, Rebecca Horn attempts to "make the music of the space ring out." In Barcelona in 1992, she created the installation *The River of the Moon*, the first part of which was presented in a hat factory. It contained keys for seven rooms in a seedy old hotel where rooms could be rented by the hour. Here, in various rooms, she told a love story in all its aspects by means of minimalist arrangements: violins operated by motors played songs, and guns aimed at each other in rumpled beds.

Since her first one-woman show in Berlin in 1973, Horn's works have been regularly exhibited in Europe and the United States. After spending many years in New York, Rebecca Horn now lives primarily in Berlin.

1944 Born 24 March in Michelstadt, Germany.
1964 Becomes a student at the College of Fine Arts in Hamburg.
1971 Studies at St. Martin School of Art in London.
1972 Takes part in *documenta* in Kassel, moves to New York.
1989 Takes up a professorship at the Berliner Hochschule.

Rebecca Horn lives and works in Berlin and New York.

FURTHER READING:
Armin Zweite, Katharina Schmidt, Doris von Drathen and others, *Rebecca Horn: Bodylandscapes: Drawings, Sculptures, Installations 1964–2004*, Hatje Cantz, Ostfildern-Ruit (Germany), 2005
Carl Haenlein (ed.) and others, *Rebecca Horn: The Glance of Infinity*, Scalo, Zurich, 1997

above:
Rebecca Horn, undated

page 122:
The Chinese Fiancée, 1976, black lacquered wood, metal construction, motor, tape recording with Chinese women's voices, 248 x 238 cm, Private collection

page 123:
Concert for Buchenwald, Part 1, 1989, Tram depot, Weimar

left page:
River of the Moon: Room of Lovers, 1992, nine violins, metal construction, motors, installation the the Hotel Peninsular, Barcelona, Private collection

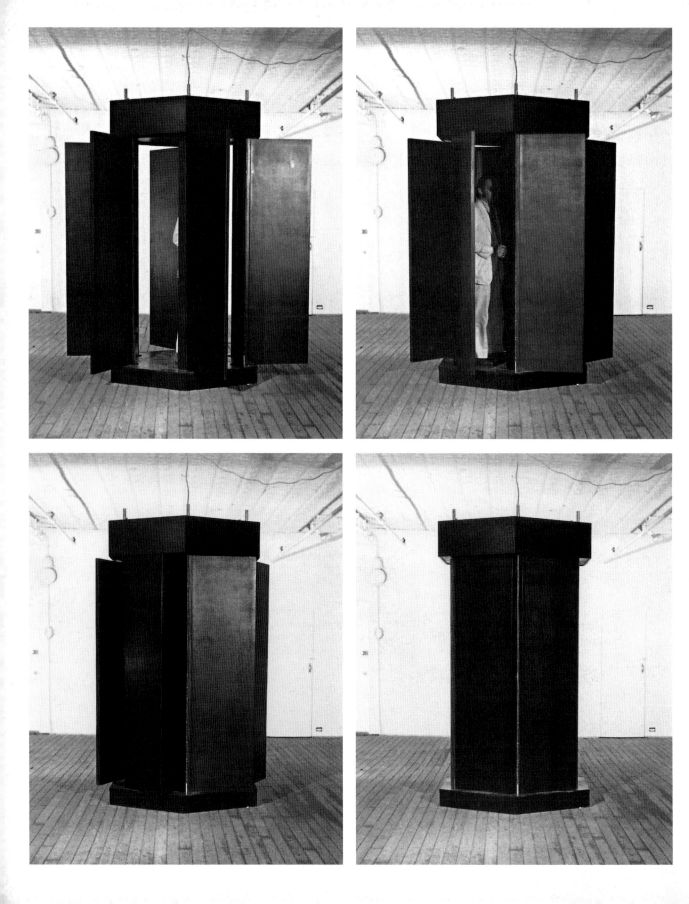

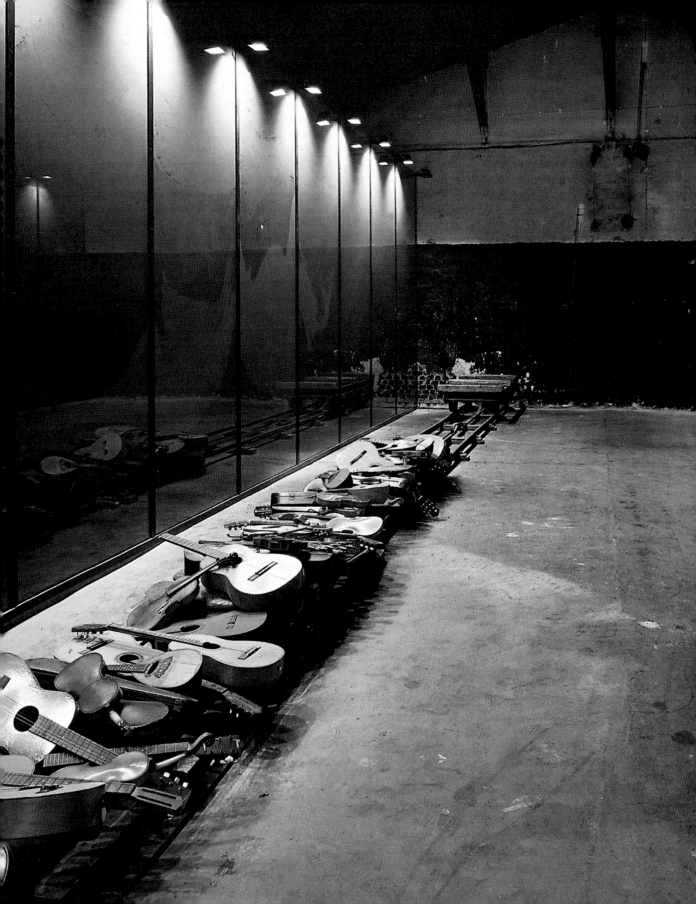

SALVADOR DALÍ

BARBARA KRUGER

MONA HATOUM

1959 Completion of Guggenheim Museum in New York (Frank Lloyd Wright)

1949 *Death of a Salesman* (Arthur Miller)

1860–1910 IMPRESSIONISM CUBISM 1910–1920 EXPRESSIONISM 1920–1940 ABSTRACT EXPRESSIONISM 1940–1960 POP ART 1960–197

1880 1885 1890 1895 1900 1905 1910 1915 1920 1925 1930 1935 1940 1945 1950 1955 1960 1965

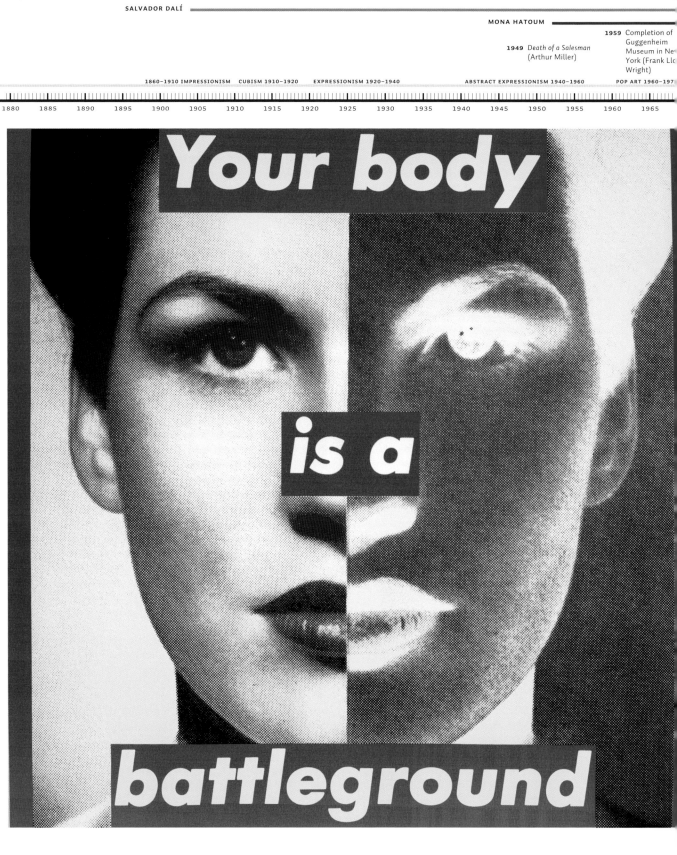

1990 Reunification of Germany
1975 Juan Carlos becomes 1989 Fall of the Berlin Wall
King of Spain 1985 Michail Gorbachev becomes General Secretary of the Communist Party of the Soviet Union
1982 Falklands War between Argentina 2003 Start of the Iraq War
and the United Kingdom

1970 1975 1980 1985 1990 1995 2000 2005 2010 2015 2020 2025 2030 2035 2040 2045 2050 2055

BARBARA KRUGER

Barbara Kruger is one of the most important conceptual artists on the international scene, noted for her large-format collages of pictures and texts exhibited in museums, galleries, and public spaces.

Barbara Kruger's collage-type works have an unmistakable style: in-your-face slogans in Futura Bold Italic reversed-out in red (i.e. white letters on a red background), aggressively demanding attention against a background of enlarged, low-resolution black-and-white photographs. Once you are familiar with the style, recognition is instant if you encounter it directly in the hubbub of everyday life, e.g. on hoardings, public transport, and walls—places where there is competition from a flood of other pictorial and textual stimuli. Kruger started out by publicizing her work herself in the 1980s, fly-sticking her posters at night along the streets of New York.

Food for Thought

Often perceived only for a brief moment, the messages are intended to provide food for thought. Behind the apparently familiar turns of speech there often lurk ambiguities. *Your body is a battleground* (1989), for example, was written on a poster to be used in a Washington demonstration about the right to abortion. It was subsequently adapted in numerous other countries in the struggle to assert women's rights. *I shop, therefore I am* is another slogan (adapted from the French philosopher Descartes) that comments on the behavior of people in a consumer society, reducing consumers to shopping zombies. "I try to deal with the complexities of power and social life," says Kruger, "but as far as the visual presentation goes I purposely avoid a high degree of difficulty. I want people to be drawn into the space of the work."

Barbara Kruger studied at Syracuse University and Parsons School of Design in New York, as a pupil of photographer Diane Arbus and Marvin Israel, the former art director of *Harper's Bazaar*. Before becoming a professional artist, she worked at various agencies and as a graphic artist at Condé Nast. With a background in the esthetics and linguistic strategies of the media, she was best placed to exploit their mechanisms and turn them into their opposites. Her collages, objects, installations, and videos have found their way into major museums such as the Guggenheim and the Museum of Modern Art in New York. At the 2005 Biennale in Venice, Kruger was awarded the Golden Lion for lifetime achievement. Besides being an artist, she is also a professor, curator, author, and critic. She lives in Los Angeles and New York.

1945 Born in Newark, New Jersey.
1964 Becomes an art student at Syracuse University, and from 1965 attends courses at the Parson School of Design.
1974 Holds her first solo show in New York.
1975 Takes teaching posts at universities and art institutions in the USA.

Barbara Kruger lives and works in New York and Los Angeles.

FURTHER READING:
Kate Linker, *Love for Sale: The Words and Pictures of Barbara Kruger*, Harry N. Abrams, New York, 1996

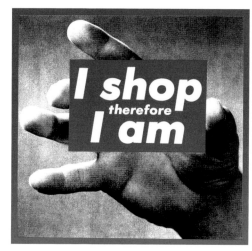

left page:
Your body is a battleground, 1989

left:
Untitled (I shop therefore I am), 1987

above:
Barbara Kruger, undated

Untitled (We don't need another hero),
1987

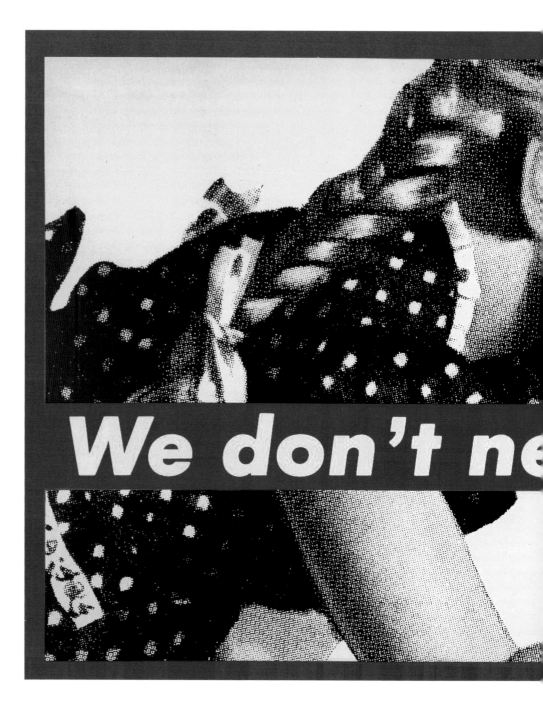

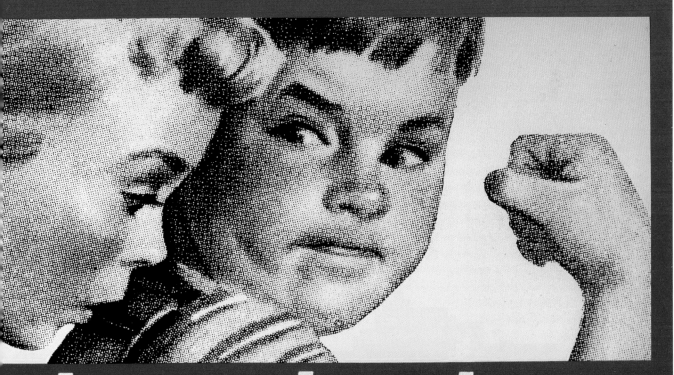

ed another hero

1948 Assassination of Mahatma Gandhi

1925 b. Ruth First, South African anti-apartheid campaigner, journalist, sociologist

1939–1945 World War II

1957 Albert Camus awarded the Nobel Prize for Literature

1860–1910 IMPRESSIONISM CUBISM 1910–1920 EXPRESSIONISM 1920–1940 ABSTRACT EXPRESSIONISM 1940–1960 POP ART 1960–1975

1880 1885 1890 1895 1900 1905 1910 1915 1920 1925 1930 1935 1940 1945 1950 1955 1960 1965

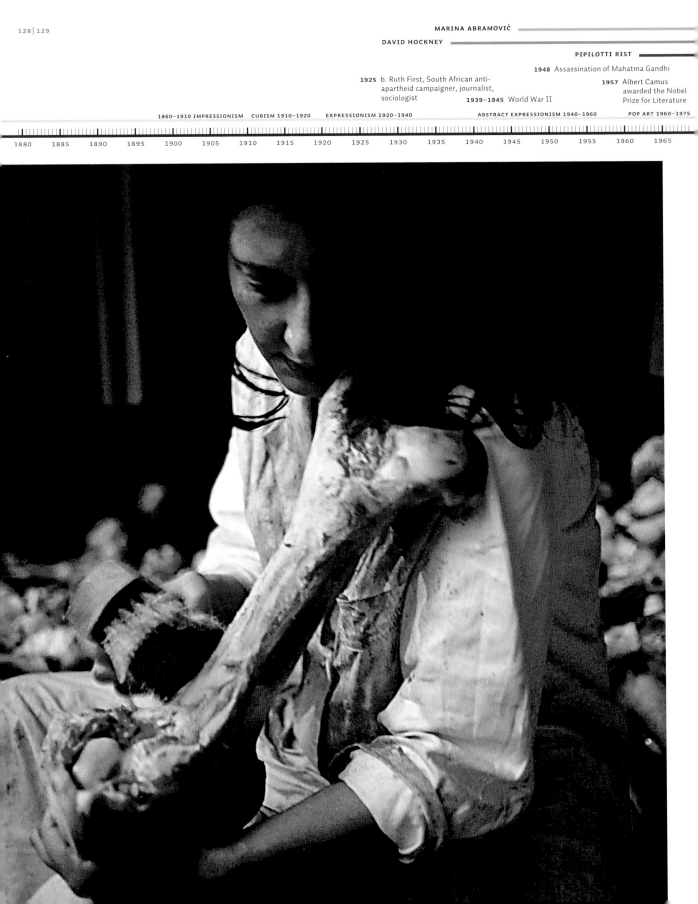

Dr. Zhivago (Boris Pasternak)
1964 The United States enters
the Vietnam War

1965 *Ariel* (Sylvia Plath)

2001 Women's voting rights rescinded
in Kuwait following introduction
in 1999

1990 Reunification of Germany

1970 1975 1980 1985 1990 1995 2000 2005 2010 2015 2020 2025 2030 2035 2040 2045 2050 2055

MARINA ABRAMOVIĆ

*Marina Abramović uses her body as a medium for artistic experiences. Behind the execution
lies the idea of a purification of the spirit, the aim being to pass on energy to the audience.*

Marina Abramović, one of the leading representatives of Body Art, likes to refer to herself as the "Grandmother of Performance." During the 1970s she became famous for her radical actions, which often lasted for several days at a time. During them she forced herself into states of total exhaustion in order to discover and extend the limits of her physical and mental awareness.

Body Performances

In a series of performances she consciously inflicted both pain and injuries on herself. In *Rhythm 10* (1973) she stabbed a knife very rapidly between her splayed fingers; in *Rhythm 0* (1974), she presented herself to gallery visitors as an object and handed them a series of real objects, including nails, alcohol, a whip, and a saw; some visitors became so involved she was almost killed during this event. The reaction of the audience formed an important part of her performances, either as participating observers or by means of unsolicited or intentional involvement.

In 1975 Abramović met the German artist Ulay (F. Uwe Laysiepen). With him she developed a form of greatly reduced double act in which the pair became the subject of the event. In 1988 they ended their artistic collaboration, as well as their personal relationship, by means of a staged hike along the Great Wall of China. In *The Lovers: Walk on the Great Wall of China*, Ulay started out from the Gobi Desert, while Marina Abramović started her journey from the Yellow Sea. They met in the middle of the Wall, before finally separating after this well-staged symbolic act.

After this event, Abramović related her works closely to objects, linked with the attempt to enable her audience to cross over into a new state of consciousness. *Red Dragon* is one of her new sculptures, which demand that one makes individual experiences through body contact with "transitory objects" like pink quartz and copper, in order to experience their energy directly. For Abramović, the changes under-gone during such processes constitute the work of art itself.

Balkan Baroque

More recently, the narrative content of her performances has become more marked. In 1997 she was awarded the Golden Lion at the Biennale in Venice for one of her most important works, *Balkan Baroque*. The performance takes as its central theme the traumatic memories aroused by her Serbian-Montenegrin origins, which acquired a new topicality as a result of the war in Bosnia. Surrounded by copper vessels filled with water, and by video installations showing the artist and her parents, she spent four days clearing 2,500 kilos (5,500 pounds) of cattle bones from a heap. While doing so, she sang songs from her homeland.

1946 Born in Belgrade, Yugoslavia
(now the capital of Serbia).
1965 Enrolls as a student at the
Academy of Fine Arts in Belgrade.
1975 Moves to Amsterdam and meets
Ulay (F. Uwe Laysiepen).
1976 Begins her collaboration with
Ulay.
1988 They terminate their relationship
and artistic collaboration with
*The Lovers: Walk on the Great
Wall of China*.
1997 Awarded Golden Lion at the
Venice Biennale

Marina Abramović lives and works in
Amsterdam and New York.

FURTHER READING:
Velimir Abramović and others, *Marina Abramović: Artist Body Performances 1969–1998*, Charta, Milan, 1998.
Germano Celant, *Marina Abramović: Public Body: Installations and Objects, 1965–2001*, Charta, Milan, 2001.
Marina Abramović, *Marina Abramović: Balkan Epic*, edited by Adelina von Fürstenberg, Skira, Milan, 2006.

left page:
Balkan Baroque, 1997, performance
installation, Venice Biennale, 1997

above:
Marina Abramović on Sardinia, 1976

left
*The Lovers: Walk on the Great Wall
of China* (with Ulay), 1988, performance,
The Great Wall of China, 1988

below:
Rhythm 0, 1974, performance,
Studio Morra, Naples, 1974

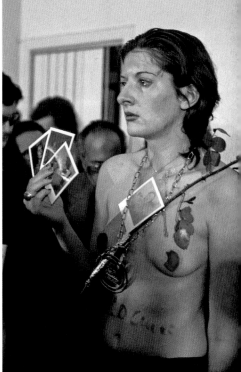

ISA GENZKEN

JACKSON POLLOCK

LEE KRASNER

1922 *In Search of Lost Time*
(Marcel Proust)

1944 Women's voting rights in France

1939–1945 World War II

1945 Atom bombs dropped on
Hiroshima and Nagasaki

1926 b. Marilyn Monroe, American film star

1860–1910 IMPRESSIONISM CUBISM 1910–1920 EXPRESSIONISM 1920–1940 ABSTRACT EXPRESSIONISM 1940–1960 POP ART 1960–1975

| 1880 | 1885 | 1890 | 1895 | 1900 | 1905 | 1910 | 1915 | 1920 | 1925 | 1930 | 1935 | 1940 | 1945 | 1950 | 1955 | 1960 | 1965 |

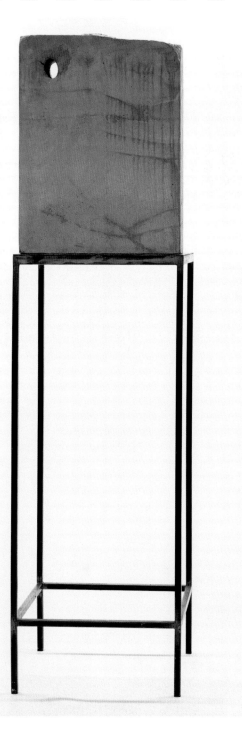

Luke, 1986, concrete, steel, 209 x 63 x 49.5 cm

1990 Reunification of Germany

1975 *Memoirs of a Survivor*
(Doris Lessing)

2001 Ariel Sharon becomes Prime Minister
of Israel
2001 9/11 attacks on United States

| 1970 | 1975 | 1980 | 1985 | 1990 | 1995 | 2000 | 2005 | 2010 | 2015 | 2020 | 2025 | 2030 | 2035 | 2040 | 2045 | 2050 | 2055 |

ISA GENZKEN

Time and again, Isa Genzken undermines esthetic conventions and expectations with her sculptures. Through unusual combinations of materials, fragmentation, and shifts of scale, familiar objects appear in a new guise.

Isa Genzken studied at the Hochschule für Bildende Künste (Academy of Fine Arts) in Hamburg, at the Hochschule der Künste (Academy of Arts) in Berlin, and at the Staatliche Kunstakademie (State Academy of Art) in Düsseldorf under Gerhard Richter, whom she married in 1982 but later divorced.

Wood, Plaster, Concrete …

Her predominantly sculptural oeuvre, which expands contemporary sculpture into new realms thanks to her countless experiments, constantly surprises with new approaches. At the end of the 1970s, she started constructing, on a computer, wooden floor sculptures that were several meters long and in various geometric forms. From the mid-1980s, she began creating plaster and concrete sculptures on iron frames or pedestals that recall architectural models and examine the contrasts between lightness and heaviness. In the following phase of her work, she turned her attention to window sculptures and other architectural details made of poured epoxy resin. The various groups of works permit us to recognize an examination of the esthetic conventions of her everyday surroundings: architecture, design, the media, and products of the culture and mass industries. At the same time, the various groups establish links with a variety of different historical concepts of sculpture, notably the Constructivism of the 1920s and Minimal Art.

Starting from the assumption that a "lack of space" exists, Genzken developed concepts for openings and the removal of barriers. These include large-format works for public spaces such as *ABC*, produced for the exhibition *Skulptur Projekte* in Münster in 1987. She drew on the built-up environment and created a construction of concrete and steel that established a sort of bridge and gateway between the main university building and the outer spaces.

The Esthetics of the Everyday

Since the end of the 1990s, Genzken has worked primarily with plastics, mirrors, and everyday objects, including newspapers and magazines, in her collages and collage books. Thus at *documenta 11* in Kassel she showed two *Spiegel* series, each created from more than 100 photos from the magazine of the same name, which in the new arrangement presented a grotesque picture of the reality of media reporting. After 9/11, which Genzken experienced in New York, her works became louder and more colorful. At the 52nd Art Exhibition at the Venice Biennale in 2007, Genzken was the artist who presented the German contribution with *Oil*, a shrill social satire in which she criticized the industrial nations: "Whether there is war, or whether there isn't—that's what it's about. About energy and oil."

1948 Born in Bad Oldesloe, Germany.
1969 Begins her studies at the Fine Arts College in Hamburg, switching first to the Berlin College of Arts, then the Art Academy in Düsseldorf.
1982 Marries artist Gerhard Richter.
1990 Becomes Visiting Professor of Sculpture at the College of Fine Arts in Berlin,
1991–1992 Visiting Professor of Sculpture at the Städel School in Frankfurt.
2007 Designs the German pavilion for the Venice Biennale.

Isa Genzken lives and works in Berlin.

FURTHER READING:
Alex Farquharson, Diedrich Diederichsen, and Sabine Breitwieser, *Isa Genzken*, Phaidon, London and New York, 2006
Nicholas Schafhausen, *Isa Genzken: German Pavilion, Venice Biennale 2007*, Dumont, Cologne, 2007

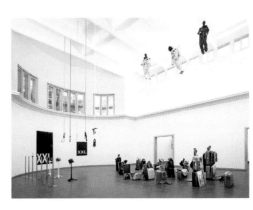

above:
Isa Genzken, undated

left:
Oil, 2007, installation, German Pavilion, Biennale Venice, 2007

MARK ROTHKO

JENNY HOLZER

BARBARA KRUGER

1950–1953 Korea War

1860–1910 IMPRESSIONISM CUBISM 1910–1920 EXPRESSIONISM 1920–1940 ABSTRACT EXPRESSIONISM 1940–1960 POP ART 1960–1975

| 1880 | 1885 | 1890 | 1895 | 1900 | 1905 | 1910 | 1915 | 1920 | 1925 | 1930 | 1935 | 1940 | 1945 | 1950 | 1955 | 1960 | 1965 |

Untitled (from: *Truisms, Inflammatory Essays, The Living Series, Under a Rock, Laments and Child Text*), 1989–1990, LED, 41.9 x 4900 x 15.2 cm, Solomon R. Guggenheim Museum, New York

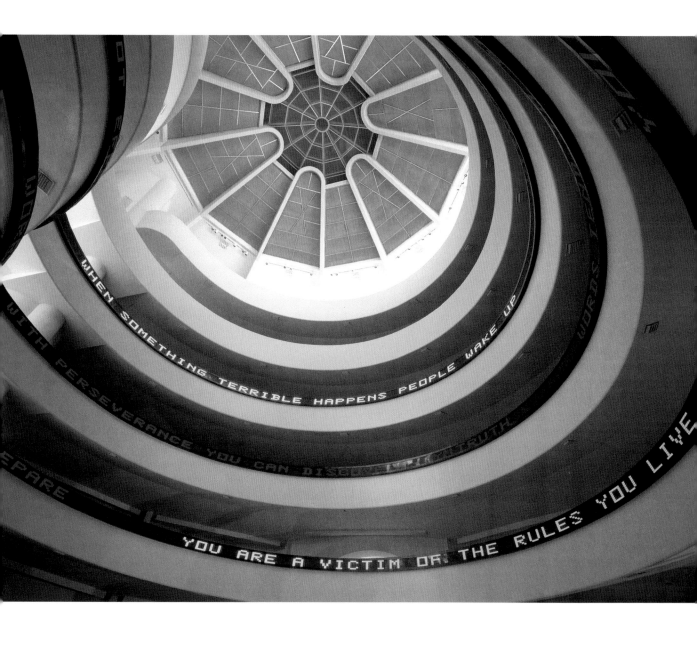

1970	1975	1980	1985	1990	1995	2000	2005	2010	2015	2020	2025	2030	2035	2040	2045	2050	2055

JENNY HOLZER

The conceptual use of written language lies at the heart of the work of the American artist Jenny Holzer. From the beginning, her aim was to convey messages, especially in public spaces. The artist sees herself as a "speaker who makes private fears public."

At the end of the 1970s, Jenny Holzer started a collection of aphorisms and everyday sayings. Throughout the entire city of New York, you could find examples of her so-called *Truisms: You are the victim of the rules by which you live* and *Fear paralyzes more than anything* could be read on advertisement hoardings, railroad cars, road signs, and flyers. In *Inflammatory Essays* (1979–1982), *Living* (1980–1982), and *Survival* (1983– 1985) there followed further language series, inspired in some cases by the writings of politicians and philosophers.

Messages in an Urban Space

In 1982, Holzer achieved her real artistic breakthrough when she executed her first work on an electronic neon sign in Times Square in New York. Surrounded by the multiplicity of advertising surfaces, whose means of representation she uses, she attempted to disturb readers for a moment in the middle of their everyday life and so encourage them to reflect. On the advertising space, which changed constantly, there followed a succession of sentences which, when considered individually, appeared to be "true," but which when read in sequence seemed question- able, in that they contradicted each other or cancelled each other out.

In her more recent light installations, Holzer used xenon spotlights to project statements onto the walls of buildings, squares, or rivers, as in her *Arno* project for the Biennale in Florence in 1996. For the retro- spective in the Solomon R. Guggenheim Museum in New York in 1989–1990 she installed over 300 of her messages in LED scrolling text in the rotunda of the building designed by Frank Lloyd Wright. Additional messages were engraved on granite benches that were arranged in a circle, creating a telling contrast to the immaterial transitoriness of the electronic ticker-tape. At the same time, she also became the first woman to design the American pavilion at the Biennale in Venice (1990), which won the country prize.

Political Art and Concrete Poetry

In addition to language stereotypes, Jenny Holzer also works with texts that confront the observer with the explosive reality of our society. *Da, wo Frauen sterben, bin ich hellwach* ("There, where women die, I am wide awake"), was the title of the weekly magazine supplement of the *Süddeutsche Zeitung* she designed in 1993. To commemorate the war in Bosnia, Holzer had it printed in a mixture of blood and ink. It was an outrageous attempt to draw attention to the rapes and sexually motivated killings in Bosnia. In addition to social and political themes, Holzer's works also draw on personal experience, such as the feelings of a mother in *Mother and Child* (1990) and *OH* (2001).

1950 Born in Gallipolis, Ohio.
1975 Enrolls as a student of painting at the Rhode Island School of Design in Providence.
1977 Moves to New York.
1982 Her work is shown in the form of aphorisms on a constantly chang- ing advertising LED billboard in Times Square, New York.
1989–1990 Holds solo show at the Guggenheim Museum, New York.
1990 Awarded the Golden Lion at the Venice Biennale.

Jenny Holzer lives and works in Hoosick, New York.

FURTHER READING:
Michael Auping, *Jenny Holzer*, Universe, New York, 1992
David Joselit, Joan Simon, and Renata Salecl, *Jenny Holzer*, Phaidon, London, 1998

Jenny Holzer, undated

JACKSON POLLOCK

MONA HATOUM

SOPHIE CALLE

1950–1953 Korea War

1939–1945 World War II

1860–1910 IMPRESSIONISM CUBISM 1910–1920 EXPRESSIONISM 1920–1940 ABSTRACT EXPRESSIONISM 1940–1960 POP ART 1960–1975

1880 1885 1890 1895 1900 1905 1910 1915 1920 1925 1930 1935 1940 1945 1950 1955 1960 1965

1982 Falklands War between Argentina and the United Kingdom 2006 Hamas wins Palestinian elections

1986 Chernobyl disaster 1997 Madeleine Albright becomes Foreign
 Minister of the United States
1974 Giscard d'Estaing becomes 1990 Reunification of Germany
 President of France 1993 Tansu Çiller becomes first female Prime Minister of Turkey

1970 1975 1980 1985 1990 1995 2000 2005 2010 2015 2020 2025 2030 2035 2040 2045 2050 2055

MONA HATOUM

With her acute awareness of political injustice, Mona Hatoum bases her works on experiences of institutional power and violence, as well as threats to (and the vulnerability of) the individual.

Mona Hatoum was born to Palestinian parents in Beirut in 1952. When civil war broke out in Lebanon in 1975, she happened to be in England, which prevented her returning to her homeland. Since then, she has lived mainly in London, though she is frequently on her travels in guest studios in Mexico City, Texas, Venezuela, Berlin, and elsewhere.
After studying at the Slade School of Art in London, Mona Hatoum gained a reputation for dramatic public performances in the early 1980s, reacting to topical political subject matter. Like her later works, they were geared towards direct communication with the public. In one of her best-known works, *Under Siege* (1982), naked and covered in clay in a polythene container, she fought for hours to stand up, slipping and falling continually, so that viewers were helpless bystanders of her role as victim. Against a background of wars going on in many parts of the globe, her performance conveyed the futility and senselessness of some human actions.

"I try to build up expectations which are then disrupted."
Since the end of the 1980s, Hatoum has continued her repertory of ideas and shapes in sculpture and large installations. In their precise choice of material and perfect execution of form, her works manifest a proximity to minimalist sculpture and conceptual art, and are at the same time enriched with personal or political content. Through changes in the material, dimensions or function, everyday objects become alien objects that on a second glance reveal latent violence or threat—swings with seats made of sharp-edged steel, or a wheelchair with knives instead of handles. These initially unnoticed perils in esthetically pleasing objects make highly memorable images of the instability of the world.
Hatoum always emphasizes the physical aspect of her art. "I did not want my work to be one-dimensional in the sense that it just appeals to the intellect. I wanted it to be a complete experience that involves your body, your mind, your emotions, everything." In the *Corps étranger* installation, which was nominated for the Turner Prize in 1995, the impartial-looking eye of the camera becomes a constant surveillance: it investigates the surface of the artist's body, then penetrates certain orifices in an endoscopic journey of the inside of the body. In Mona Hatoum's work, the body becomes a metaphor of violence against the individual.

1952 Born in Beirut, Lebanon, to
 Palestinian parents.
1975 Studies at the Byam Shaw School
 of Art in London.
1981 Graduates from the Slade School
 of Art, London.
1995 Nominated for the Turner Prize.

Mona Hatoum lives and works in London and Berlin.

FURTHER READING:
Michael Archer, Guy Brett, and Catherine de Zegher, *Mona Hatoum*, Phaidon, London, 1997
Edward W. Said and Sheena Wagstaff, *Mona Hatoum: The Entire World as a Foreign Land*, Tate Gallery, London, 2000

left page:
Corps étranger, 1994, video installation with cylindrical wooden structure, video projector, video player, amplifier and four speakers, 350 x 300 x 300 cm, courtesy Centre Pompidou, Paris

left:
Corps étranger (detail), 1994

above:
Mona Hatoum, undated

Silence, 1994, laboratory glass
tubes, 127 x 92,7 x 59,1 cm, courtesy
Jay Jopling / White Cube, London

MARK ROTHKO

SOPHIE CALLE

CINDY SHERMAN

1948–1949 Equal rights for men and women laid down in German constitution

1860–1910 IMPRESSIONISM CUBISM 1910–1920 EXPRESSIONISM 1920–1940 ABSTRACT EXPRESSIONISM 1940–1960 POP ART 1960–197

1880 1885 1890 1895 1900 1905 1910 1915 1920 1925 1930 1935 1940 1945 1950 1955 1960 1965

The Hotel, Room 25, 1981

1965 UNICEF awarded Nobel Peace Prize

2000 Tate Modern in London opened

2005 Angela Merkel becomes Chancellor of the Federal Republic of Germany

1975 International Women's Year

2001 9/11 attacks on United States

2003 Start of the Iraq War 2006 War in Lebanon

1970 1975 1980 1985 1990 1995 2000 2005 2010 2015 2020 2025 2030 2035 2040 2045 2050 2055

SOPHIE CALLE

Sophie Calle is an exponent of "narrative photography." Her arrangements of image and text are about getting close to others, often surreptitiously, exploring the experiences of absence, anonymity, intimacy, and voyeurism.

In 1979, Sophie Calle returned to Paris from a seven-year trip round the world and tried to ease herself back into a now alien-looking city. She followed unknown passers-by like a sleuth, documenting her observations in photographs and notes, and finally exhibiting them. In 1980 she published her first book, *Suite Vénitienne*, which developed out of probably the best-known of her eaves-droppings on the private life of a stranger, whom she had followed all the way to Venice.

The Reality of Others

Calle says that her works are about the psychology of interpersonal relationships. This includes setting out the most intimate details: she invited people she did or did not know to sleep in her bed, and worked as a chambermaid in a hotel so as to rummage in guests' rooms and speculate about their lives. After coming across the notebook of a certain "Pierre D'" she got in touch with the people listed in it. The results of her interviews she published in a daily column in French newspaper *Liberation* over several weeks in the summer of 1983. The owner of the address book (the documentary film-maker Pierre Baudry) only learnt after the event that he had become the subject of public interest, and threatened legal action; according to Sophie Calle, he had still not forgiven her years after.

In later works, Calle gave up her anonymity in favor of direct encounters with those involved—but these turned out no less provocatively. *The Blind* (1986) was the outcome of her interviewing people born blind about their ideas of beauty. She juxtaposed their answers with photographs of the interviewees, along with photographs of their ideas of beauty.

Sowing Confusion

Sophie Calle's works consist of series of photographs and text whose sober, documentary character is contrasted with highly personal content. In these, she can mix real events with fictional and staged occurrences. This happened twice over in various works associated with Paul Auster's novel *Leviathan* (1992). Auster based his heroine Maria Turner on Calle's life and work. Sophie Calle's response was to turn the fictional art works of the heroine into reality and to try to match her own life to that of Maria, thereby turning the traditional concept of reality on its head.

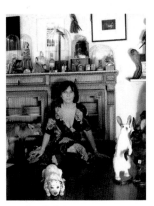

1953 Born in Paris.
1979 Returns to Paris after seven years traveling the world. For over a week she invites friends, acquaintances and strangers to sleep in her bed and then photographs them: *The Sleepers* project.
1992 Paul Auster's novel *Leviathan* is published; one of his characters (Maria Turner) is based on Sophie Calle.
2007 Designs the French pavilion at the Venice Biennale.

Sophie Calle lives and works in New York and Malakoff near Paris.

FURTHER READING:
Kathleen Merrill and Lawrence Rinder, *Sophie Calle: Proofs*, Hood Museum of Art, Darmouth College, Hanover, NH, 1993
Trudy Wilner Stack and others, *Sophie Calle ...* , Center for Creative Photography, University of Arizona, Tucson, AZ, and New York, 1995

above:
Sophie Calle, undated

following double page:
The Blind, 1986

« *The most beautiful thing I ever saw is the sea, the sea going out so far you lose sight of it.* »

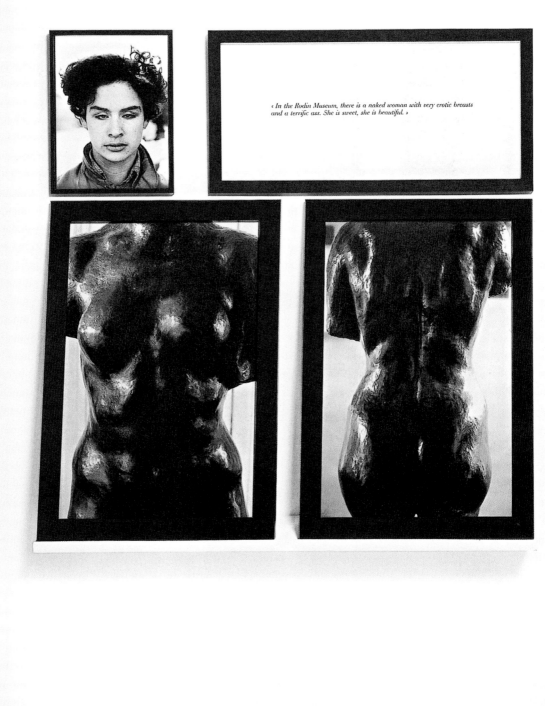

‹ In the Rodin Museum, there is a naked woman with very erotic breasts and a terrific ass. She is sweet, she is beautiful. ›

KIKI SMITH

DAVID HOCKNEY

TRACY EMIN

1960 John F. Kennedy
becomes President
of the United States

1860–1910 IMPRESSIONISM CUBISM 1910–1920 EXPRESSIONISM 1920–1940 ABSTRACT EXPRESSIONISM 1940–1960 POP ART 1960–1975

1880 1885 1890 1895 1900 1905 1910 1915 1920 1925 1930 1935 1940 1945 1950 1955 1960 1965

Virgin Mary, 1992, wax, fabric, wood and
steel, 171.5 x 66 x 36.8 cm, courtesy
PaceWildenstein, New York

1962 United States imposes trade embargo on Cuba

1986 Olof Palme assassinated in Stockholm

1991 Dissolution of Warsaw Pact

2006 Resumption of atomic research program by Iran

1975 First International Women's Conference in Mexico

1978 Karol Wojtyla elected Pope (John Paul II)

1999 Poland, Hungary and the Czech Republic join NATO

1970 1975 1980 1985 1990 1995 2000 2005 2010 2015 2020 2025 2030 2035 2040 2045 2050 2055

KIKI SMITH

"The body is our common denominator and the stage for our pleasure and pain. Through it I aim to express who we are, and how we live and die." Kiki Smith

Kiki Smith was born in 1954 into an artist's family in Nuremberg. Her mother, Jane Smith, was an opera singer; her father, Toni Smith, was one of the most famous American sculptors of the 1960s and a fore-runner of Minimalism. She sees the death of her father in 1980 as marking her "real birth as an artist."

Art and Body

Human existence, Man's exposure to nature and the environment, the story of the human body, life and death form the subjects in Kiki Smith's art. She initially produced sculptures made of various materials that represented fragments of the human body (such as glass feet, above which an ankle-length skirt hangs on strings) and organs (including a uterus in the form of two nutshells). As a basis for her studies of the female body, she used the English standard medical work *Gray's Anatomy*. With the help of the illustrations, she translated the subject of anatomical dissection and fragmentation into graphical works, drawing cell structures, blood and nerve pathways, and other elements.

The first picture of an entire body, *Untitled*, appeared in 1987. After the death of her sister, who died of AIDS in 1988, she produced increasing numbers of representations of human existence in all its vulnerability, underlined by the use of delicate materials such as paper, wax, porcelain, glass, and polyester. Her work *Tale* (1992) shows a crawling female figure dragging behind her a long trail of feces; *Blood Pool* (1992) shows a female body in a fetal position with an open spine. Kiki Smith also examined the figure of the *Virgin Mary* in a number of works. *Virgin Mary* (1992) is a true-to-life representation of the female body made of wax, but with the skin missing in numerous places. Questioned about the shocking impression created by her body sculptures, Smith replied, "It is not my work which is problematic, but the history of our bodies, our love-hate relationship with our own bodies."

The Beauty of Creation

During the 1990s, Kiki Smith extended her range of subjects by turning her attention to the relationship between Man, nature, and the cosmos. Her fantastic, poetic arrangements are now based on myths, fairy tales, literary works, or works of art history, even her own dreams. One of her cosmic scenarios consisting of stars and animal figures was partly produced in cooperation with the architects Coop Himmel(b)lau for the exhibition *Paradise Cage* in the Museum of Contemporary Art in Los Angeles in 1996.

1954 Born 18 January in Nuremberg, Germany, the daughter of opera singer Jane Smith and sculptor Tony Smith. Spends her childhood and youth in New Jersey, USA.
1976 Moves to New York.
1980 Death of her father leads to her "real birth as an artist."
1988 Death of her sister, Beatrice.
2000 Awarded Skowhegan Medal for Sculpture.

Kiki Smith lives and works in New York.

FURTHER READING:
Jon Bird (ed.), *Otherworlds: The Art of Nancy Spero and Kiki Smith*, Reaktion, London, 2003
Helaine Posner and Christopher Lyon, *Kiki Smith*, Monacelli Press, New York, 2005

Kiki Smith, undated

Seer (Alice II), 2005, white
coachwork enamel on bronze,
162.6 x 182.9 x 114.3 cm, Galerie Lelong,
Paris

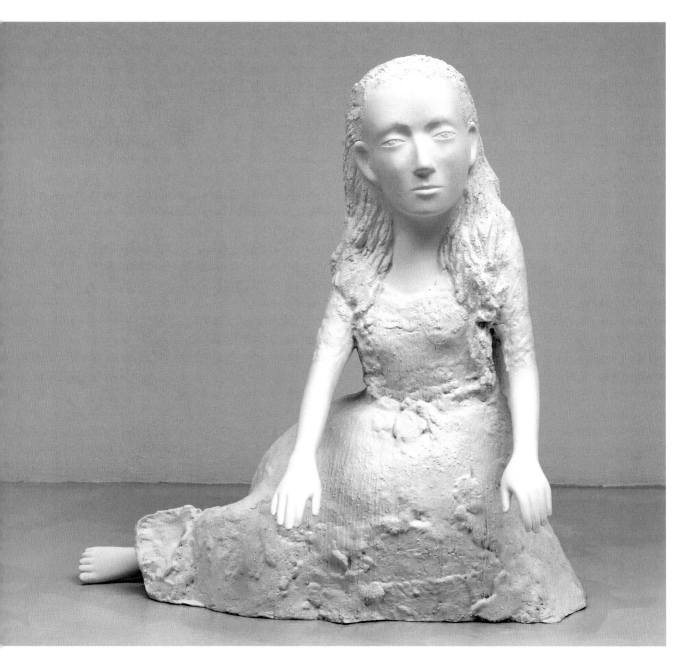

Blood Pod, 1992, painted bronze,
35.6 x 99.1 x 55,9, courtesy
PaceWildenstein, New York

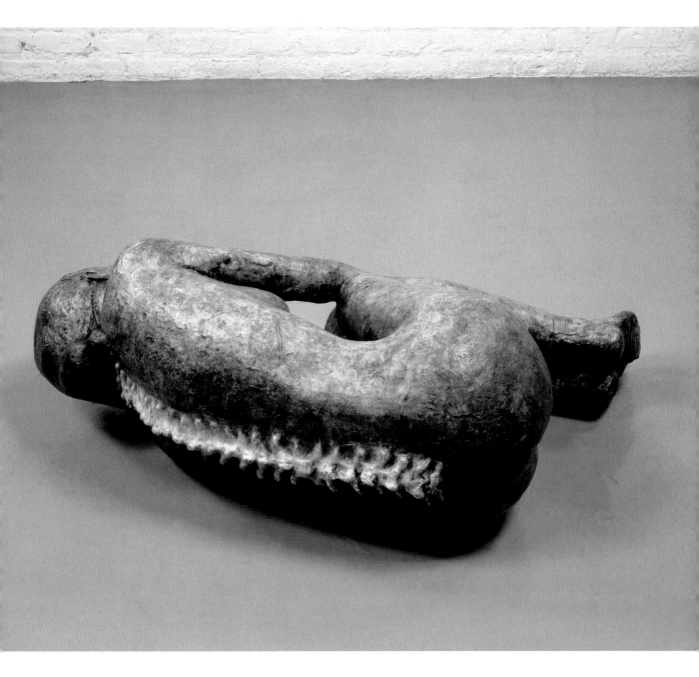

CINDY SHERMAN

JOSEPH BEUYS

MARINA ABRAMOVIĆ

1960 John F. Kennedy becomes
President of the United Stat

1950 End of racial segregation in the United States

1958 *On the Road* (Jack Kerouac)

1860–1910 IMPRESSIONISM CUBISM 1910–1920 EXPRESSIONISM 1920–1940 ABSTRACT EXPRESSIONISM 1940–1960 POP ART 1960–1975

1880 1885 1890 1895 1900 1905 1910 1915 1920 1925 1930 1935 1940 1945 1950 1955 1960 1965

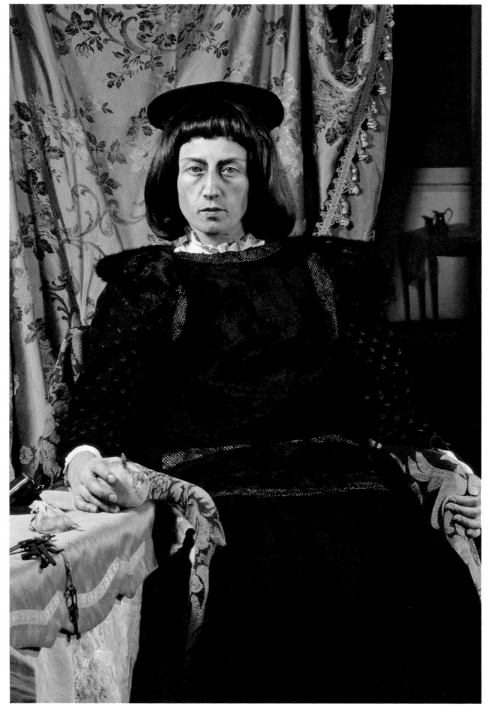

Untitled Film Still #206, 1989, color photo-
graph, 6th edition, 171.4 x 114.3 cm, Courtesy
of the Artist and Metro Pictures

1972 Munich massacre (attack on Israeli
team at the Olympic Games)

2001 Women's voting rights rescinded in Kuwait
following introduction in 1999

1961 Construction of the Berlin Wall

1972 Heinrich Böll awarded Nobel Prize for Literature

1969 Yasser Arafat becomes
Chairman of the PLO

1988 Withdrawal of Soviet
troops from Afghanistan

2003 Start of the Iraq war

1970 1975 1980 1985 1990 1995 2000 2005 2010 2015 2020 2025 2030 2035 2040 2045 2050 2055

CINDY SHERMAN

As a contribution to the recent history of art, the work of Cindy Sherman marks a redefinition and widening of what contemporary photography can achieve by means of dressing up and staging scenes. With Sherman usually in the title role, nothing is ever what it seems.

Cindy Sherman's pictures show things that in reality do not exist: they are made up just for the picture. They are tableaux by a photographer acting both as director and often the principal actor.

Acting

Striking examples can be found in *Untitled Film Stills* (1977–1980), a series of 69 black-and-white photographs that are central to her early work. Dressing up in various disguises so that her identity becomes almost unrecognizable, Sherman takes on different guises in mocked-up film stills featuring different types of women, reminiscent of 1950s/1960s film clichés: "woman waiting," the "vamp," the "little woman at home," and so on. These parody the role models the media offered at the time. In later series of works, she parades her own person in contemporary ideal images of femininity and beauty, conventional projections of sexuality, power, and violence in a male-dominated society, initially rather light-heartedly, and then more and more aggressively.

The Power of Presentation

In the 1980s, Sherman went over to color photography in substantially larger formats. She withdrew from her own pictures, her place being taken by dolls and prostheses, which in the *Disaster* series she arranged into grotesque studies of decay using waste products, moldy food remnants, and body excretions. In the *Sex Pictures*, grotesque body parts of mannequins, prostheses, and anatomical models simulate sexual acts.

In the *History Portraits/Old Masters* photographs (1988– 1990), Sherman echoes old master genres, sometimes restaging famous pictures by Caravaggio or Botticelli: "I treated these pictures as artistic constructs just like everything you find in fashion magazines these days," declares Sherman. She challenges the idealizing character of famous paintings, adopting the roles of the figures (men and women), and sending up the celebrated images

with badly placed wigs, obviously staged props, and clearly visible prostheses.

The provocative character of Cindy Sherman's work is again evident in her series from 2003–2004. Her *Clowns* are intended to show the "deeper characteristics behind the clown's masks." Once again, this is a departure from familiar genre codes. Beneath the surface of face and gesture, something shines through that constitutes the disconcerting appeal of her photographs and that lodges uncomfortably in the memory.

1954 Born 19 January in Glen Ridge, New Jersey.
1972 Enrolls at the State University of New York (SUNY) at Buffalo, majoring in painting but later switching to photography.
1974 Founds Hallwalls Contemporary Art Center with Robert Longo, Charles Clough, and others.
1977 Moves to New York.

Cindy Sherman lives and works in New York.

FURTHER READING:
Zdenek Felix and Martin Schwander (eds.) and others, *Cindy Sherman: Photographic Work 1975–1995*, Schirmer Art Books, London, 1995
Johanna Burton (ed.) and others, *Cindy Sherman*, MIT Press, Cambridge, MA, 2006

Cindy Sherman, undated

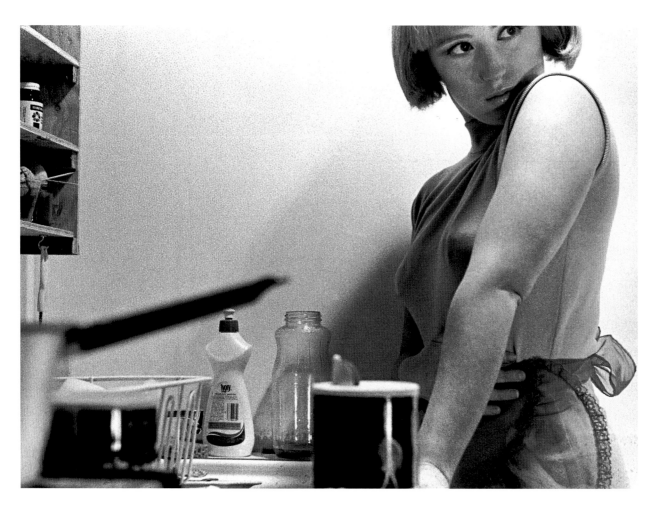

Untitled Film Still #3, 1977, black-and-
white photograph, 27th edition,
5 x 25.4 cm, courtesy of the Artist and
Metro Pictures

Untitled Film Still #188, 1989, color photo-
graph, 6th edition, 110.5 x 166.4 cm,
courtesy of the Artist and Metro Pictures

1963 *The Feminine Mystique*
(Betty Friedan, American
sociologist)

1860–1910 IMPRESSIONISM CUBISM 1910–1920 EXPRESSIONISM 1920–1940 ABSTRACT EXPRESSIONISM 1940–1960 POP ART 1960–1975

| 1880 | 1885 | 1890 | 1895 | 1900 | 1905 | 1910 | 1915 | 1920 | 1925 | 1930 | 1935 | 1940 | 1945 | 1950 | 1955 | 1960 | 1965 |

Fervor, 2000, Production still

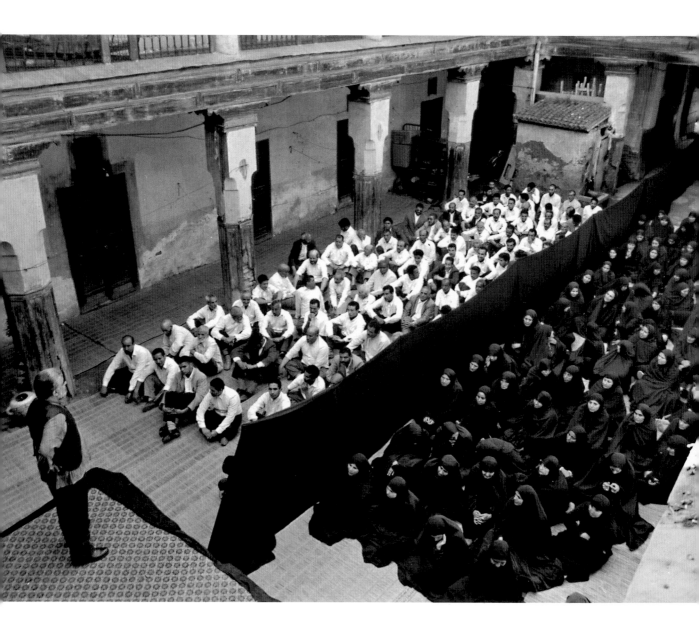

1969 US moon landing	1990 Reunification of Germany	1995 Christo and Jeanne-Claude wrap the Reichstag in Berlin	2003 Start of the Iraq War
		1997 Kofi Annan becomes Secretary-General of the United Nations	2005 Dedication of the Holocaust Memorial (Memorial to the Murdered Jews of Europe) (Peter Eisenman)
		1999 War in Kosovo	2005 Terror attacks in London

1970 1975 1980 1985 1990 1995 2000 2005 2010 2015 2020 2025 2030 2035 2040 2045 2050 2055

SHIRIN NESHAT

"I come from a world which is in every respect a total antithesis of the Western world and which currently represents the greatest threat to Western civilization … The challenge for me is to mediate between these cultures, the Orient and the Occident." Shirin Neshat

Shirin Neshat was born in Qazvin in Iran in 1957. When she was 17, she went to Berkeley, University of California, to study art. When she first visited her family again in 1990, she began to work as an artist under the impression of the profound changes happening in her homeland as a result of the Islamic revolution. Her photographs, videos, and films home in on social developments in contemporary Islam from the perspective of two highly different cultural backgrounds. A particular issue for her is the strictly controlled situation of women.

Politicization of Images
Her photographic series *Women of Allah* (1993–1997) attracted a great deal of attention in Western art circles immediately they were published. The black-and-white photographs show armed Islamic women—often Neshat herself—clothed in full-length chadors. They present a contiguity of female-ness and violence, a tension between eroticism, innocence, and aggression. The uncovered areas of skin are overwritten with Farsi texts written by contemporary Iranian female poets, though their viewpoints are highly divergent. Sometimes they talk of being captive in Iranian culture, sometimes about their enthusiasm for the Islamic revolution. Visually, they are calligraphic ornamentation.

Double Projections
Neshat's videos are also notable for strong contrasts between Western and Islamic culture, or generally between men and women, individuals and society, control and desire. On a formal level, the dualism often takes the form of double projections. The black-and-white video installation *Turbulent* (1998) is the first part of a trilogy that continues with *Rapture* and ends with *Fervor*. They focus on the separation of public and private space, and so with worlds defined as male and female respectively. The viewer is placed between two screens, one showing a man, the other a woman, each of whom begins to sing in turn. The man faces the camera, with the public sitting behind him, while the woman occupies an empty room with the camera circling round her. In the end, only the voice of the woman is heard, the man lapsing into silence.

Neshat succeeds in putting across socio-political content by means of vivid images of Islamic society. This is a highly topical subject, but she does not offer solutions or take sides. At its best, her work is an invitation to open a dialog between the cultures. At all events, it prompts thought about our own notions of "foreignness."

1957 Born 26 March in Qazvin, Iran.
1974 Goes to California to study art, later moving to New York.
1990 Visits Iran for the first time since 1974, and explores the subject of the role of women in Islam.
1999 First International Prize at the Venice Biennale.

Shirin Neshat lives and works in New York.

FURTHER READING:
Ladan Akbarnia, *Speaking Through the Veil: Reading Language and Culture in the Photographs of Shirin Neshat*, thesis (MA), University of California, Los Angeles, 1997
John B. Ravenal and others, *Outer & Inner Space: Pipilotti Rist, Shirin Neshat, Jane & Louise Wilson, and the History of Video Art*, Virginia Museum of Fine Arts, Richmond, VA / University of Washington Press, Seattle, WA, 2002

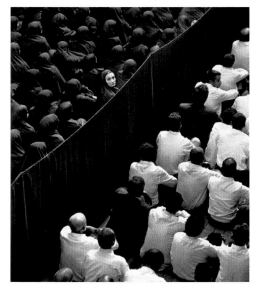

left:
Fervor, 2000, production still

above:
Shirin Neshat, 2006

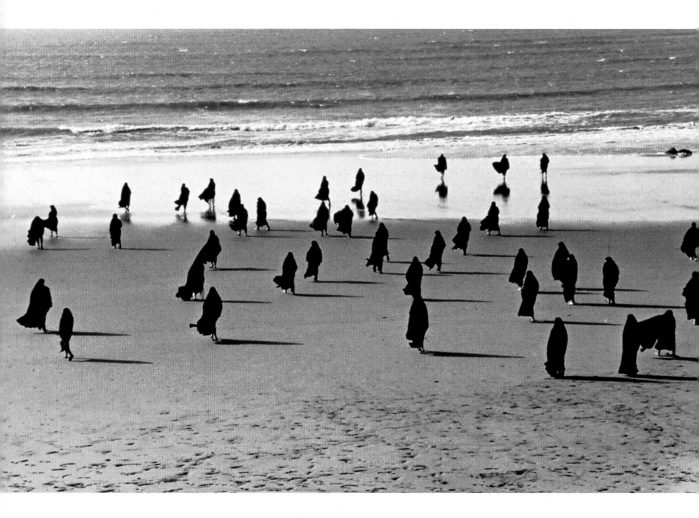

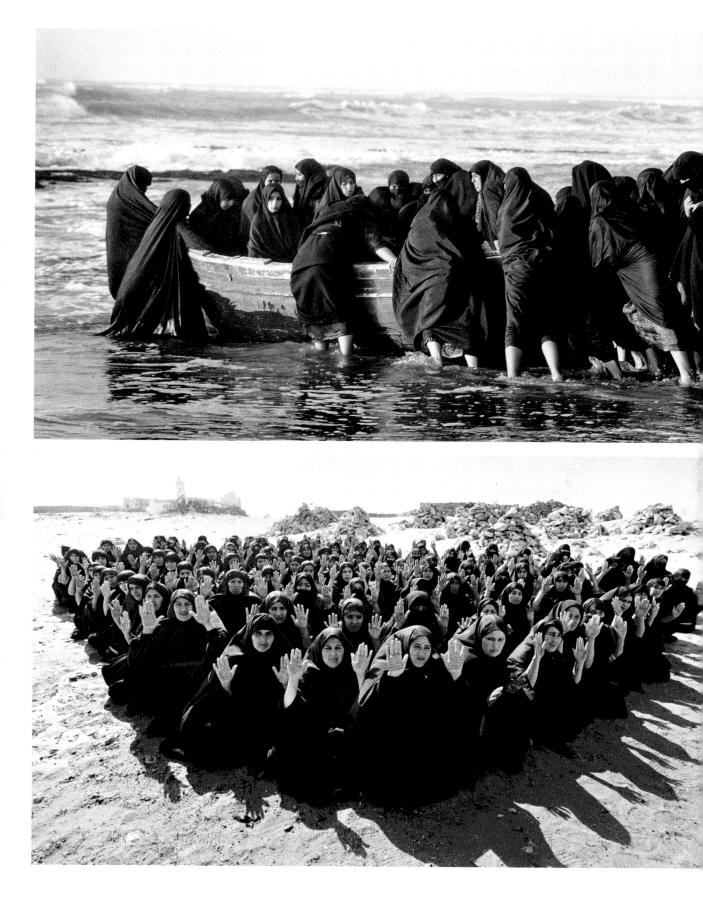

1860–1910 IMPRESSIONISM CUBISM 1910–1920 EXPRESSIONISM 1920–1940 ABSTRACT EXPRESSIONISM 1940–1960 POP ART 1960–1975

1880 1885 1890 1895 1900 1905 1910 1915 1920 1925 1930 1935 1940 1945 1950 1955 1960 1965

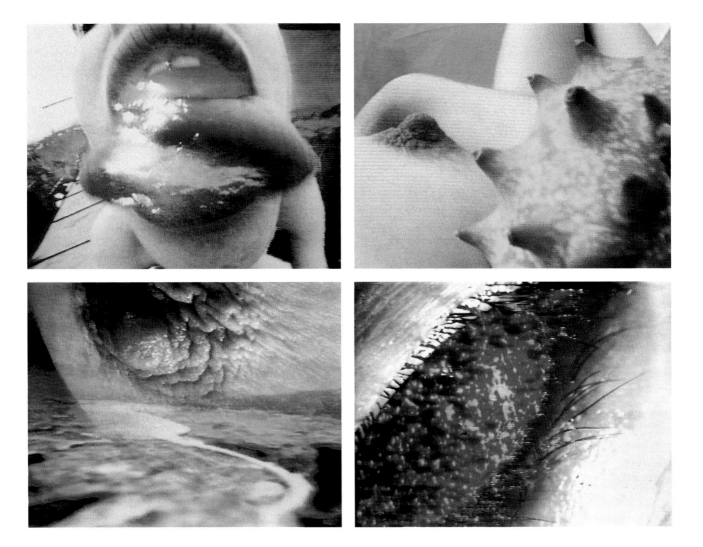

Pimple Porno, 1992, video stills

1986 Challenger space shuttle explodes after takeoff

1990 Reunification of Germany

1994 Yasser Arafat, Yitzhak Rabin and Shimon Peres awarded Nobel Peace Prize

2005 IRA ends armed hostilities after 34 years

2006 War in Lebanon

1990 OSCE conference in Paris declares the Cold War to be over

1973 First oil crisis

2004 Tsunami flood catastrophe in Asia

1970 1975 1980 1985 1990 1995 2000 2005 2010 2015 2020 2025 2030 2035 2040 2045 2050 2055

PIPILOTTI RIST

"Video is like a compact handbag; it contains everything, from literature to painting to music." Pipilotti Rist

I'm Not The Girl Who Misses Much, dated 1986, is Pipilotti Rist's first video. After working with performance and pop music, at the end of the 1980s she transferred her main artistic interest to video and video installations. It shows the artist hopping up and down while she hums to herself the title of the work. Her videos catapulted her into the art business, as Rist herself observed. In 1992, she became famous internationally with *Pimple Porno*. The camera follows a woman and a man as they approach each other physically, while their sensory impressions are translated visually into various nature motifs such as flowers, waves, and clouds.

With the Power of Sight and Sound

Sexuality and eroticism, the difference between the sexes and the physical appearance of men and women, especially women, are frequent themes of Pipilotti Rist. Her works are a mixture of visual and musical elements with images that are then manipulated on the computer. They are often consciously distorted and out-of-focus, showing pictures that are washed out, bleached by the sun, and faded into each other. The results are materializations of Pipilotti Rist's utopias. The artist is convinced that human and cultural progress is possible only through positively formulated works. The result is a cheerful, brightly colored, sensuous, poetic oeuvre backed by gentle music. In it she attempts to "regain the ingenuousness of childhood" and to permit the observer to plunge into her world. A video in the collection of the Museum of Modern Art in New York shows her sense of humor: in *Ever is Over All* (1997) a woman holding an enormous phallic flower stalk delightedly smashes the windows of parking cars while a policewoman benevolently watches what she is doing.

Art Stations

Pipilotti Rist, whose real name is Elisabeth Charlotte Rist, studied between 1982 and 1986 at the Hochschule für Angewandte Kunst (College of Applied Arts) in Vienna before attending the video course at the Schule für Gestaltung (School of Design) in Basel. In 1997, she was appointed Artistic Director of the Swiss National Exhibition Expo.01, which was realized as Expo.02. Pipilotti Rist has been awarded various prizes, including the Premio 2000 at the Biennale in Venice in 1997, the Wolfgang Hahn Prize in 1999, and the 01 award for extraordinary artistic or scientific achievement in the field of multimedia, which was awarded in 2004 and which included a nomination as Honorary Professor at the Universität der Künste (Academy of Arts) in Berlin.

1962 Born Elisabeth Charlotte Rist 21 June in Grabs, Switzerland.
1982 Becomes a student at the College of Applied Art in Vienna.
1986 Enrolls at the School of Design, Basel, first video, audio works, and installations.
1988 Becomes a member of the band Les Reines Prochaines (until 1994)
1999 Takes part in the Venice Biennale.

Pipilotti Rist lives and works in Zurich.

FURTHER READING:
Peggy Phelan, Hans Ulrich Obrist and Elisabeth Bronfen, *Pipilotti Rist,* Phaidon, London and New York, 2001
John B. Ravenal and others, *Outer & Inner Space: Pipilotti Rist, Shirin Neshat, Jane & Louise Wilson, and the History of Video Art,* Virginia Museum of Fine Arts, Richmond, VA / University of Washington Press, Seattle, WA, 2002

Pipilotti Rist, undated

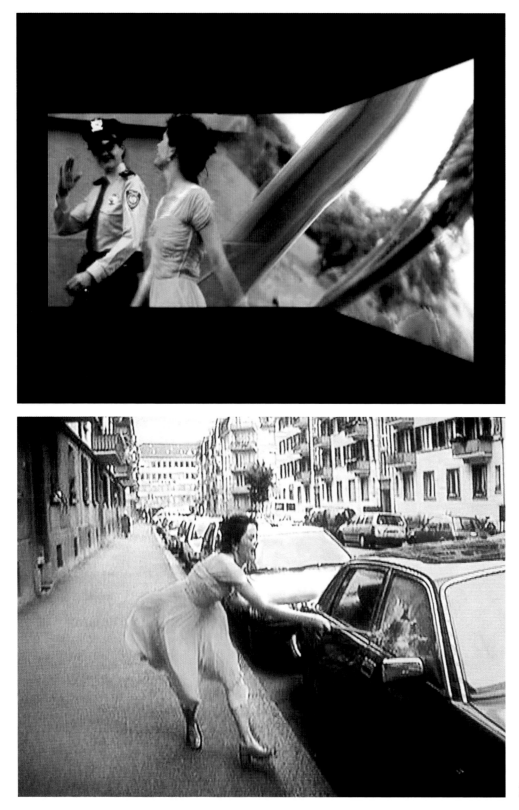

Ever is Over All, 1997, audio-video installation

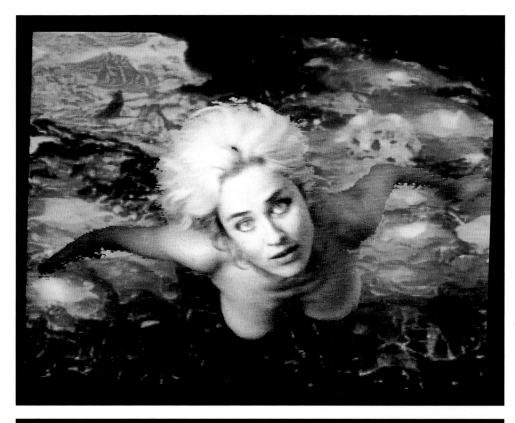

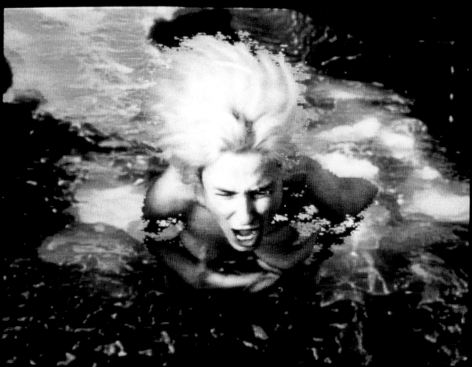

Selfless In The Bath Of Lava, 1994,
audio-video installation

1860–1910 IMPRESSIONISM CUBISM 1910–1920 EXPRESSIONISM 1920–1940 ABSTRACT EXPRESSIONISM 1940–1960 POP ART 1960–1975

1880 1885 1890 1895 1900 1905 1910 1915 1920 1925 1930 1935 1940 1945 1950 1955 1960 1965

Everyone I Have Ever Slept With
1963–1995, 1995, appliquéd tent,
mattress and light, 122 x 245 x 215 cm

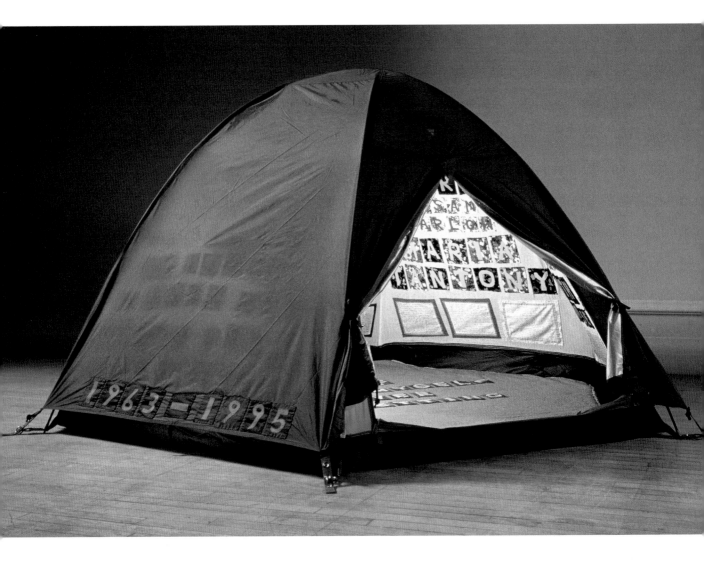

1979	Joseph Beuys retrospective in the Solomon R. Guggenheim Museum in New York	1990	Reunification of Germany		2005	Pope John Paul II dies
					2007	Benazir Bhutto assassinated in Pakistan
	1980	Picasso Exhibition to mark the 50th anniversary of the MoMA in New York		2004	Tsunami flood catastrophe in Asia	
				2003	Start of the Iraq War	

| 1970 | 1975 | 1980 | 1985 | 1990 | 1995 | 2000 | 2005 | 2010 | 2015 | 2020 | 2025 | 2030 | 2035 | 2040 | 2045 | 2050 | 2055 |

TRACEY EMIN

For some, the British artist Tracey Emin strains the term art without scruple, while others see her as something like a pop star. Either way, her work is provocative and entirely autobiographical, blatantly recycling bits of her life.

Tracey Emin was born in the seaside town of Margate in Kent in 1963. She left school at 13, two years before the minimum leaving age, in order to "learn from life." In 1983, she became a student at Maidstone College, and subsequently the Royal College of Art in London. Emin was one of the second wave of Young British Artists (YBAs) who made themselves a reputation in the 1990s by their ability to shock. Their great breakthrough came in 1997 when Charles Saatchi staged a show called *Sensation* at the Royal Academy, which later caused as much uproar in Berlin. Emin's frank display of her sexuality and the intimate details of her life earned her the label of the "bad girl" among the YBAs and a national reputation for explicitness.

Autobiography Rehashed
Emin herself describes her work as "living autobiography." Drawings, neon works, objects, wall hangings, installations, films and books are about events in her life. She is the tragic victim: "I was abused, I was sexually abused, I was treated like shit, I was deceived, I was lied to," she says in the video *The Interview*.

One of her more personal pieces is *Everyone I Have Ever Slept With 1963–1995*, a small tent decorated inside with cut-out fabric letters listing the names of all the people she had shared a bed with in her life (destroyed in a fire in May 2004). In 1999, Emin's installation My Bed, an unmade bed covered in such objects as a half-empty vodka bottles, underwear, and condoms, was nominated for the Turner Prize and shown at the Tate.

In a mix of super-8 and video, she explores a might-have-been in her past life. *Why I Never Became a Dancer* looks back at her life as a girl in Margate and countless sexual adventures. Thinking it might be a way out of life in Margate, she dreams of becoming a dancer, but then the local dancing competition put an end to that idea. She breaks off her showpiece when a chorus of men and former boyfriends jeer at her as a "slut." In a second part seen from the

present, she rewrites the script with a positive outcome: "Shane, Eddy, Tony, Doug, Richard—this one is for you." The adult Tracey comes on stage and blithely dances to a 1970s disco hit.

Emin often makes her past life a public talking point in provocative fashion. She produces personal confessions and drastic self-therapies in an attempt to palliate the emotional trauma she parades. This is so in-your-face that viewers may feel directly addressed, and respond just as directly.

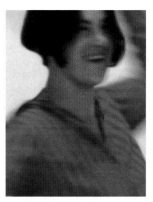

1963 Born 3 July in London. Spends her childhood and youth in Margate.
1980 Enrolls at Medway College of Design.
1984 Enrolls at Maidstone College of Art.
1987 Moves to London and studies at the Royal College of Art and Birkbeck College, University of London (philosophy).
1993 She and Sarah Lucas open The Shop.
1999 *My Bed* is nominated for the Turner Prize.
2007 Creates the interior of the British pavilion at the Venice Biennale.

Tracey Emin lives and works in London.

FURTHER READING:
Mandy Merck and Chris Townsend (eds.), *The Art of Tracey Emin*, Thames and Hudson, London and New York, 2002
Neal Brown, *Tracey Emin*, Tate, London / Harry N. Abrams, New York, 2006
Carl Freedman and Honey Luard, *Tracey Emin*, Rizzoli, New York, 2006

Why I Never Became a Dancer, 1995, Single screen projection and sound shot on Super 8

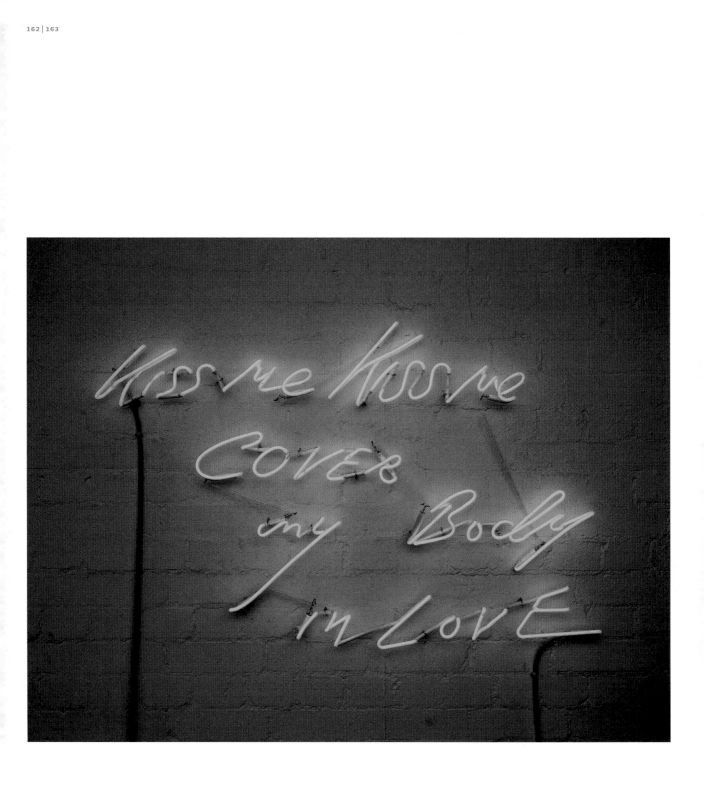

Kiss me, Kiss me, Cover my Body in Love,
1996, neon, 76.2 x 91.4 cm

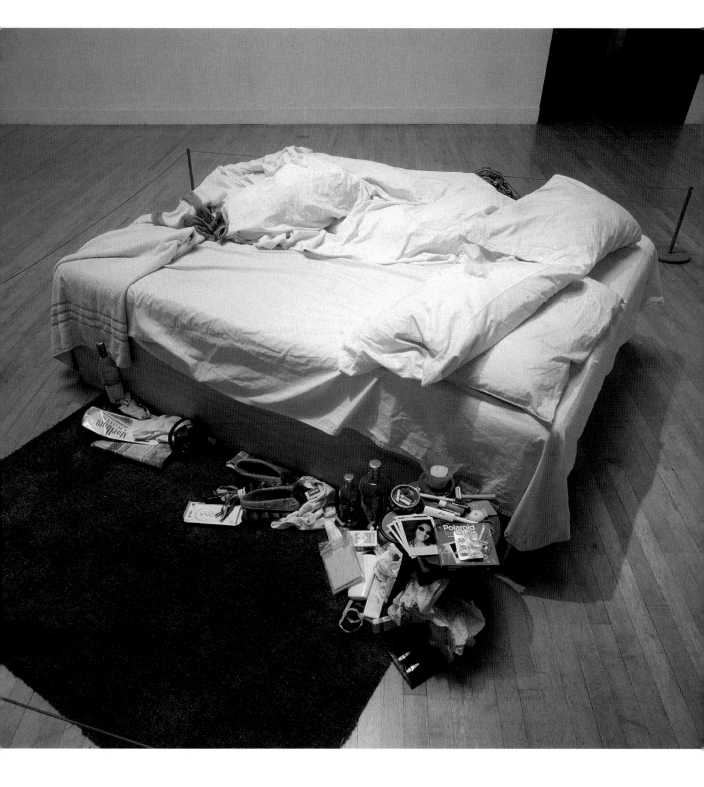

My Bed, installation, Turner Prize
Exhibition, 20 October 1999–23 January
2000, Tate Gallery, London

1950 End of racial segregation
in the United States

1941 b. Martha Argerich,
Argentinian pianist

1860–1910 IMPRESSIONISM CUBISM 1910–1920 EXPRESSIONISM 1920–1940 ABSTRACT EXPRESSIONISM 1940–1960 POP ART 1960–1975

| | | | | | | | | | | | | | | | | | |
1880 1885 1890 1895 1900 1905 1910 1915 1920 1925 1930 1935 1940 1945 1950 1955 1960 1965

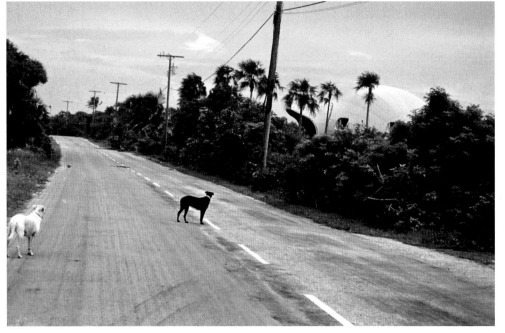

Bubble House, 1999, film still

1988 Withdrawal of Soviet troops from Afghanistan	**2001** George W. Bush becomes President of the United States		
1990 Reunification of Germany	**2003** Start of the Iraq War		
	2007 Benazir Bhutto assassinated in Pakistan		
	2001 Start of the war in Afghanistan		

1970 1975 1980 1985 1990 1995 2000 2005 2010 2015 2020 2025 2030 2035 2040 2045 2050 2055

TACITA DEAN

Originally trained as a painter, since the 1990s British artist Tacita Dean has devoted herself to film, drawing, and photography. The special feature of her work is an attempt to capture fleeting moments in images.

Tacita Dean is best known internationally for her unconventional 16 mm films. Her long takes and steady camera angles create an almost meditative atmosphere focusing on the subject of time and telling of its passing. According to Dean, "Everything I'm attracted to is in on the point of disappearing."

Islands of Time

A number of the artist's films were made in her adopted home city, Berlin. In *Fernsehturm* (TV Tower), a camera installed on the balustrade of the TV tower high above Alexanderplatz follows the slow revolutions of the restaurant around its axis. It records the everyday labors of the waiters and waitresses serving guests non-stop, laying tables and then clearing them away as it gradually gets dark outside. Another film meditation on the past, present, and forgetting, with poetic shots of reflections on the façade, was made at the highly symbolic Palast der Republik, the former East German "people's palace" now being demolished.

A potent source of effects in her work is light: in *Disappearance at Sea* (1996) she focuses on a lighthouse that comes on at the end of the day, alternating with twilight shots of the horizon out at sea. In *The Green Ray* (2001) she filmed a sunset so as to record the "green ray," a phenomenon of nature that takes place at the very moment the sun vanishes below the horizon off Madagascar.

Tacita Dean works with various artistic media that are closely related. In her works on paper, the motif of the storyboard frequently crops up; they appear like visual drafts of a planned film. Her crayon drawings on black panels, magnetic tape, or stone slabs were often produced in several stages, deleted and then gone over again, the various phases being documented photographically. A series of 20 photogravures based on old picture postcards is furnished with handwritten instructions or explanations. Dean called the collection *The Russian Ending* (2001), alluding to a practice in silent-film days when two export versions of European films were made—one for the American market with a happy ending, one for the Russians with a tragic ending.

Among the artist's works is also a cloverleaf collection that she has kept up since childhood: a graphic example of her talent for tracking down the unobtrusive and yet precious things of life. Her works are an invitation to follow suit.

1965 Born in Canterbury, England.
1988 Completes her studies at the Falmouth School of Art.
1992 Graduates from the Slade School of Fine Art, London.
1998 *Disappearance at Sea* is nominated for the Turner Prize.
2000 Takes up a scholarship in Berlin.

Tacita Dean lives and works in Berlin.

FURTHER READING:
Jean-Christophe Royoux and others, *Tacita Dean*, Phiadon, London and New York, 2006
Tacita Dean, Briony Fer and Rina Carvajal, *Tacita Dean: Film Works*, Miami Art Central / Charta, Miami, 2007

Tacita Dean, undated

The Green Ray, 2001, film still

GLOSSARY

Abstract Expressionism See page 104

Academy
An art institution that provides training, exhibitions, and prizes. The first modern academies emerged in Italy during the Renaissance. Traditionally they have exercised a huge influence on the development of art, though they were frequently associated with maintaining traditional values than with encouraging modernizing tendencies. The Académie Royale in Paris was founded in 1648, the Royal Academy in London in 1768, the American Academy in New York in 1802.

Action
An art action, like a performance or a happening, resembles an experimental theatrical or musical performance rather than a traditional art work. Unlike the latter, they all take the form of an event, an occurrence that exists only in the here and now. During a performance or a happening there is an audience to witness or participate; an action, by contrast, can take place without an audience and then be observed only retrospectively (e.g. by means of photographs, video etc.). See **Body art**

Art Deco
A decorative style named after a major exhibition in Paris, the Exposition *Internationale des Arts Décoratifs et Industriels Modernes* in 1925. It was the direct successor to Art Nouveau, but in contrast to that style Art Deco is characterized by simple, geometrical shapes. Luxurious materials such as bronze, ivory, lacquer, and ebony were frequently used.

Atelier
(French) An artist's studio or place of work.

Baroque
The predominant style in European art from c. 1600 until the middle of the 18th century. It is characterized by the use of dynamic movement and dramatic effects. The Baroque style was thus opposed to the preceding style, Mannerism, which was noted for its intellectualism and emotion introversion. The Baroque gave way to **Rococo**.

Biennale
Any international art exhibition that take place every two years. One of the best known is the Venice Biennale.

Body art
An art form in which an artist uses his or her own body as a medium. Body art, which developed at the end of the 1960s largely in New York, includes the body in action or manipulations of the surface of the body, including the infliction of injury. Most body art takes the form of single events that are usually recorded by means of film, video, or photography. See **Action**.

Caravaggisti See page 24

Collage
(French *coller*, "to glue") An art technique in which newspaper cuttings, pieces of fabric, wallpaper, cut-up pictures etc. are stuck together to form pictures.

Dada
An anti-art movement that emerged in Zurich in 1916. The name supposedly harks back to a French children's name for a hobby-horse, but in fact it was made up. A protest against the pretensions and complacency of art, it employed nonsensical and anarchic actions and texts. Among the protagonists of the movement were the writer Hugo Ball and the painters Tristan Tzara and Hans Arp. It served as the forerunner of **Surrealism**.

documenta
A large, international exhibition of contemporary art held in Kassel, Germany, every five years.

Genre painting See page 59

History painting
Depictions of historical events, often in conjunction with themes from classical mythology or antiquity. During the Renaissance, history painting developed into an independent genre. At times, especially during the 17th and 18th centuries, it was regarded as the highest form of art after religious painting.

Impressionism See page 65

Installation
A three-dimensional art work set up in an existing space. A great variety of materials and media can be used.

Minimal Art
Minimal Art arose during the 1960s as a reaction to **Abstract Expressionism** (page 104). Its aim was to abandon all forms of representation, symbolism, and metaphor. This resulted in almost exclusively sculptural works that were reduced to simple basic forms, interest being focused less on the works themselves than on their relationship with the surrounding space. Characteristic of Minimal Art is above all the striving for objectivity, depersonalization, and schematic clarity.

Neo-Classicism See page 55

Nouveau Réalisme
(French, "New Realism") An expression coined by the French art critic Pierre Restany to identify a group of French artists that includes Yves Klein, Jean Tinguely, and Arman. The group rejected the idea of free

abstraction and used existing objects and material they found by chance to produce their art. The objects came to serve as an ironic commentary on contemporary society. Nouveau Réalisme was a parallel movement to **Pop Art**.

Oil painting
A painting technique in which an oil (usually linseed, poppy, or walnut) is used as a medium to bind color pigments. On exposure to the air, the oil gradually dries to form a hard surface. The technique developed in the Netherlands in the 15th century and from the 16th century was the predominant painting medium, largely because of its versatility. They can be applied either as a translucent glaze or opaquely. When used thickly, the very paint and brushwork can contribute to a work's expressiveness. It is also capable of extremely fine gradations of color and tone.

Pastel
Pastel is a form of dry painting executed with drawing sticks consisting of compressed powder color and a binding medium (e.g. gum arabic). The colors can be blended on paper to produce soft transitions, or applied in individual lines or dots. Pastel smudges easily and so must be sprayed with a color-less fixative solution.

Plein-air painting See page 77

Pop Art
An art movement emerging in Britain and the United States during the 1960 and lasting until the mid 1970s. Rejecting abstract art, Pop artists aimed to use popular items from everyday life, notably from popular culture and advertising, in artistic contexts—film stars, pop musicians, automobiles, comics, beer cans, flags etc. Important pop artists include Andy Warhol, Roy Lichtenstein,

Richard Hamilton, David Hockney, and Claes Oldenburg.

Renaissance See page 16

Retrospective
("Looking back") An art exhibition that presents a complete overview of a specific creative periods or the entire oeuvre of an artist.

Rococo
(from the French *rocaille*, "sea shell"). A style in European art that formed the final phase of the Baroque era. Extending from c. 1700 until c. 1780, it replaced heavy, dramatic Baroque forms with light, intricate, and playful images that often included representations of flowers, fruit, and garlands. In Rococo painting, which was primarily found at court and in the salons of the wealthy, the pictures are characterized by delicate, fine, detailed ornamentation. The Rococo style thus provided a playful end to the Baroque era. It flourished in particular in France, Germany, and Austria.

Salon See page 53

Signature
(Lat. *signare*, "to denote") With a signature—written out in full, abbreviated, or in the form of a sign or symbol—artists identify a work as their own. Signatures were customary even on painted Greek vases; during the Middle Ages they were rare, and works were initially signed only on the frame. With the rise of the middle class as purchasers of art during the Italian Renaissance and later in Netherlandish painting during the 17th century, the signature became a customary (authenticating) feature.

Still-life
The representation of lifeless objects such as everyday objects, dead animals, and (above all) fruit and flowers. By including depictions of fading blossoms or a skull, so-called *vanitas* still-lifes draw attention to the transient nature of all things. The symbolic meaning of still-lifes was important primarily during the Baroque era.

Surrealism
(French, "beyond reality"). The Surrealist movement, which came into being in Paris, was a continuation of **Dada**. Its central figure was the poet André Breton. The painters around Breton did not want to depict the visible world of everyday life, but to reveal the world that lies concealed in our unconscious minds, glimpsed in dreams. And as in dreams, in their paintings apparently unconnected or absurd things come together to form strange, even disturbing images. The range of styles was very wide. While artists like Salvador Dalí and René Magritte presented works with an almost photographic accuracy, painters like Joan Miró, André Masson, and Hans Arp created strange, often distorted or child-like shapes vaguely reminiscent of human or animal forms.

Watercolor
A thin, translucent painting medium using water-soluble colors. Watercolor painting is one of the oldest painting techniques; it was used by the ancient Egyptians to paint on papyrus in the Books of the Dead (2nd century BC).

INDEX

TEXTS

Melanie Klier: pp. 34, 42, 62, 78, 86
Doris Kutschbach: p. 46
Petra Larass: pp. 14, 18, 20, 22, 26, 28, 38, 48, 54, 68, 72
Claudia Stäuble: pp. 44, 52, 58, 76
Christiane Weidemann: pp. 10, 82, 84, 90, 94, 96, 100, 104, 106, 110, 114,
 116, 120, 124, 128, 132, 134, 136, 140, 144, 148, 152, 156, 160, 164
Andrea Weißenbach: pp. 32, 60, 64, 74, glossary, timeline

PHOTO CREDITS